teNeues

LIVING ROOFS

Texts by Ashley Penn

CONTENT

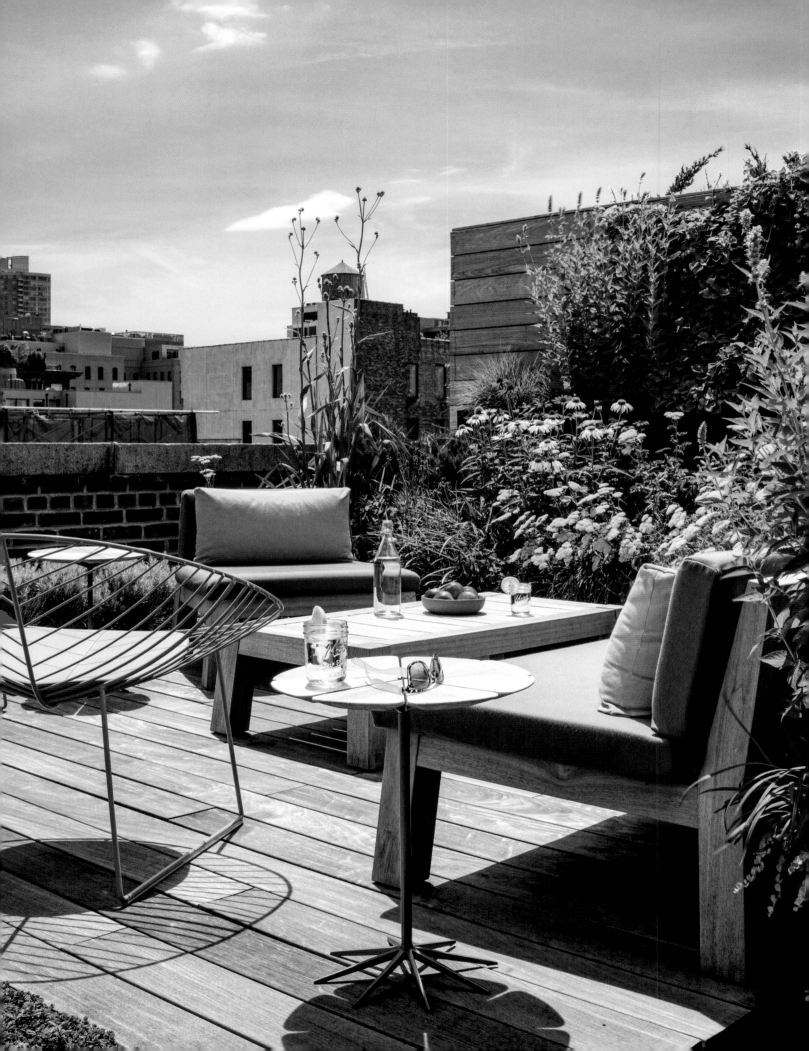

A ROOF WITH A VIEW

by Ashley Penn

With more than three and a half billion people living in cities and growing population densities putting mounting pressure on our green space, the once idyllic dream of a detached house surrounded by gardens is no longer achievable for the vast majority. However, with the advent of projects like The High Line in New York City demonstrating that it is possible to turn once neglected areas in cities into popular green oases by growing plants high above the ground, architects, landscape architects, garden designers, and even enthusiastic gardeners are creating bold roof gardens. These green roofs enhance homes with vital areas in which to relax, entertain, for children to play in, and fertile areas in which to grow herbs, fruits, and vegetables. As well as additional living space, green roofs can add a whole host of other benefits including increasing the value of properties, supporting biodiversity, filtering air pollution, and even mitigating stormwater runoff and alleviating overflow. Green roofs are progressively viewed as vital "green infrastructure" within the urban matrix.

Green roofs fall into two main categories: extensive and intensive. Extensive green roofs are lightweight and can easily be installed on existing roofs of any size from garden sheds to large houses and commercial buildings. They consist of a thin layer of growing medium, or soil, over various layers of waterproofing, insulation, filter membranes, and water reservoirs. Due to the shallow nature of the soil, plant selection is limited to shallow rooted species such as herbaceous perennials. Extensive green roofs need minimal maintenance

and do not require watering. They can offer a range of wildlife habitats as can be seen in Forest Lodge Eco House (*page 77*) or be visually simple with one homogeneous species-rich plant community like at Edgeland House (*page 17*). One common trait of all extensive green roofs is that they have the ability to hold onto an amount of stormwater, slowing its passage into the storm sewer. In this way, they can reduce flooding.

Intensive green roofs typically have a greater depth of soil or growing medium, and thus can accommodate larger species such as shrubs and trees. Intensive green roofs require a greater amount of maintenance, including watering, but can achieve stunning results such as the beautiful and cozy garden at Central Park West (*page 127*) or the spectacular contemporary Tribeca Penthouse Garden (*page 215*).

The term "roof garden" can refer to intensive green roofs or roof terraces where plants are planted in containers. More and more these days, property developers and architects are realizing the advantages of including roof gardens in their most luxurious schemes. Projects like Chelsea Creek Dockside House (*page 205*) and Willow House (*page 9*) both feature lavish roof gardens as major features of their designs.

Roof gardens and terraces are even becoming integral parts of the architecture, such as in the architect's studio and apartment at Archilabo (*page 65*), where multiple gardens and terraces thrive at different levels.

Opposite: Tribeca Loft. photo: Albert Vecerka, Esto

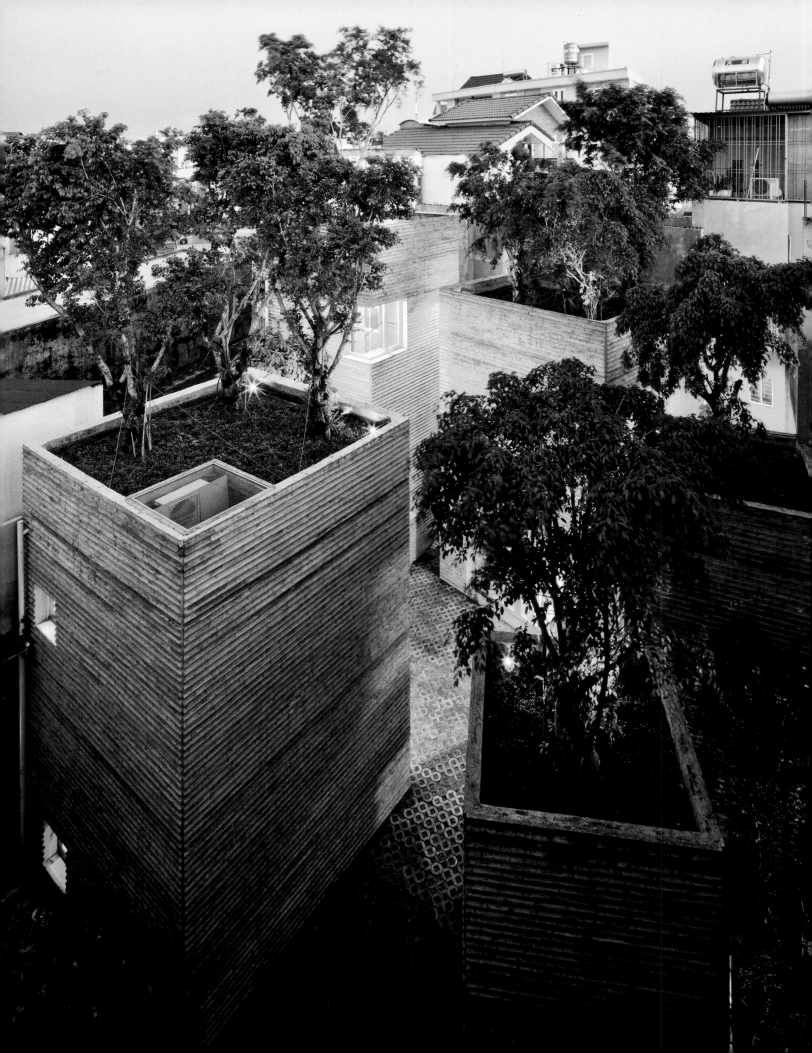

Ashley Penn is a Chartered Member of the Landscape Institute in the United Kingdom where he worked for many years as a landscape architect. He has written extensively for the Landscape Architects Network website as a volunteer since 2012 and is currently the Content Director. He studied horticulture before specializing in landscape design as an undergraduate. Upon graduation, he was awarded the Turner Prize for Innovation in Design. While studying his Post Graduate Diploma in Landscape Architecture, Ashley Penn developed interests in landscape history and green technologies, including green roofs and green walls. He has written many articles about green roofs for Landscape Architects Network. He currently resides in Nokia, Finland, where he works as a freelance landscape designer.

In an even more recent trend, we see architects deliberately blur the lines between interior and exterior spaces with projects like Tribeca Loft (*page 101*) fully integrating a portion of the roof terrace into the property with a retractable glass ceiling allowing one space to be both inside and outside, depending on the weather.

Of course, it's not just architects who are designing beautiful roof terraces. With property prices remaining high in many countries, homeowners are turning to their roofs to offer valuable outdoor space. Even small roofs can provide space for planting with many owners making the most of container gardens to green their terraces, such as in Copacabana de luxe (*page 163*) and Ziggurat Rooftop Terrace (*page 169*).

This volume includes 35 outstanding residential projects from around the world and across the spectrum of green roofs and roof gardens—from small extensive green roofs to luxury penthouse terraces. Beautiful photographs demonstrate the unique aesthetic characteristics of each property. Each project is examined in detail, including the plants and materials used, as well as the spatial and aesthetic effects created by the design. *Living Roofs* represents the very best in traditional and contemporary green roofs and roof gardens, and it is an invaluable source of inspiration for anybody interested in the field of urban garden design as well as readers looking for new ideas to reinvigorate their own gardens, terraces, and balconies.

Opposite: House for Trees. photo: Hiroyuki Oki

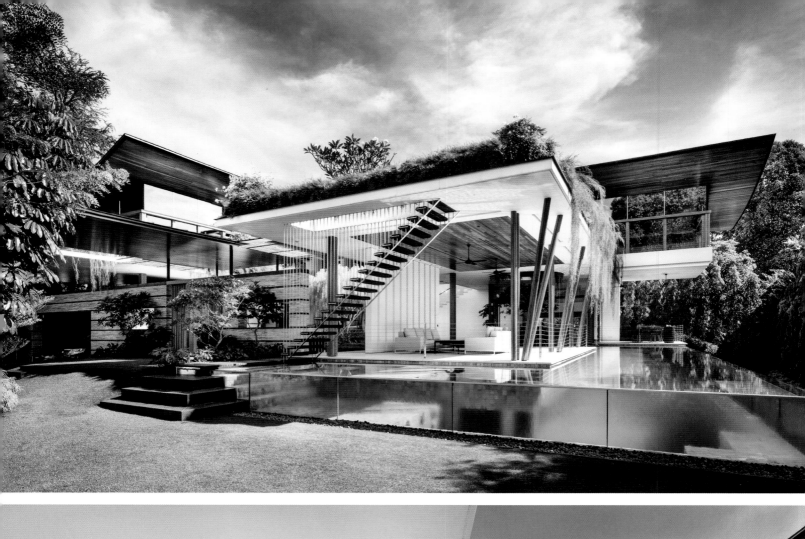
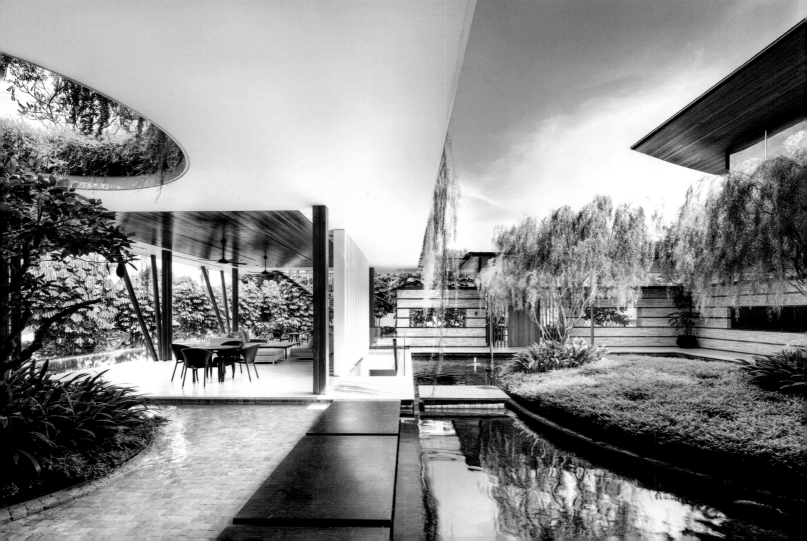

WILLOW HOUSE

Singapore

Category
Intensive green roof

Year
2012

Area
Site: 1,440 m² (15,500 sq. ft.)

Landscape Architecture / Architecture
Guz Architects Pte Ltd

Photography
Patrick Bingham-Hall

Willow House epitomizes the luxuriousness of the exotic post modern house with outdoor living forming the fundamental core to this open-plan architecture, softened by an abundance of lush foliage.

The layout of the house is arranged to make maximum use of the prevailing breezes to ameliorate the humid Singapore climate. A generous central courtyard has been placed within the property to provide outdoor living space. A large rectilinear fishpond is also included to lend the house the psychological cooling and calming effect of water. In the center of the pond is an island of teatrees that offers dappled shade to the courtyard, further cooling the space.

Where this house really excels, however, is in the verdant roof garden, which appears to be barely contained by the architecture of the house—spilling out over every available edge to soften the rectilinear forms of the building. The inclusion of the two roof terraces ensures that each level of the house has access to outside space. Three pinewheelflower trees provide structure and height to the green roof, while lawn and herbaceous planting create a pleasant view that is easy to maintain.

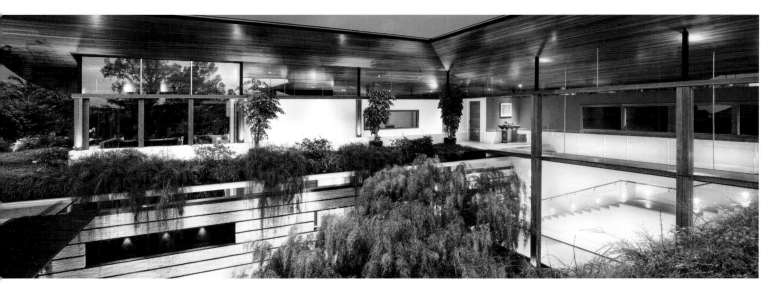

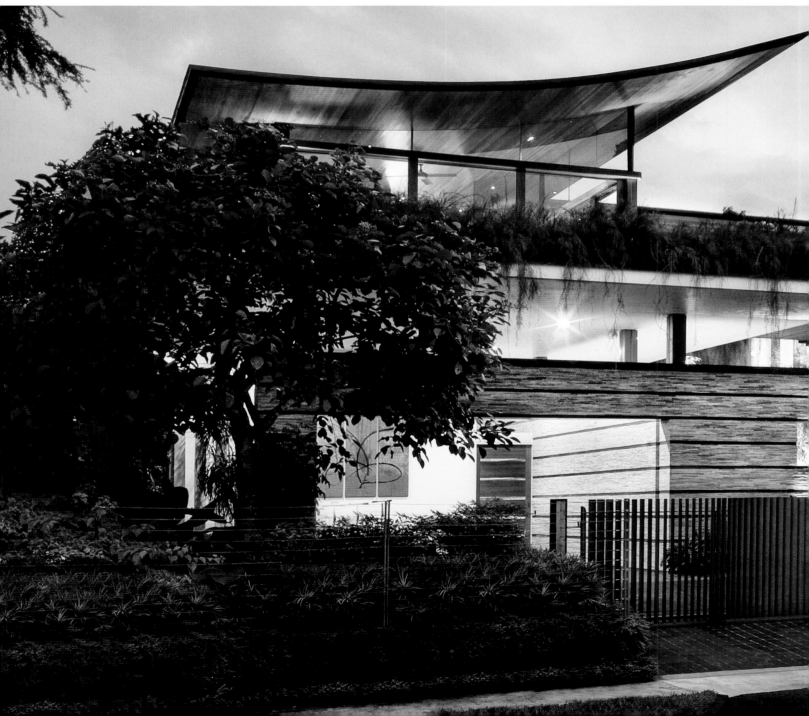

Below and overleaf: The cascading foliage of
the coral plant and bougainvillea trails over the
edge of the roofline.

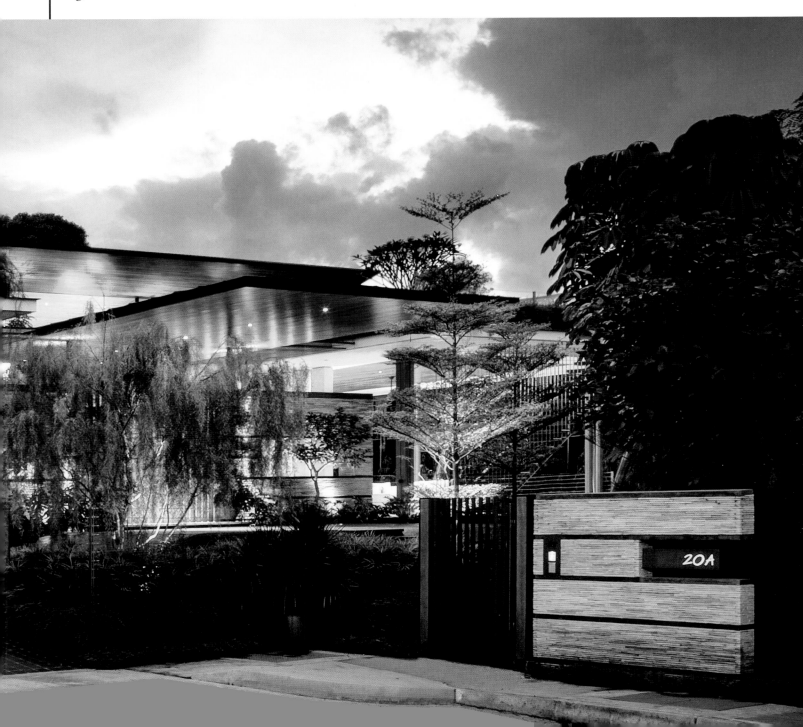

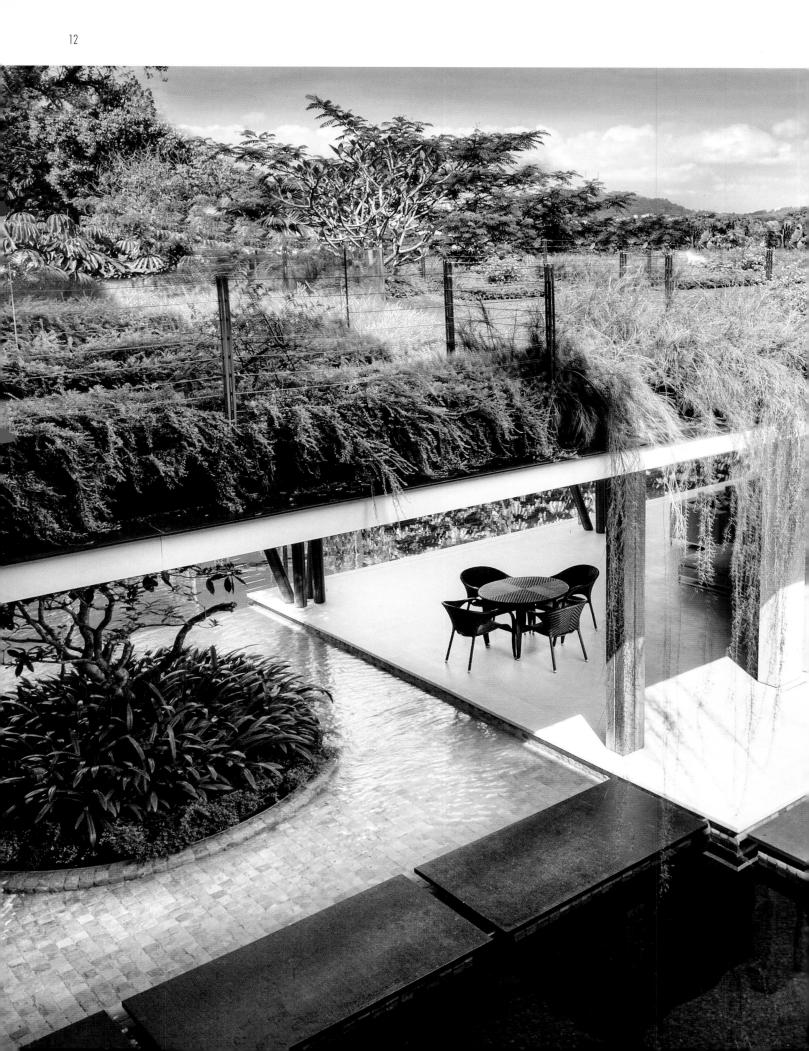

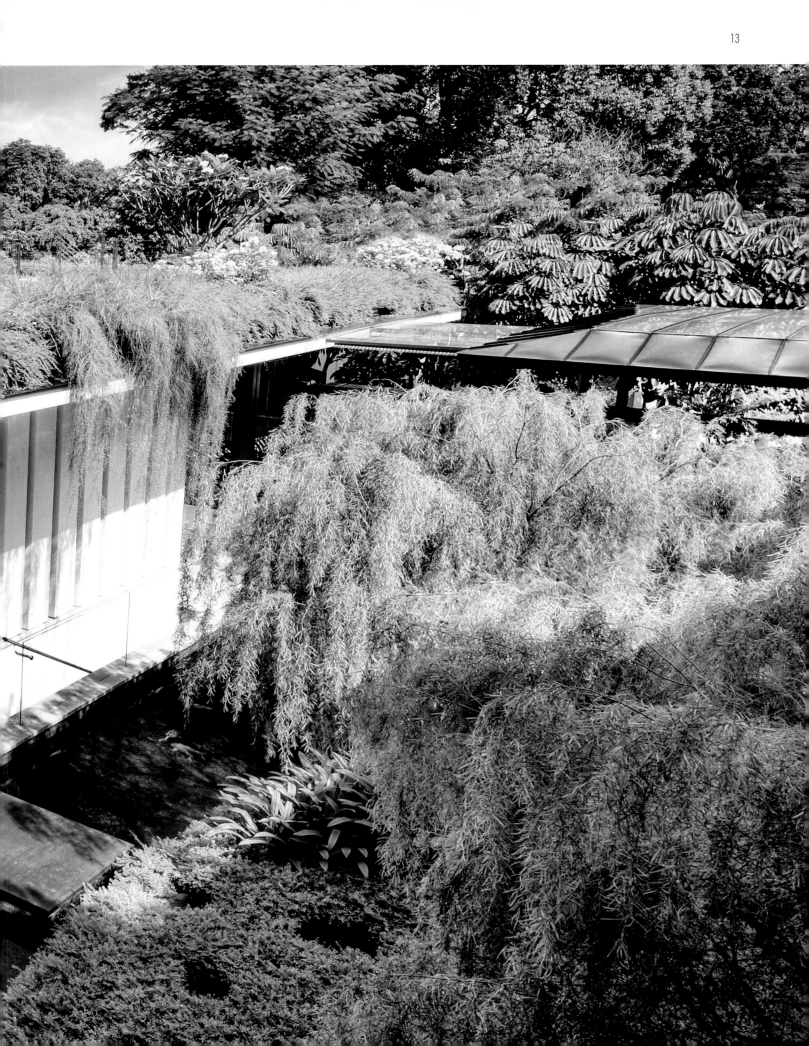

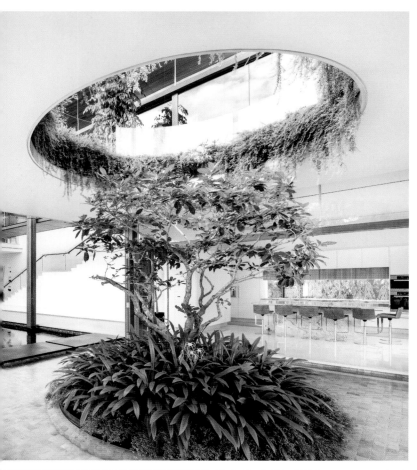

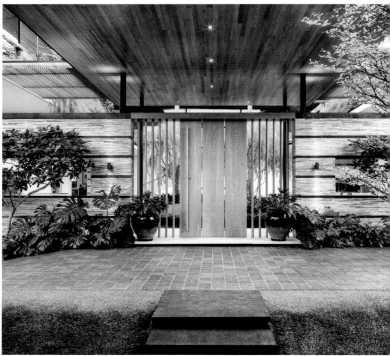

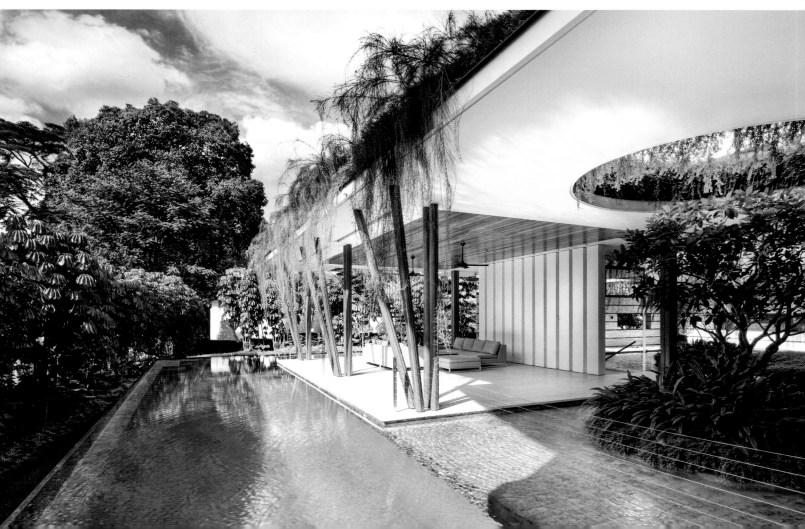

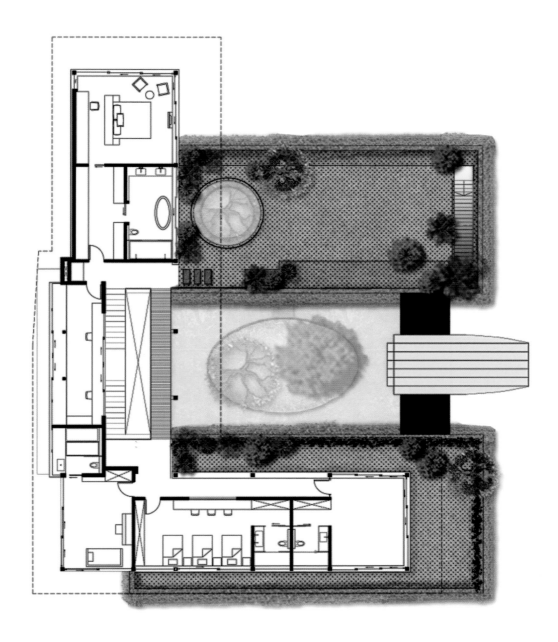

Climate
Tropical rainforest climate (20ºC / 60ºF)

Plants
Bougainvillea (*Bougainvillea sp*)
Coral plant (*Russelia equisetiformis*)
Dragontree (*Dracaena draco*)
Pinewheelflower (*Tabernaemontana divaricata*)
Teatree (*Leptospermum sp*)

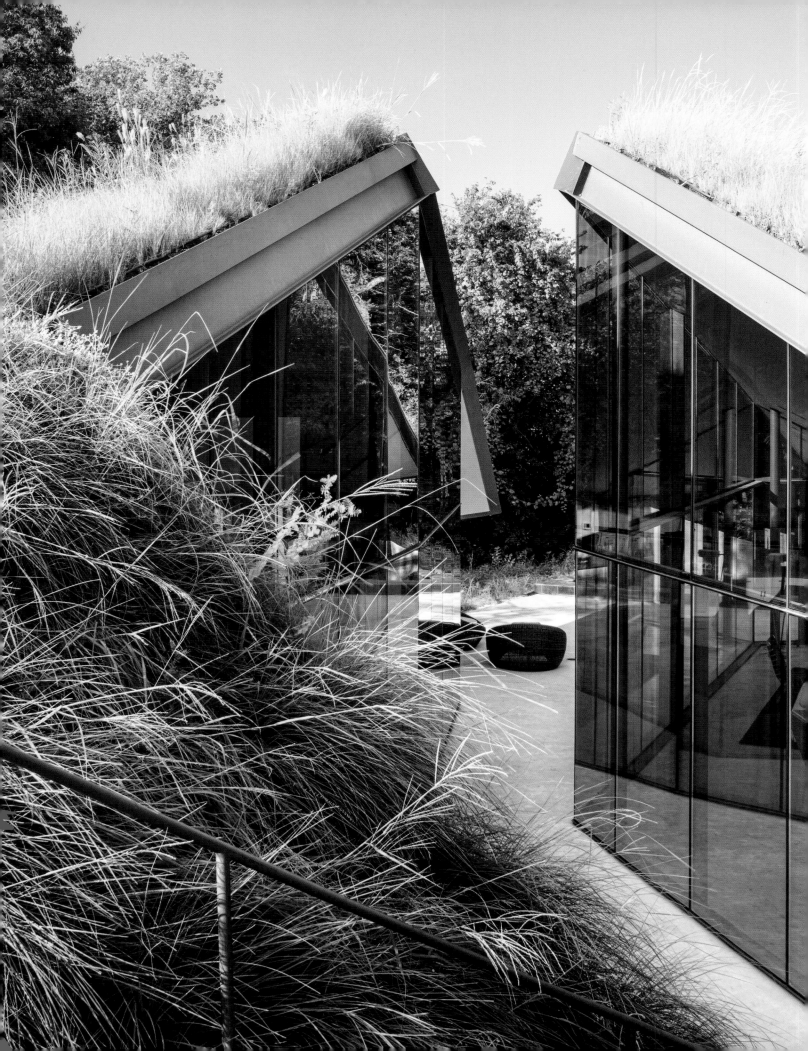

EDGELAND HOUSE

Austin, Texas, USA

Category
Extensive green roof

Year
2011

Area
130 m² (1,400 sq. ft.)

Landscape Architecture
Lady Bird Johnson Wildflower Center
and Bercy Chen Studio, LP

Architecture
Bercy Chen Studio, LP

Awards
Architizer A+ Award
Fast Company House of the Year

Photography
Paul Bardagjy

Edgeland House is a spectacular modern dwelling that draws on Native American building practices to create a minimal house. The house is partially buried in the ground, using the thermal insulation of the surrounding soil to ensure the internal temperature stays cool in summer and warm in winter. A thick sod roof also insulates the building from above, while aesthetically and ecologically blending into the grassland around.

The house has been designed with two separate pavilions; one for sleeping and one for living. A striking angular scar separates the two halves, juxtaposing form and texture.

The extensive green roof of native grasses and mixed herbaceous perennials softens the otherwise harsh lines of the architecture. It also enhances the artifice of the building in its correlation of nature and man-made structure.

Wrapping the grassland over the building like a blanket not only ensures insulation, but also camouflages the house from some angles, helping it blend into the site.

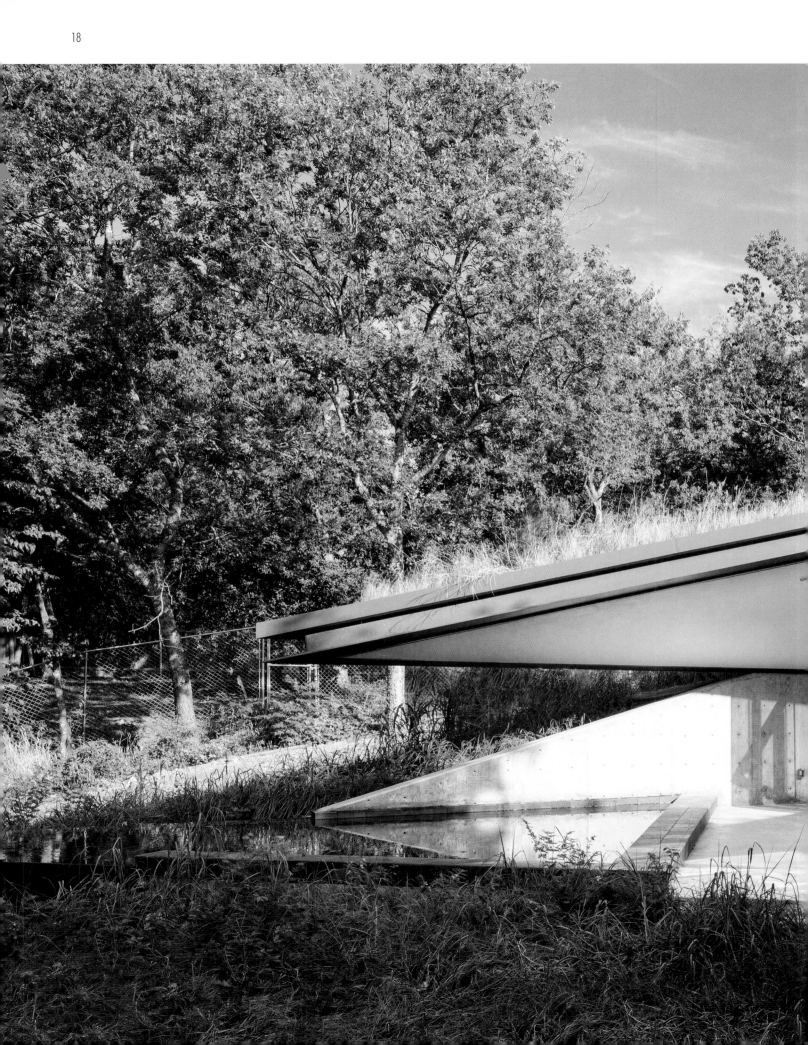

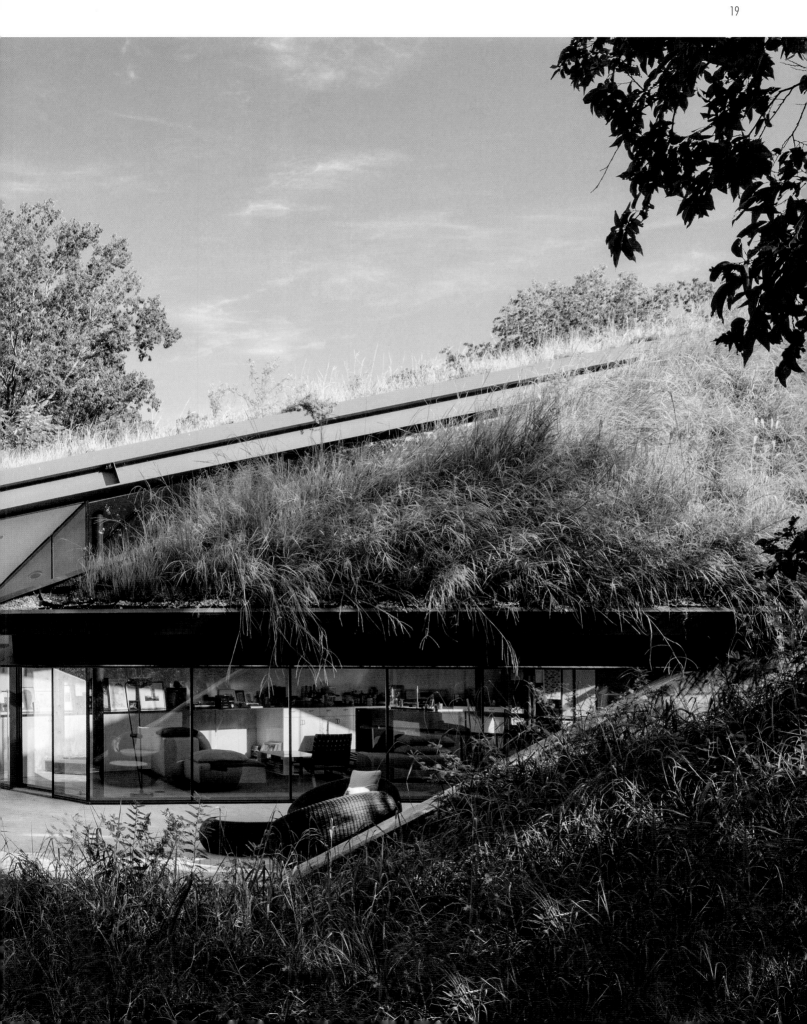

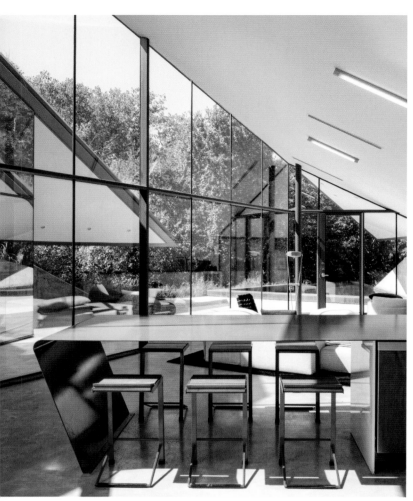

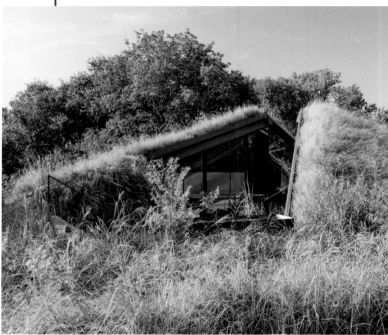

Left: From the inside there is almost no hint of the amount of soil and vegetation on the green roof above.

Below: The pyramid-like forms of the building blend beautifully with the tree-lined background.

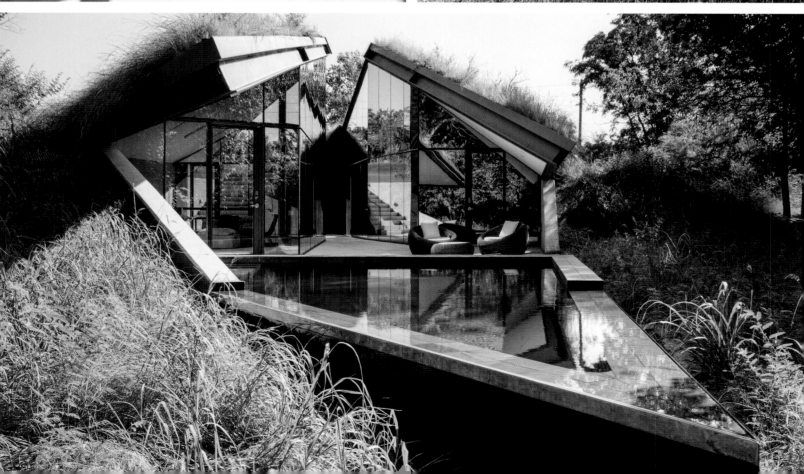

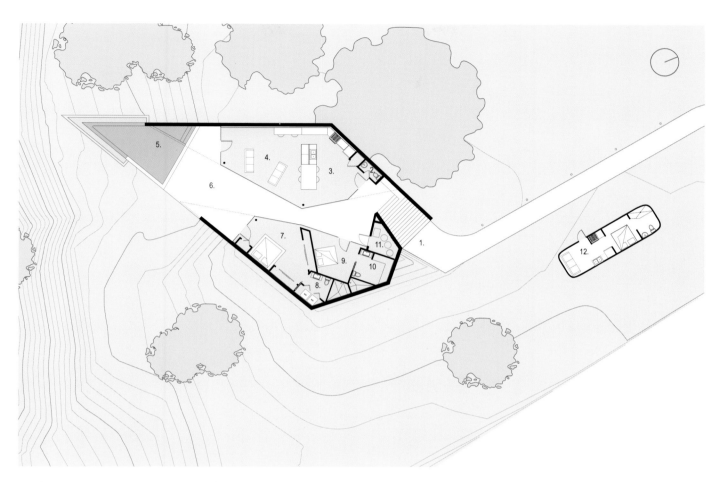

1. Entry	7. Bedroom
2. WC	8. Bathroom
3. Kitchen	9. Bedroom
4. Living	10. Bathroom
5. Smart Pool	11. Mechanical Room
6. Patio	12. Guest Trailer

Climate
USDA Zone 8b (-9.4 to -6.7°C / 15 to 20°F)

Plants
Over 40 native species of plants including:
Bush pea (*Pultenaea*)
Texas lantana (*Lantana urticoides*)
Texas lupine (*Lupinus texensis*)

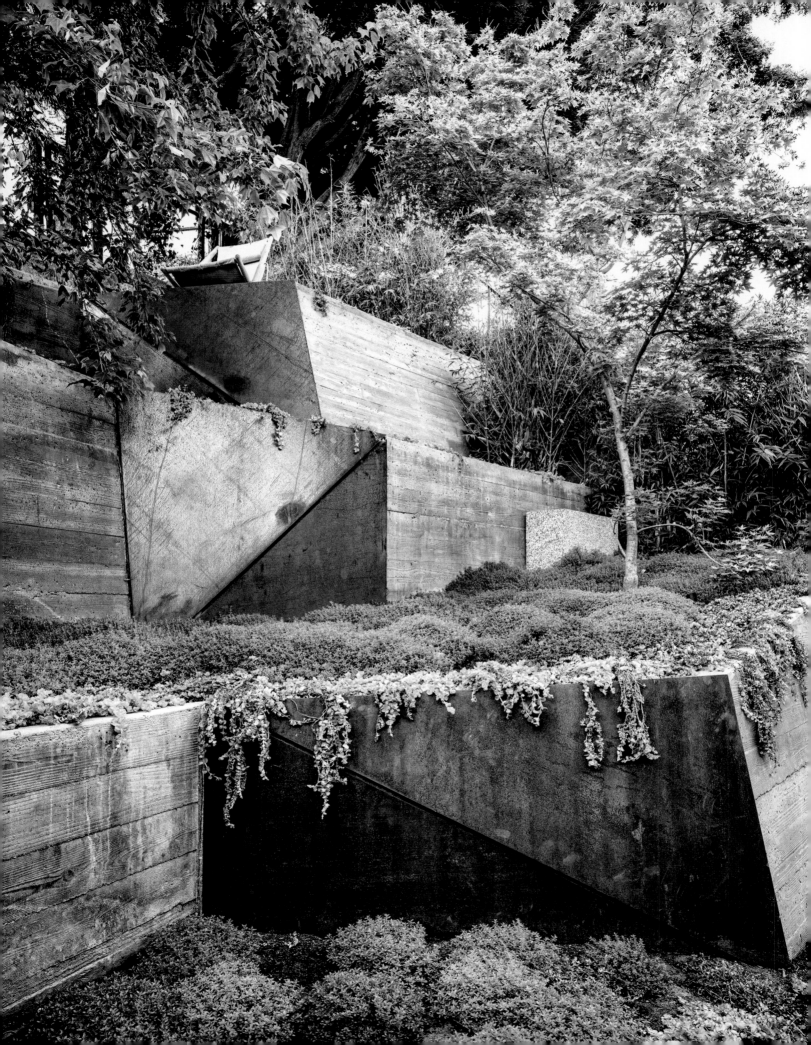

HILGARD GARDEN

Berkeley, California, USA

Category
Intensive green roof

Year
2012

Area
107 m² (1,150 sq. ft.)

Architecture / Landscape Architecture
Mary Barensfeld Architecture

Awards
ASLA Northern California Chapter,
 Honor Award

Photography
JoeFletcher.com

Hilgard Garden is a sublime solution to a difficult design brief. This small townhouse garden of 7 x 15.25 meters (23 x 50 feet) rises in elevation by over 5 meters (17 feet), creating a very steep slope. Rather than chose to terrace the slope traditionally and use conventional steps to access the space, the designer created a meandering ramped access to the higher level, where she placed an ipe wooden deck to provide commanding views of the San Francisco Bay Area.

The material palette of the garden is inspired by the clients' love of modernist architecture. In situ cast concrete retaining walls, heavily textured weathered steel screening, and ipe wood decking provide rich textures, contrasted by a smooth reflective pond in the center of the garden.

The route to the upper level passes through scented lemon thyme and creeping jenny, creating a relaxing sense of journey. Structure in the planting is provided by beautiful, sculptural Japanese maples and koi bamboo which subtly reference the wooden-framed white planes of the house, reminiscent of traditional Japanese architecture.

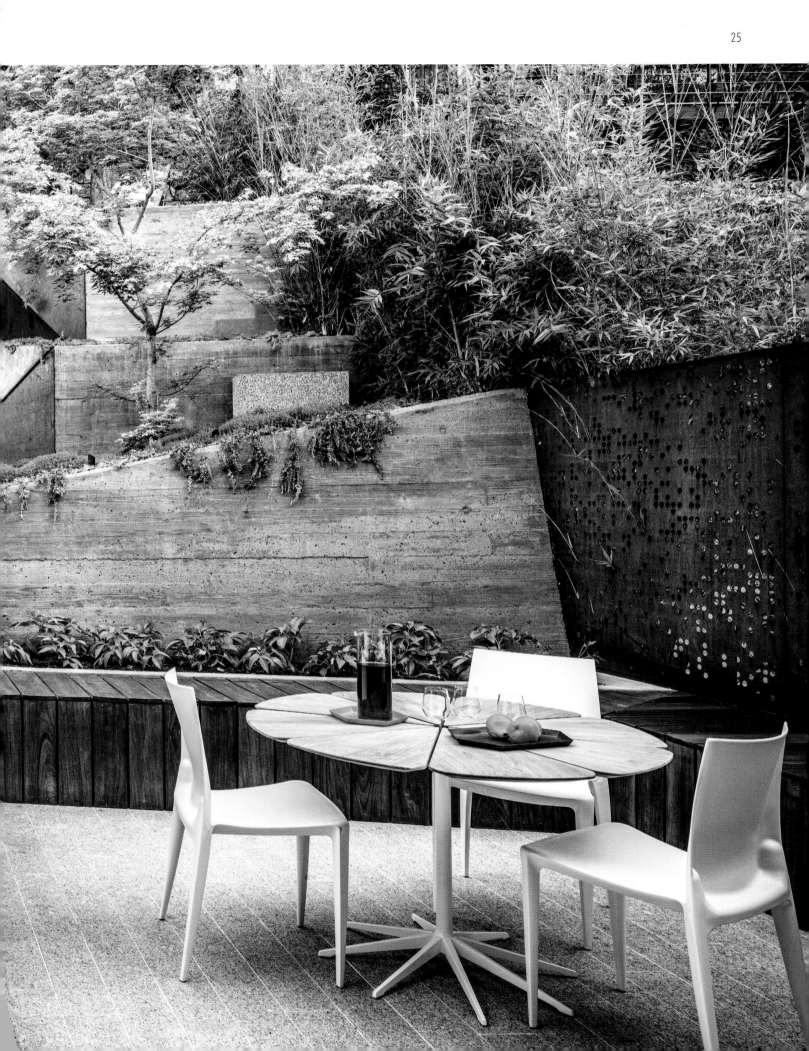

Left and overleaf: The center of the ramped access to the higher level is fractured by triangular steel plates that are lit from behind by LED lights, creating a river of light that cascades down the slope to the reflective pool below.

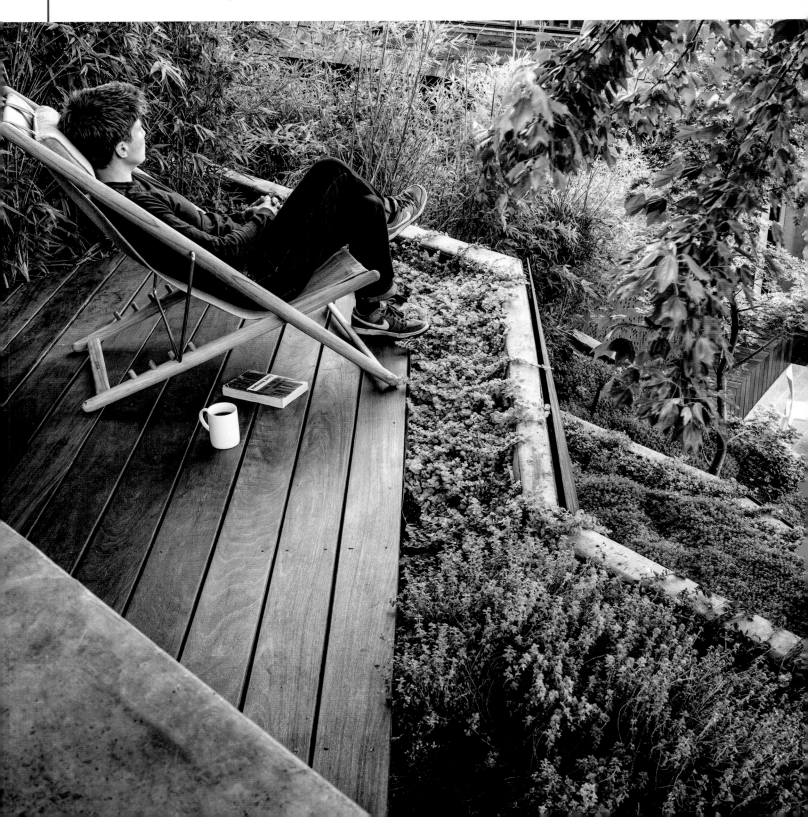

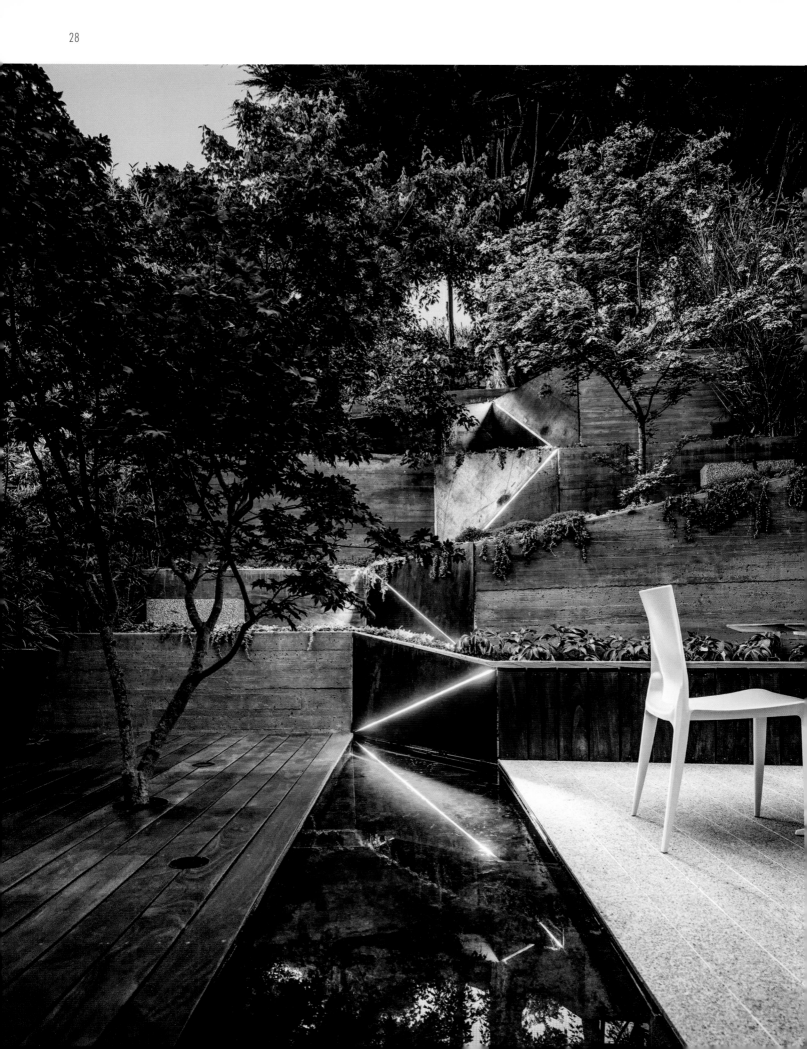

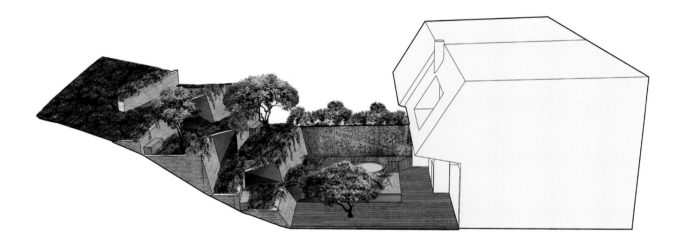

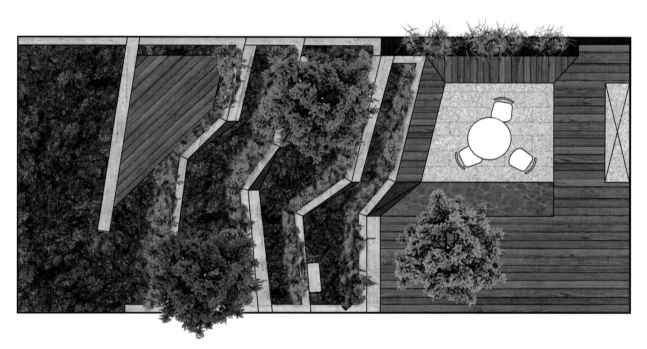

Climate
USDA Zone 10a (-1.1 to 1.7°C / 30 to 35°F)

Plants
Creeping jenny (*Lysimachia nummularia*)
Japanese maple (*Acer palmatum*)
Koi bamboo (*Phyllostachys aurea* 'Koi')
Lemon thyme (*Thymus citriodorus*)

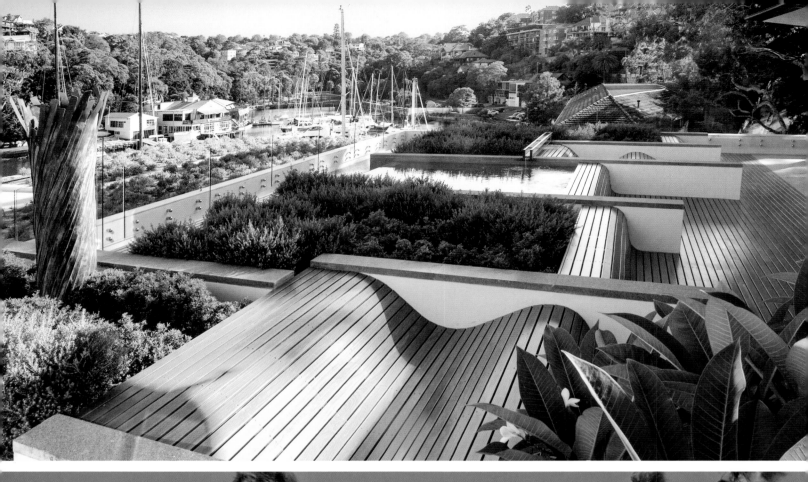

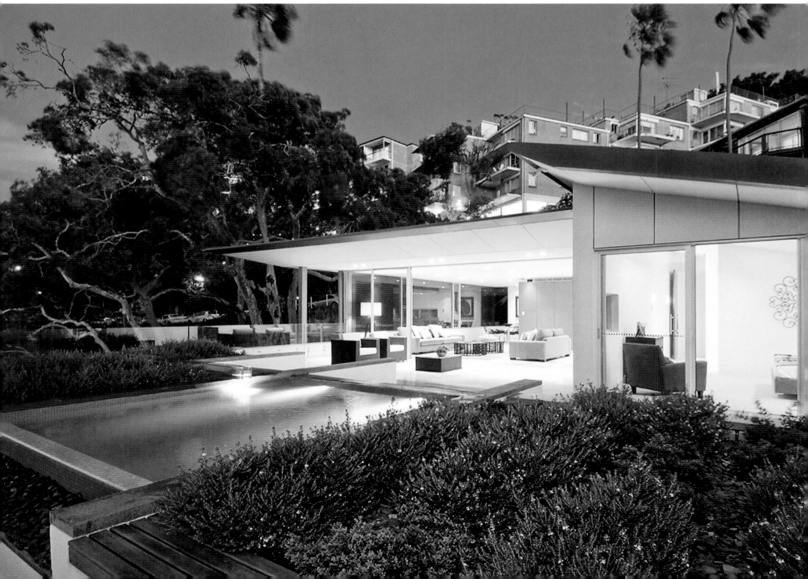

WATERMARQUE

Sydney, Australia

Category
Intensive green roof

Year
2008

Area
240 m² (2,600 sq. ft.)

Landscape Architecture
Terragram Pty Ltd – Vladimir Sitta

Architecture
Allen Jack + Cottier

Photography
Vladimir Sitta, Anthony Charlesworth

Watermarque is a sleek, contemporary lifestyle roof garden designed for modern outdoor living and entertaining. The designer has taken inspiration from the local area to create a roof garden that is truly Australian.

Spatially this large penthouse garden is simple with few vertical elements that might obstruct the stunning view of the bay. The two main features of the garden are the therapy pool, which both conceptually and aesthetically links with the water of the bay, and the waveform decking. The striking undulating forms of the deck not only reference the coastal location, but also provide flexible seating that accommodates a range of passive activities from sitting through reclining to lying.

A beautiful and intriguing art installation that resembles the standing trunk of a long dead tree conceals an ugly and utilitarian chimneystack. The patina of the weathering copper is picked up in the slate tones of the foliage of the Australian rosemary green.

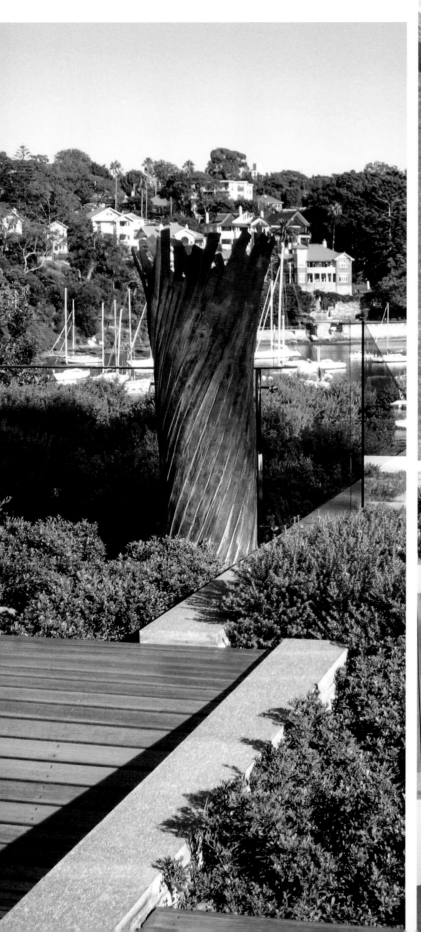
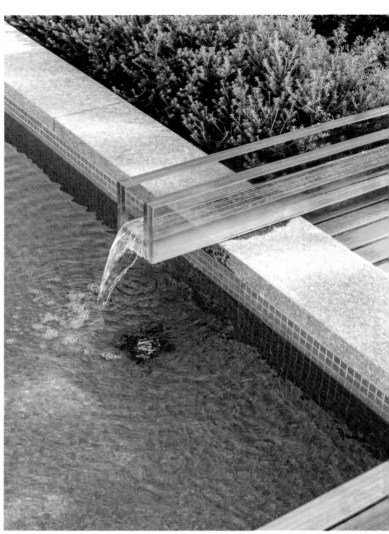
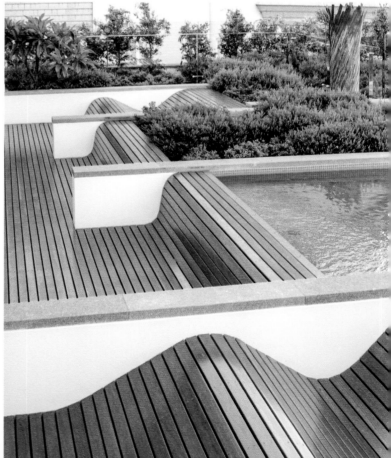

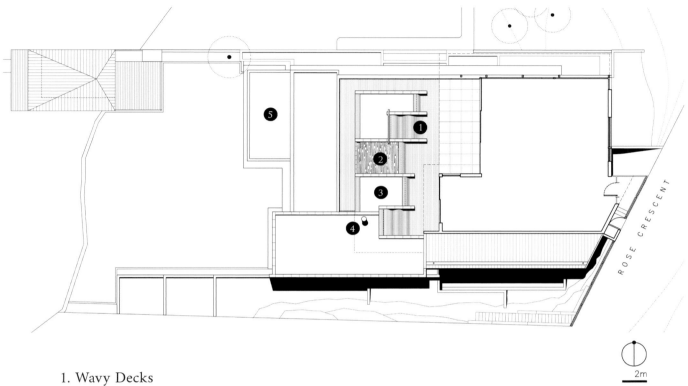

1. Wavy Decks
2. Spa Pool
3. Roof Planting
4. Copper Chimney
5. Planting

Climate
USDA Zone 11a (4.4 to 7.2°C / 40 to 45°F)

Plants
Australian rosemary (*Westringia fruticosa*)
Dwarf mock orange (*Murraya paniculata* 'Min-a-Min')
Frangipani (*Plumeria acutifolia*)

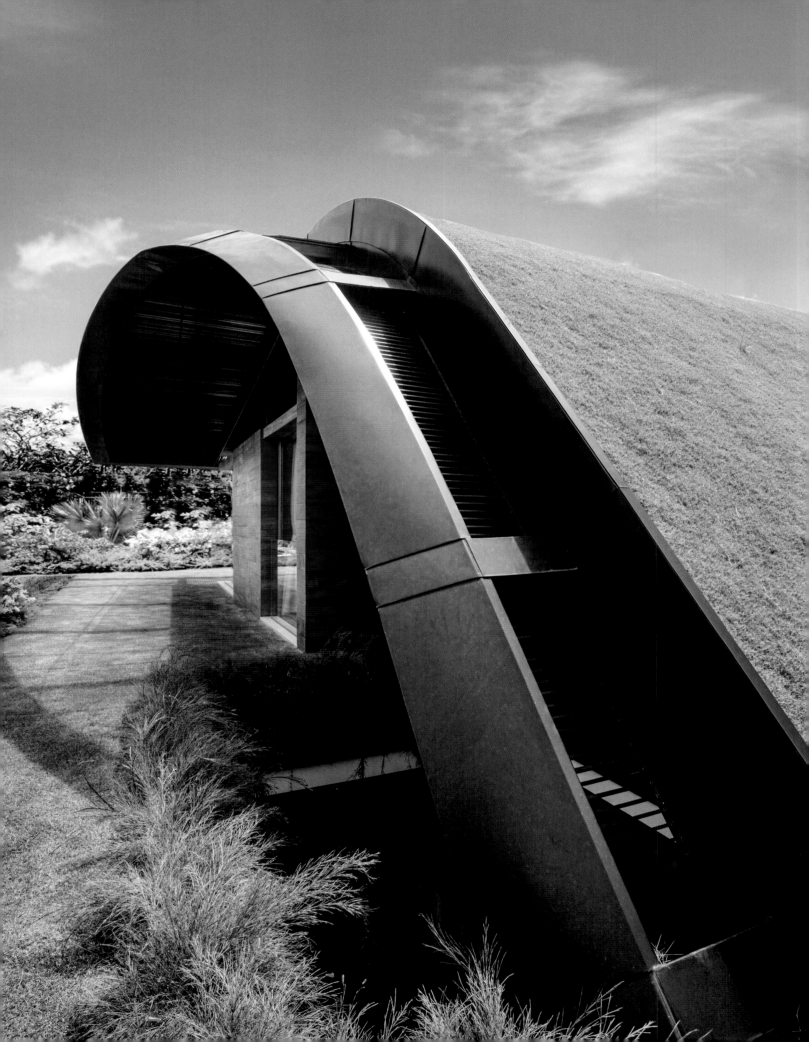

SKY GARDEN

Singapore

Category
Intensive green roof

Year
2010

Area
Site: 852 m² (9,170 sq. ft.)

Landscape Architecture / Architecture
Guz Architects Pte Ltd

Awards
LLAS Awards of Excellence, Gold

Photography
Patrick Bingham-Hall

The green roof and terraces at Sky Garden form an integral part of the architecture for this exciting and dramatic contemporary house. The building has been designed so that each story has either physical or visual access to green space, with every floor being stepped back to provide terraces. A central stairwell also acts as a light well, drawing fresh air into the property.

The first floor terrace is a simple, minimal garden of lawn, bordered by herbaceous planting. A single specimen Norfolk Island pine lends the space an elegant, almost zen-like quality. The lack of balustrade offers unobstructed views over Sentosa Bay. From the edge of the terrace, a view of the luxurious pool can be glimpsed below.

The upper terrace is a smaller, more secluded terrace of lawn and predominantly herbaceous planting that wraps around two sides of the second story. A single specimen dragontree balances the space and forms a focal point.

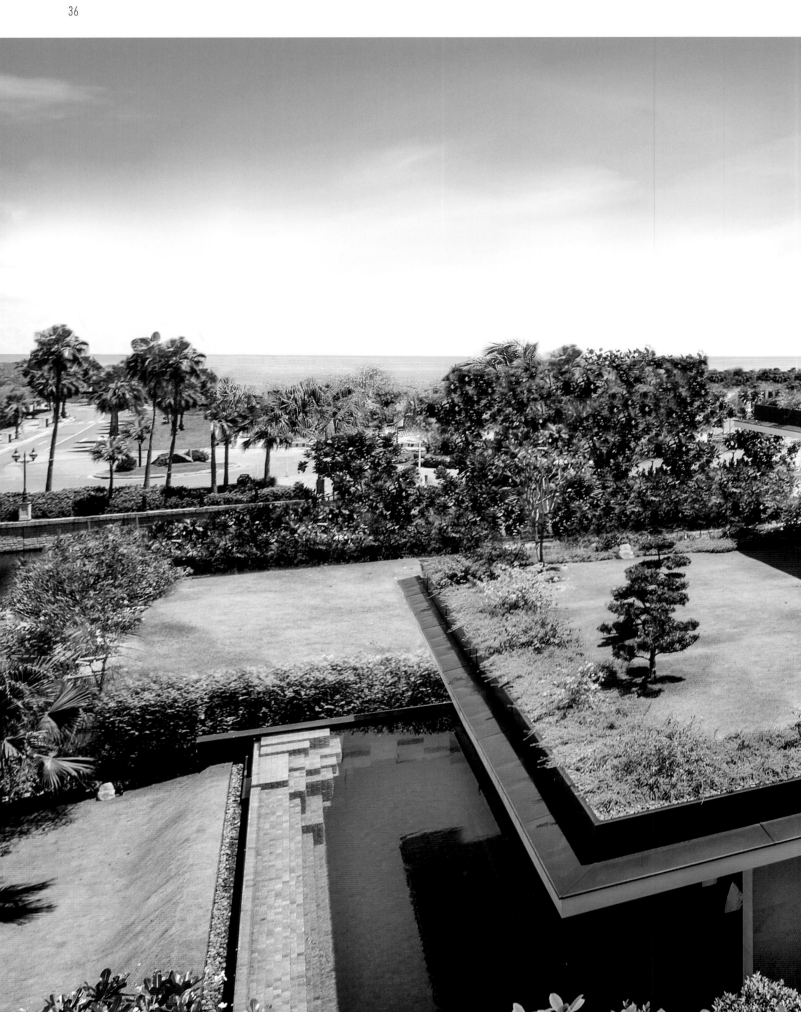

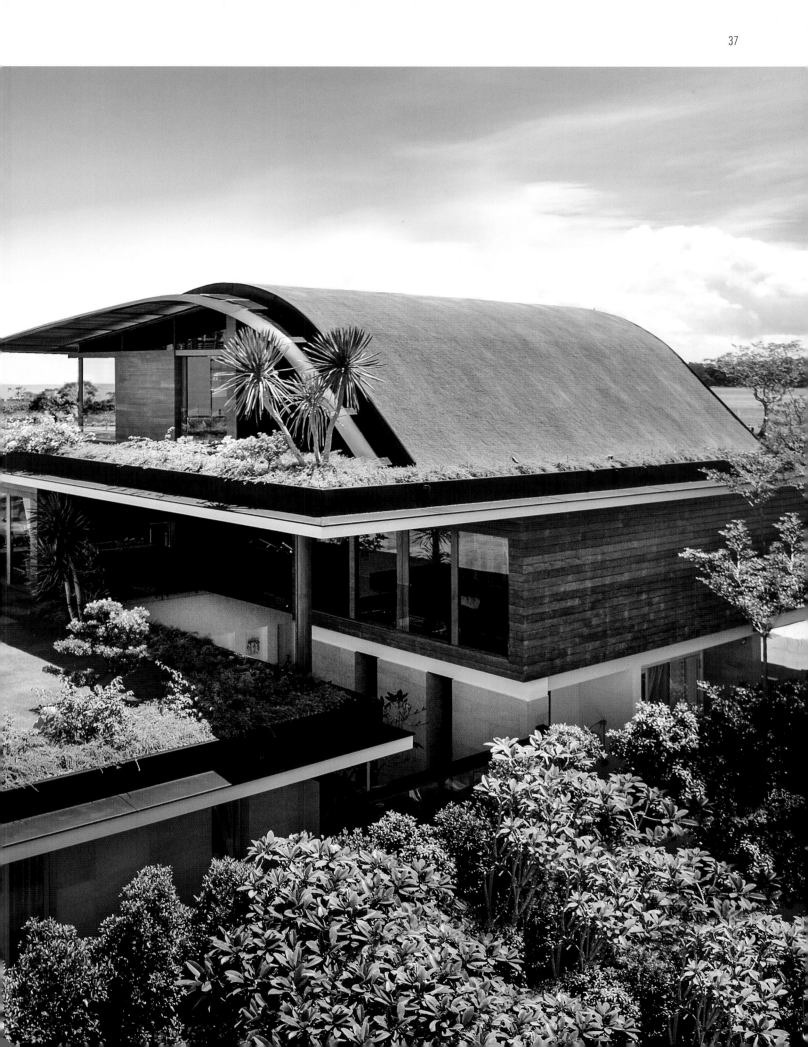

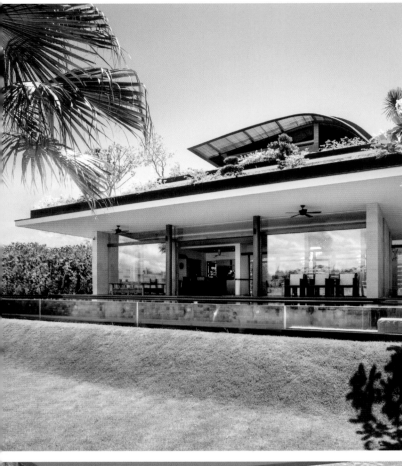

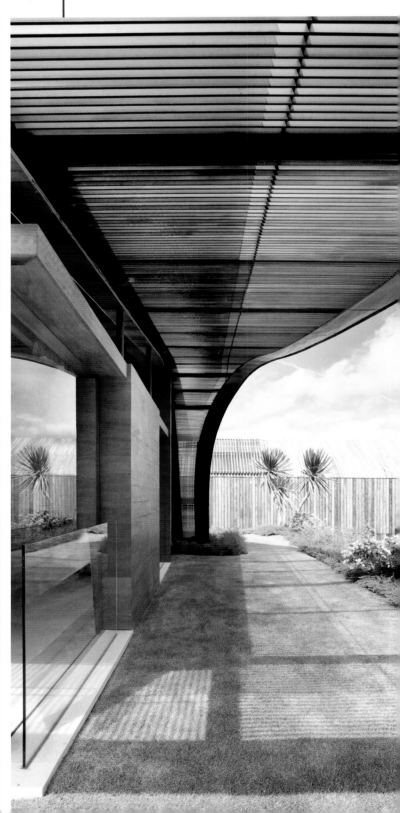

Previous page: The effect of stepping the terraces back from each other and carpeting the roof in grass, gives the house a unifying appearance so that each terrace appears larger than it really is by visually "borrowing" from the other green spaces around it.

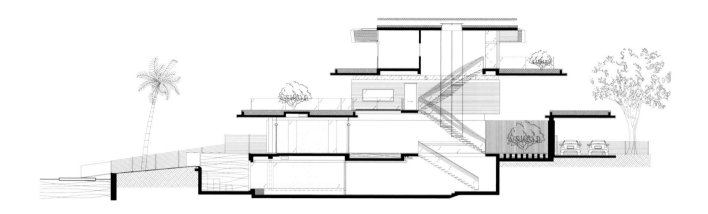

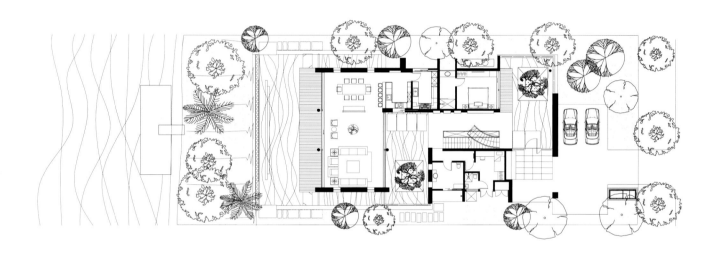

Climate
Tropical rainforest climate (20ºC / 60ºF)

Plants
ROOFS
Bougainvillea (*Bougainvillea sp*)
Dragontree (*Dracaena draco*)
Norfolk Island pine (*Araucaria heterophylla*)
Phyllanthus (*Phyllanthus myrtifolius*)
Pinewheelflower (*Tabernaemontana divaricata*)
Plumeria (*Plumeria sp.*)
Pride-of-Barbados (*Caesalpinia pulcherrima*)
Weeping teatree (*Leptospermum brachyandrum*)

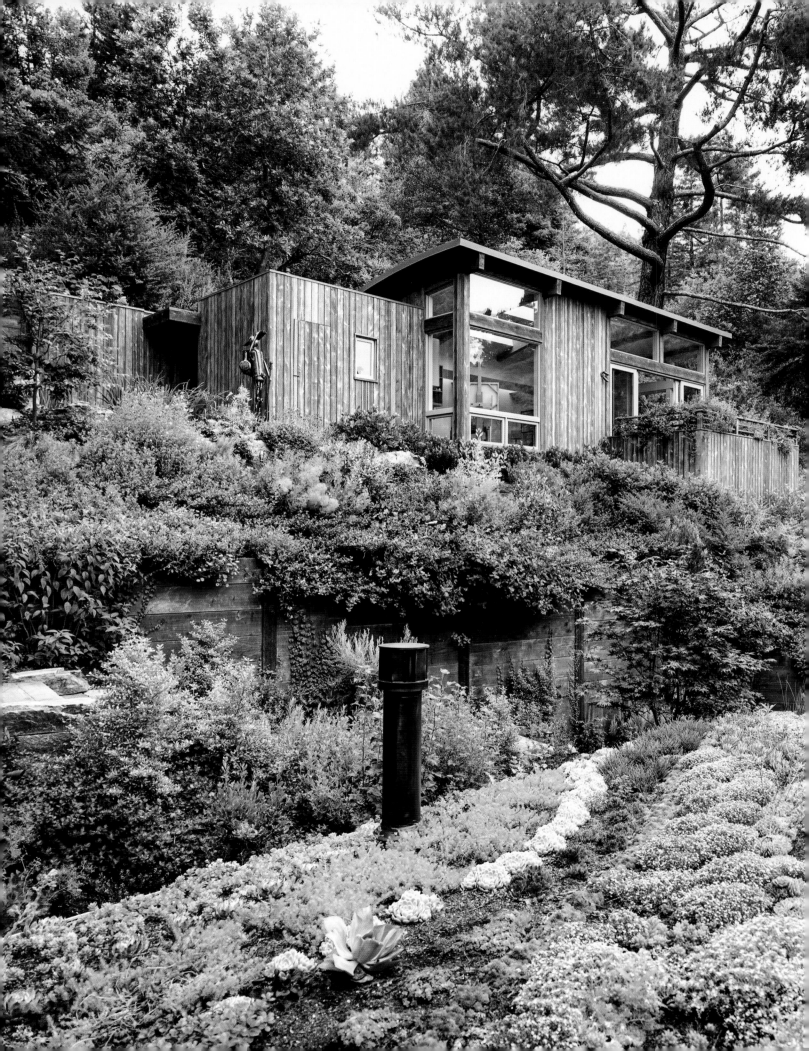

MILL VALLEY CABINS

Mill Valley, California, USA

Category
Extensive green roof

Year
2010

Area
35 m² (380 sq. ft.) and 46 m² (500 sq. ft.)

Landscape Architecture
Jori Hook Landscape Architecture

Architecture
Feldman Architecture, Inc.

Awards
Custom Home magazine, Merit Award

Photography
JoeFletcher.com

The Mill Valley Cabins beautifully blend into their natural surroundings with ecologically sympathetic design that inspires "biophilia"—an innate love of nature. The cabins have been created as retirement residences for two artists. The lower of the two cabins has an accessible extensive green roof to mitigate stormwater run off, as well as provide gardening space for the owner.

The green roof of the lower cabin has been designed with layers of materials, planting medium, and succulent plants which together intercept rainwater, and slow its transition down to the hillside below. In so doing, any possible erosion caused by the waterproof roof of the cabin is alleviated.

As well as being functional the green roof is also highly aesthetic. Sweeping drifts of sedums, houseleek, and echeveria break up the rectangular form of the roof.

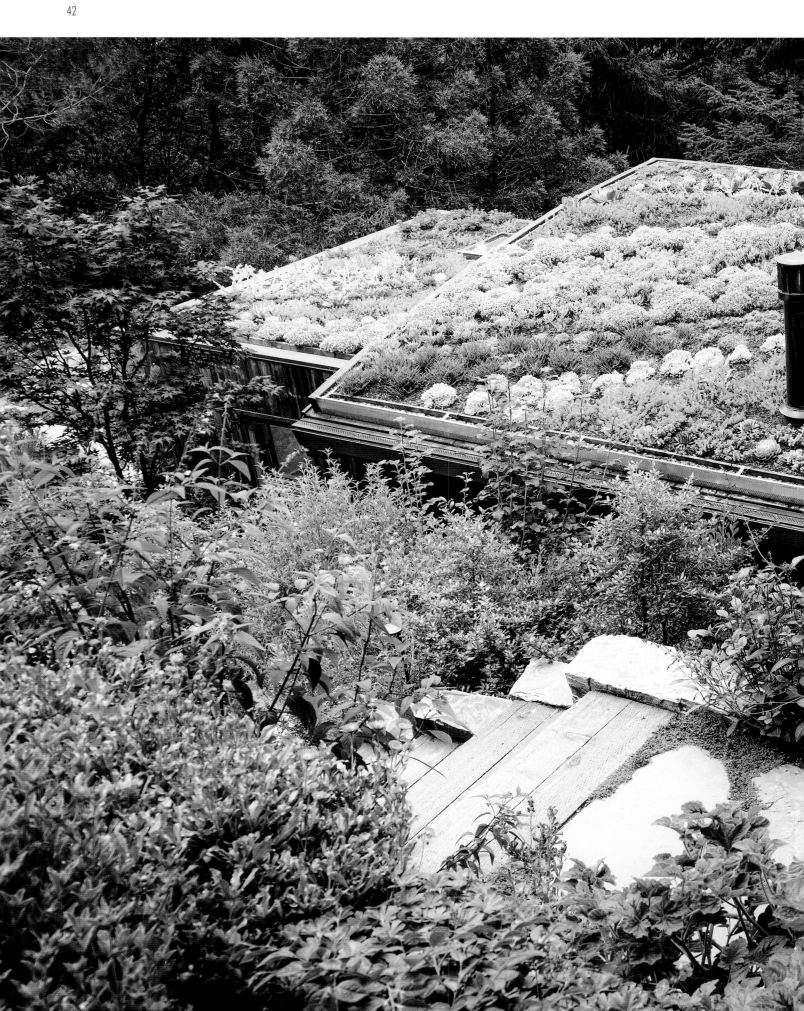

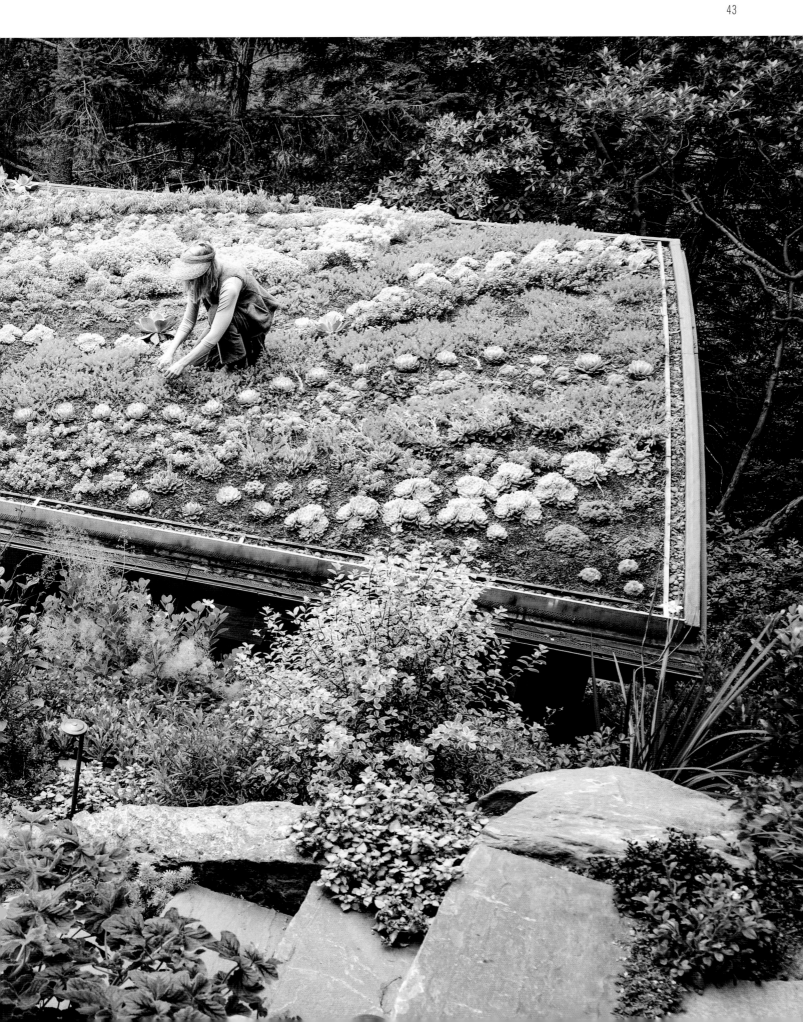

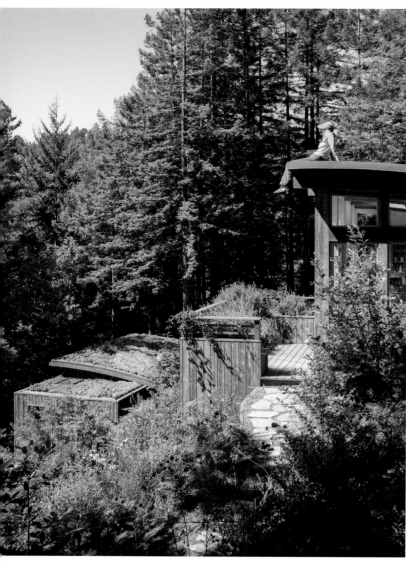

The cabins have been designed to blend into their environment both aesthetically and functionally through the use of the green roof, low impact natural materials, and minimal disturbance to the surrounding forest.

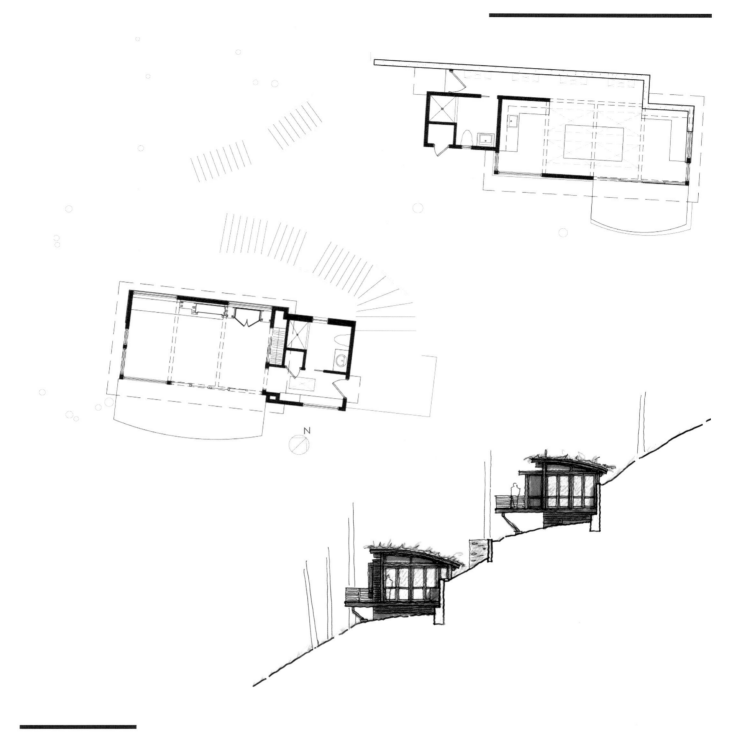

Climate
USDA Zone 10a (-1.1 to 1.7°C / 30 to 35°F)

Plants
Blue chalksticks (*Senecio serpens* 'Dwarf Blue Pickle')
Echeveria (*Echeveria sp*)
Houseleek (*Sempervivum sp*)
Sedum (*Sedum sp*)
Trailing jade (*Senecio jacobsenii*)

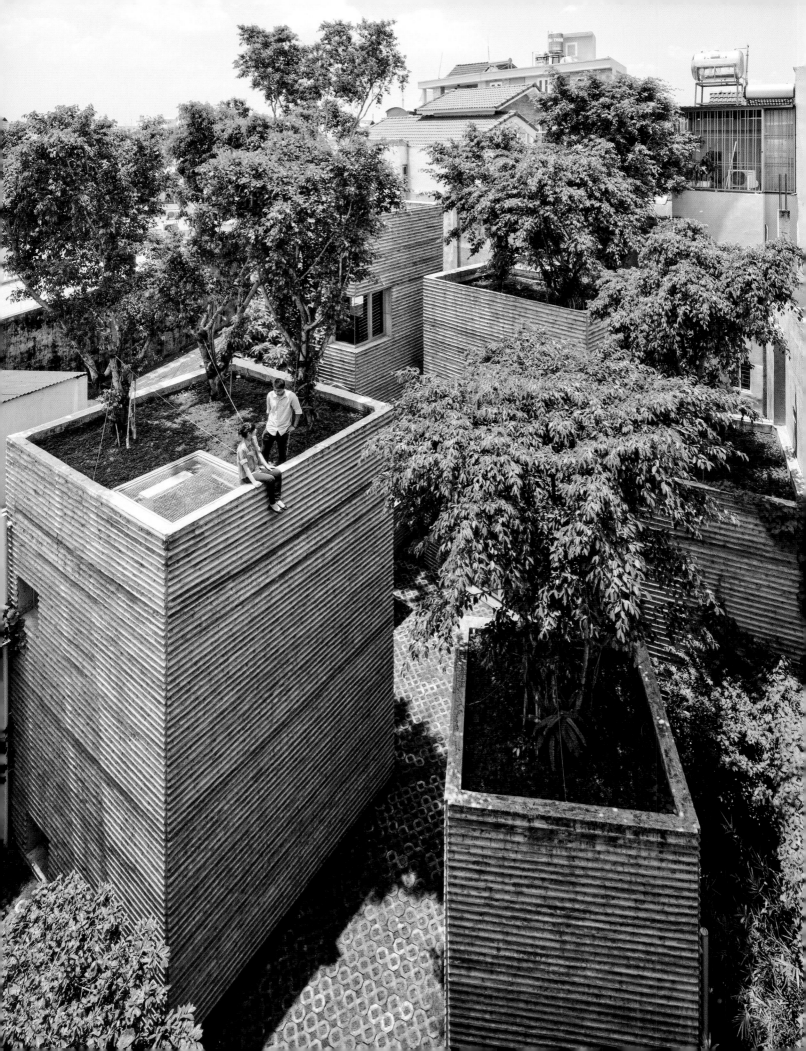

HOUSE FOR TREES

Ho Chi Minh City, Vietnam

Category
Intensive green roof

Year
2014

Area
111 m² (1,200 sq. ft.)
Site: 474 m² (5,100 sq. ft.)

Landscape Architecture / Architecture
Vo Trong Nghia Architects

Awards
The Chicago Athenaeum,
International Architecture Award
Green Good Design Award
FuturArc Green Leadership Award, Winner
World Architecture Festival,
 Winner House Category
AR House Award

Photography
Hiroyuki Oki

The five pavilions at House of Trees together make up an extraordinary dwelling that seeks to challenge mainstream Vietnamese architecture in the most profound way. The house will enhance the lives of not only those who live there, but the wider city in general as the trees filter particulate pollution and add oxygen to the air.

The pavilions are modeled on a local style of bamboo plant pot, and each houses at least one weeping fig. The structure of the buildings is remarkable given the considerable weight that a mature tree and its associated volume of soil can have. The buildings are made of on site cast concrete reinforced not with steel, but with local bamboo, which reduces the overall carbon footprint of the house.

The volume of soil on the roofs acts as a rainwater basin retaining storm water, thus reducing the risk of local flooding. This water is then taken up by the trees and given off through evapo-transpiration by their leaves, cooling the air around them. As well as human benefits, the maturing trees will play host to a range of species, offering a net wildlife benefit.

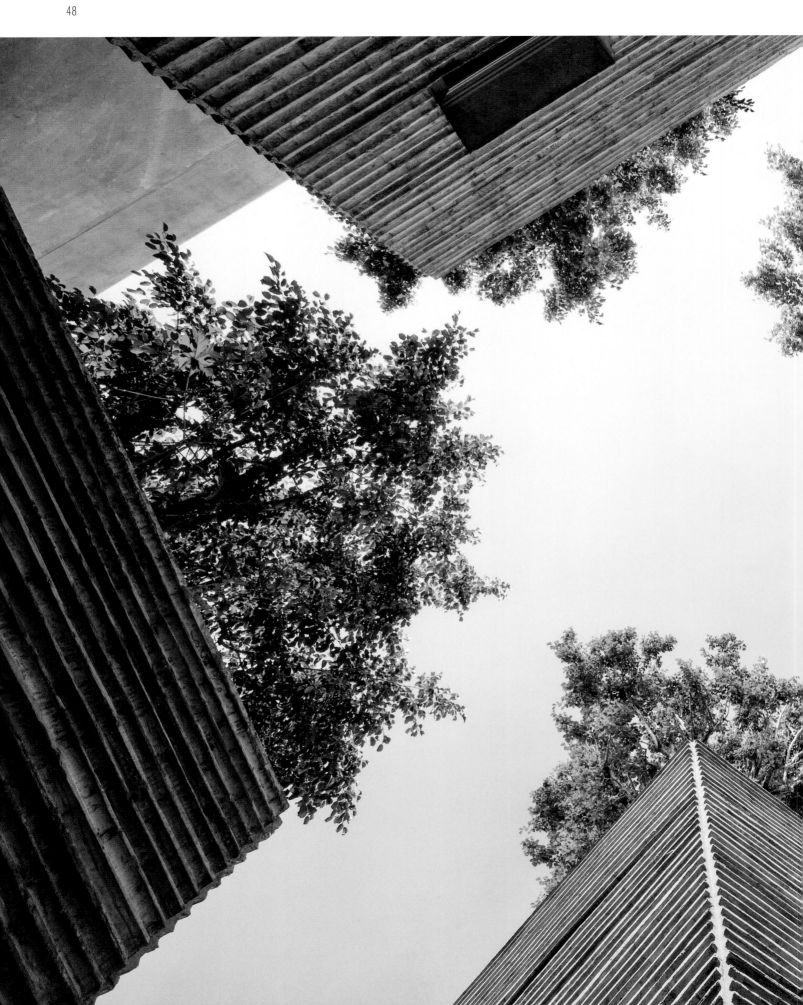

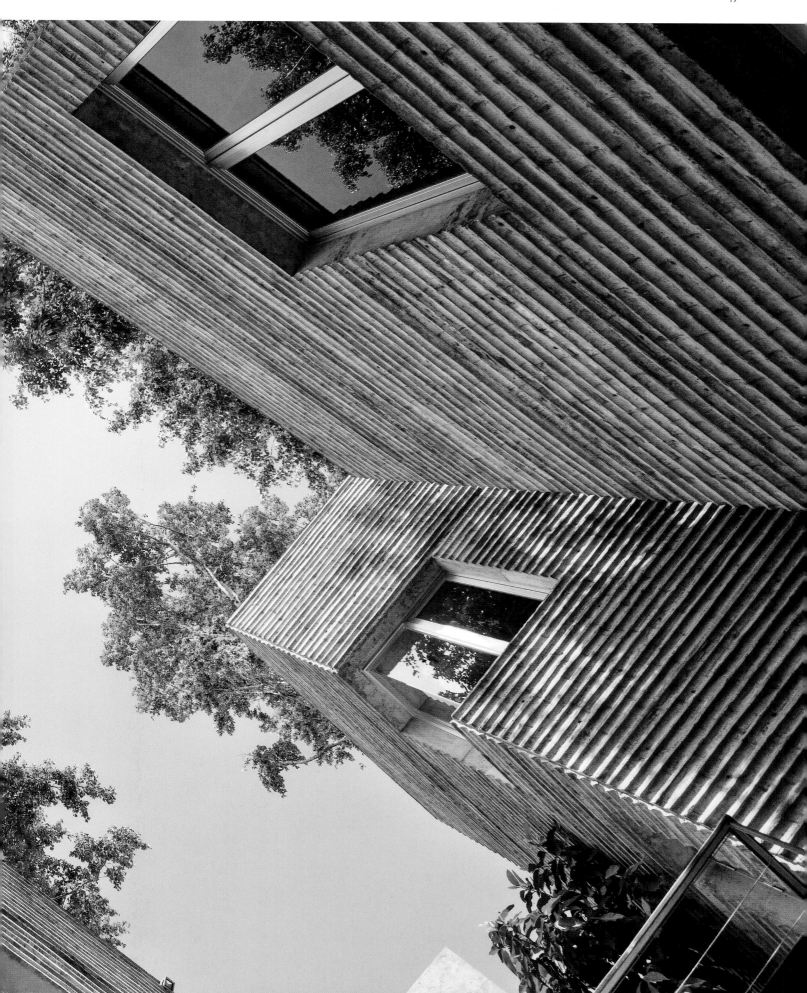

Previous page: In time, as the trees grow, their canopies will spread out and shade the pavilions and their central courtyard, thus providing a cool and pleasant environment in this tropical climate.

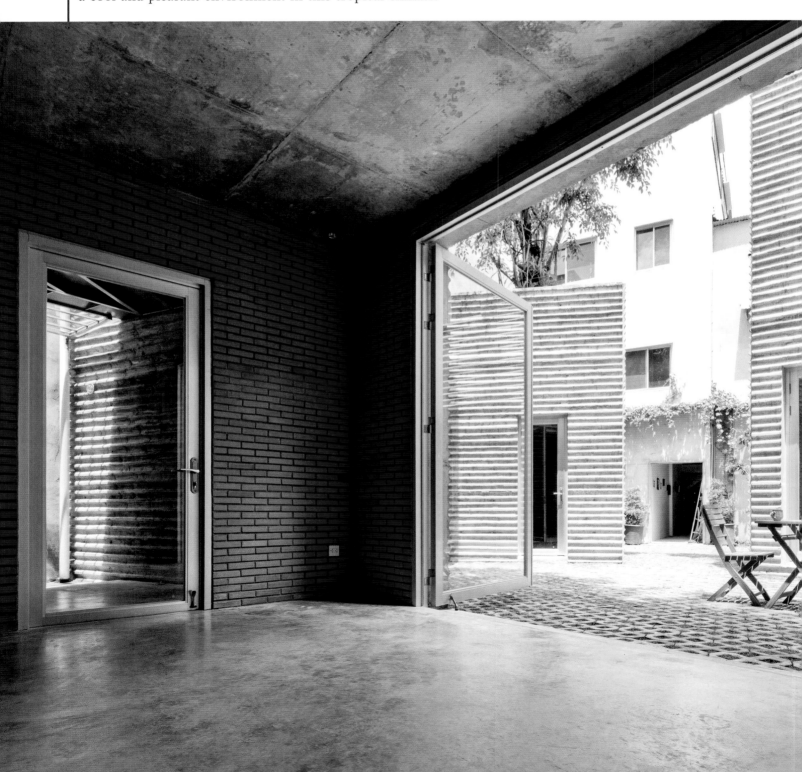

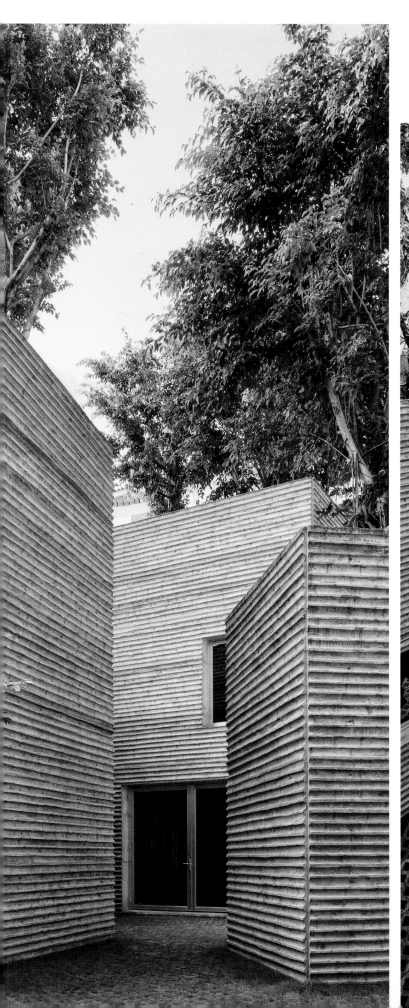

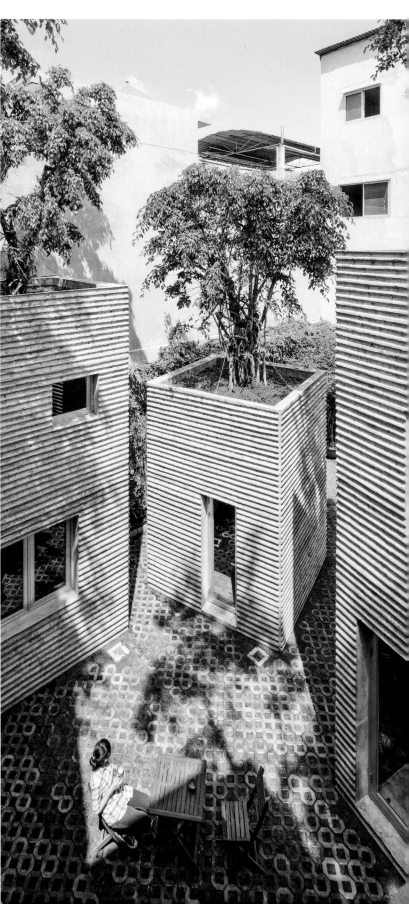

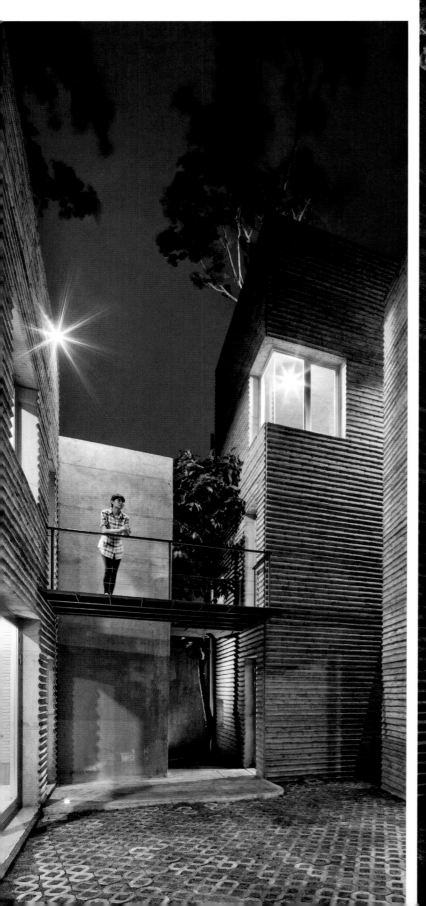
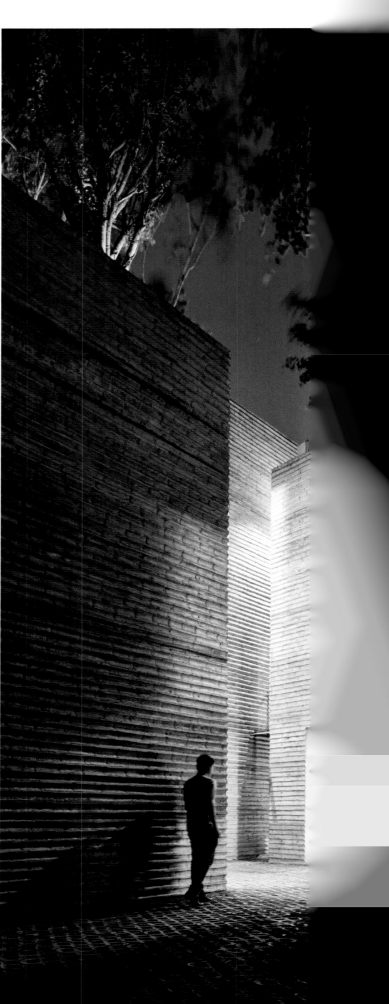

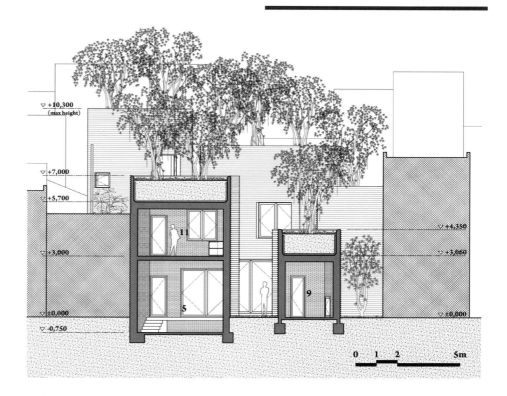

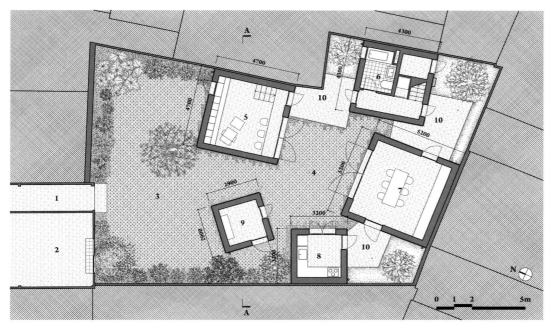

1. Approach
2. Storage
3. Front Courtyard
4. Central Courtyard
5. Library
6. Bathroom
7. Dining Room
8. Kitchen
9. Altar Room
10. Corridor

Climate
Tropical climate (25ºC / 77ºF)

Plants
Weeping fig (*Ficus benjamina*)

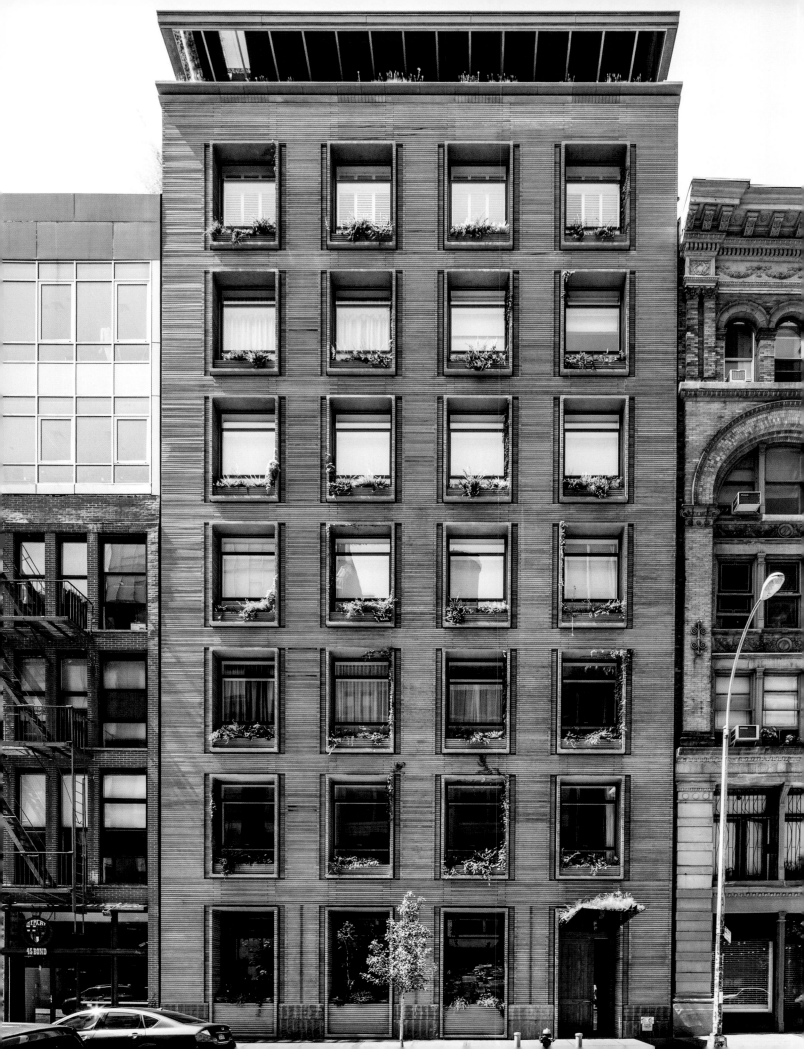

41 BOND

New York, USA

Category
Extensive green roof

Year
2011

Area
280 m² (3,000 sq. ft.)

Landscape Architecture
Future Green Studio

Architecture
DDG

Awards
SARA, Silver Award of Honor
ULI Global Awards for Excellence, Finalist
Architizer A+ Awards, Finalist

Photography
K. Taro Hashimura, Emma DeCaires,
David Seiter, Francis Dzikowski

The building at 41 Bond Street in Manhattan's NoHo district seeks to harmoniously integrate building and landscape with lush window box and loggia planting greening the facade and herbaceous perennials carpeting the generous roof terrace.

The building is clad in the local New York bluestone, which also paves the roof terrace. The strict rigidity of the facade's pattern of windows is softened by the inclusion of plantings at every window. This gently guides the eye up towards the lush parapet planting that cascades over the sides of the roof. Species like Boston ivy and Japanese forest grass compliment the pastel shades of the bluestone.

The roof terrace includes a verdant carpet of extensive green roof with blue fescue grass dancing in the breeze above clump-forming herbaceous perennials like catmint. The large pebbles act as a "brown roof" adding diversity to the range of habitats on the green roof and providing refuge for insects and arachnids, and thus a food source for wild birds.

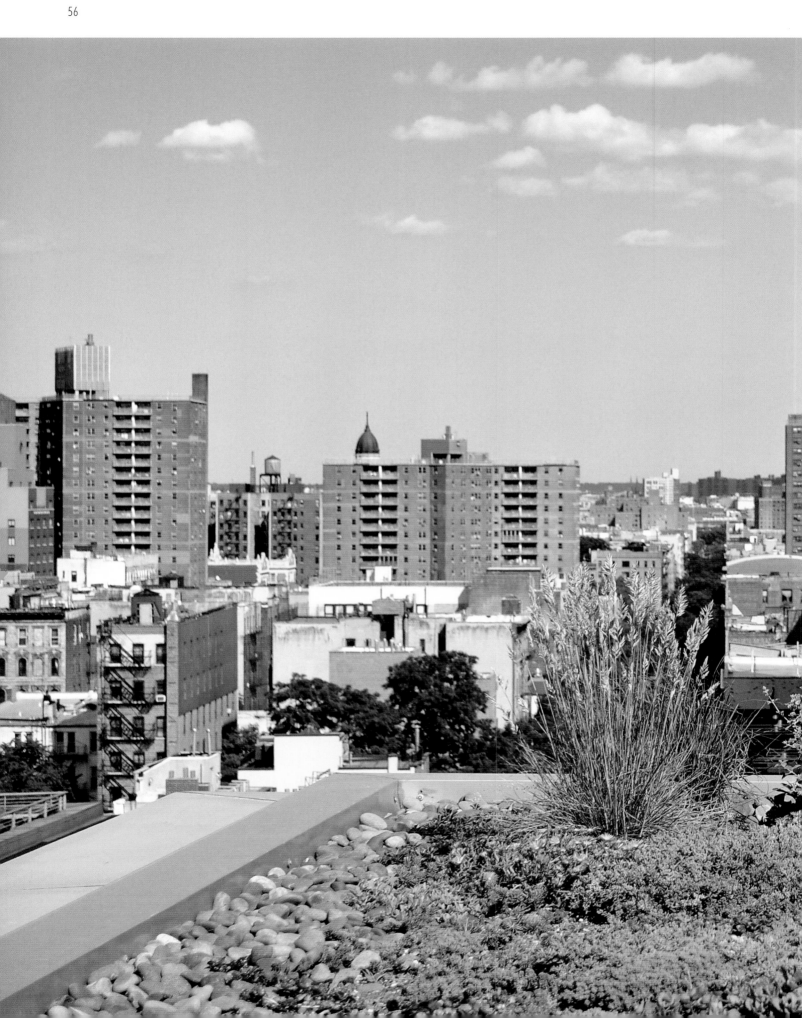

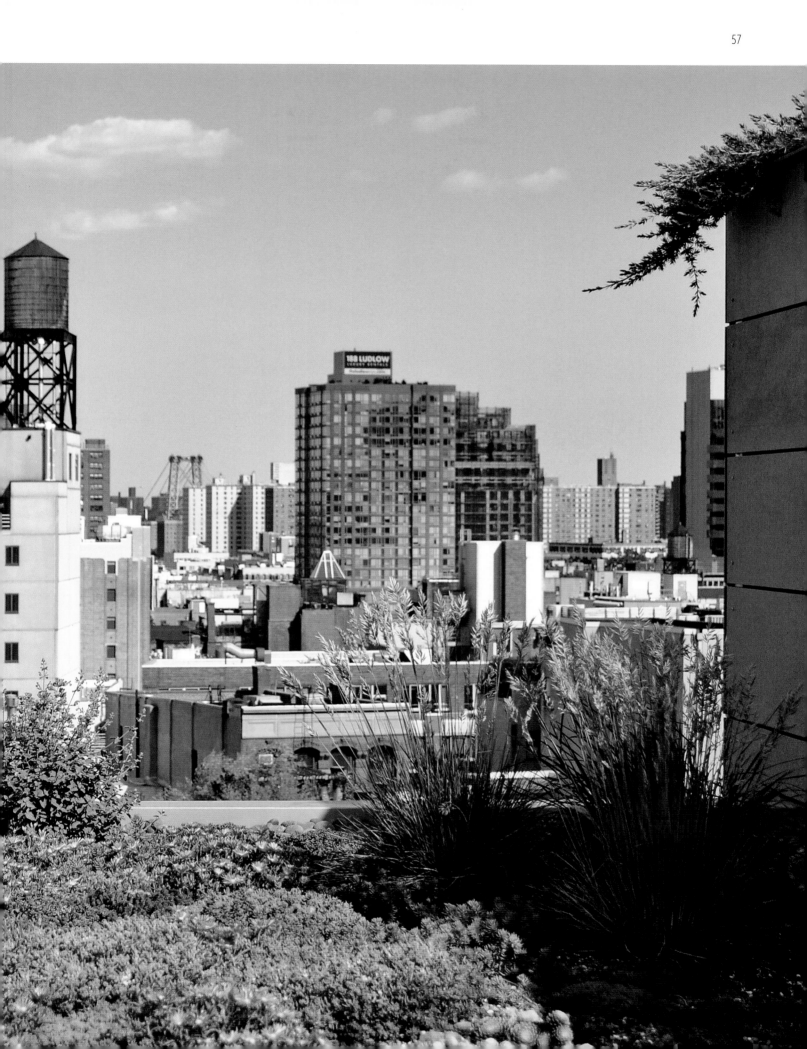

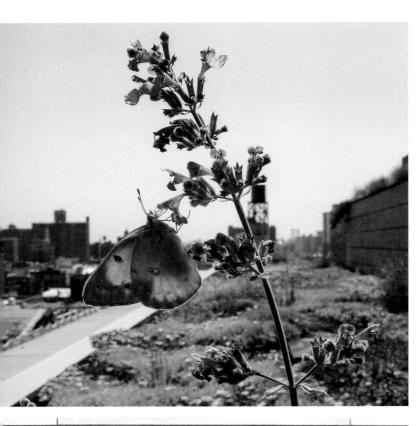

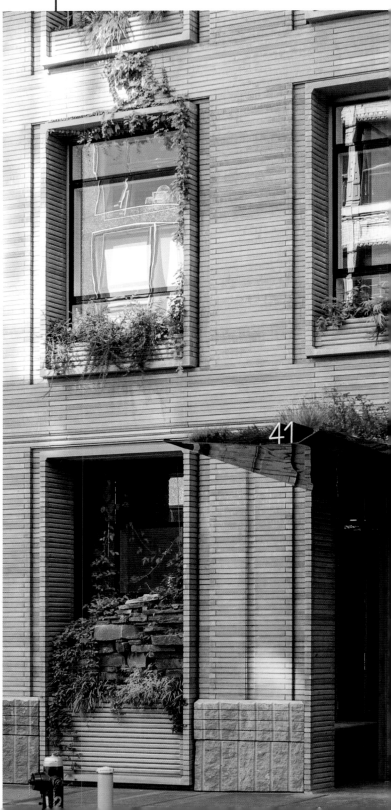

Left: The extensive green roof is not only aesthetic but also benefits local wildlife, offering an early nectar source for insects.

Below and opposite: Windows are surrounded by planting so that from inside, the view is framed by green foliage.

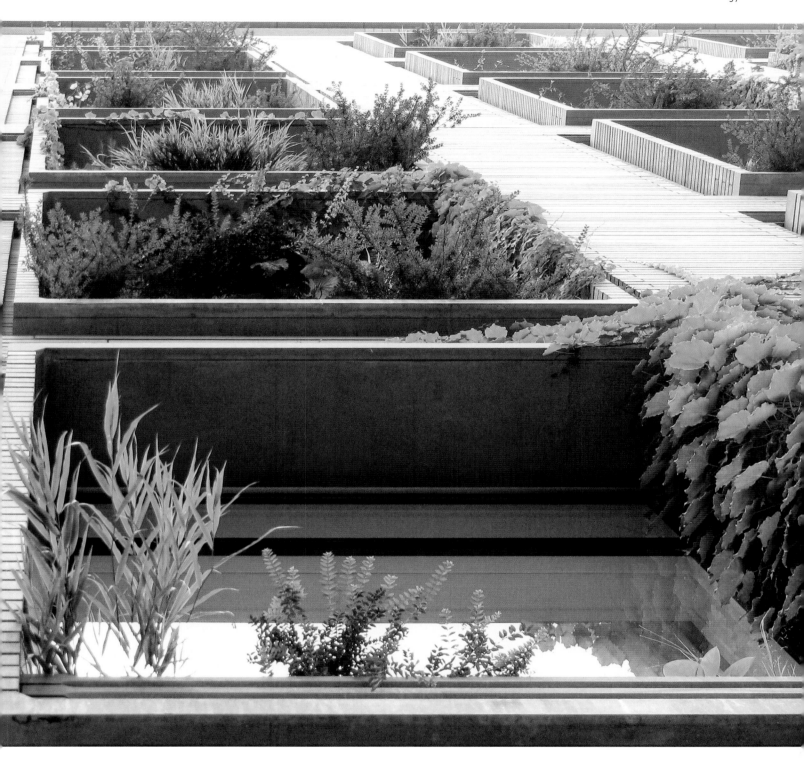

Climate
USDA Zone 7b (-15 to -12.2°C / 5 to 10°F)

Plants
Blue fescue grass (*Festuca glauca* 'Elijah Blue')
Boston ivy (*Parthenocissus tricuspidata* 'Fenway Park')

Candytuft (*Iberis sempervirens*)
Catmint (*Nepeta sp*)
Japanese forest grass (*Hakonechloa macra* 'Aureola')
Mexican feather grass (*Stipa tenuissima*)
Shore juniper (*Juniperus conferta* 'Blue Pacific')

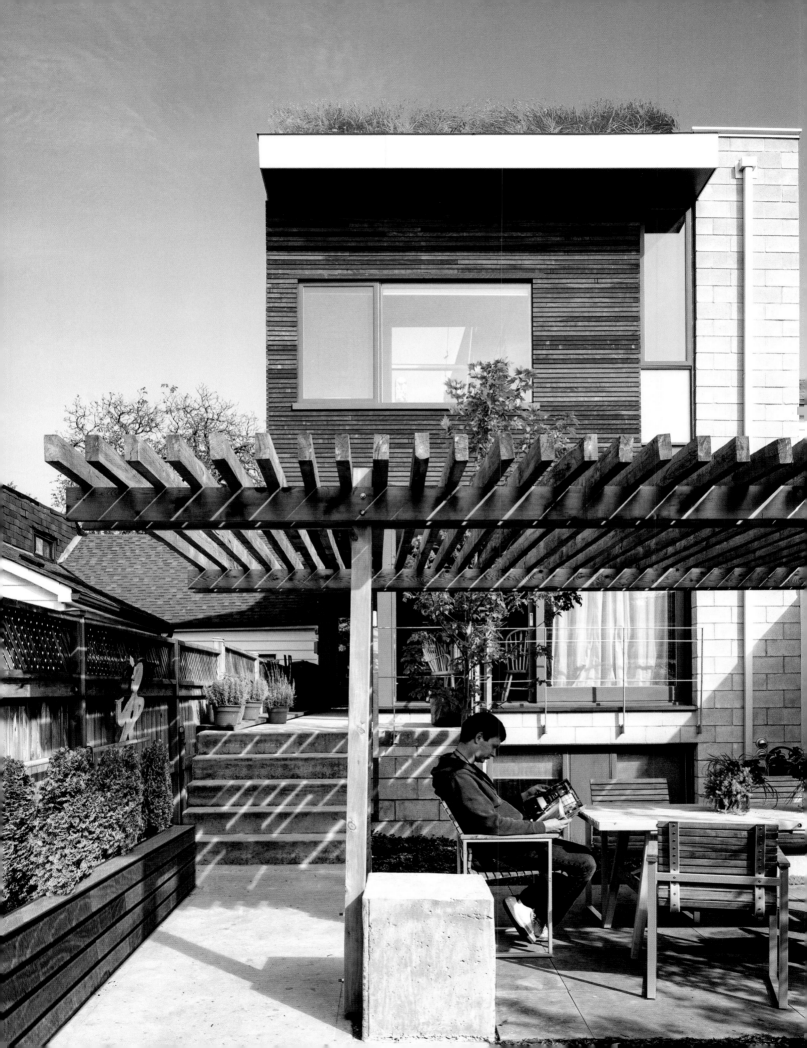

EUCLID AVENUE

Toronto, Canada

Category
Extensive green roof

Year
2006, replanted in 2011

Area
130 m² (1,400 sq. ft.)

Landscape Architecture
Restoration Gardens Inc.

Architecture
LGA Architectural Partners

Awards
Custom Home magazine, Merit Award

Photography
Ben Rahn, A-Frame Studio

The extensive green roof at Euclid Avenue is a simple yet elegant solution to provide the building with insulation while also mitigating storm water drainage. Most of the plants that have been chosen are all native to Ontario, increasing the potential for wildlife habitats and food sources to flourish.

There are three green roofs, a smaller one over the entrance, a larger one on the first story, and one covering the entire second story. On the lowest roof a variety of sedums and ornamental chives create a whimsical pattern while collecting water from the upper roofs.

The middle roof contains native little bluestem and Indiangrass, which create movement in the wind, while lower growing and edible species such as creeping juniper, chive, lavender, thyme, and wild strawberry provide treats for both the owners and wildlife. Additional native species include nodding wild onion, marginal wood fern, and Christmas fern.

The upper green roof is more functional with sedums acting as sponges retaining rainwater and releasing it later through evapo-transpiration, cooling the surrounding air and helping to mitigate the urban heat island effect.

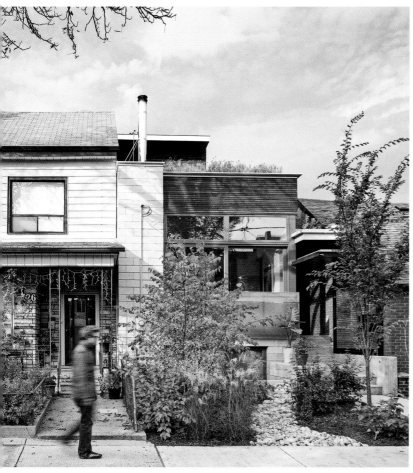

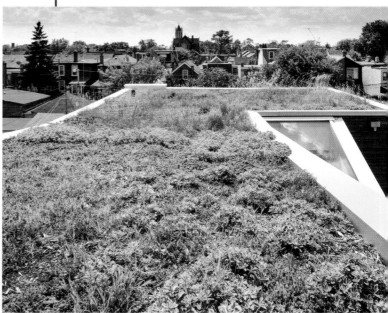

Opposite: The lower of the two green roofs can be seen from one of the bedrooms and therefore has to be as aesthetically pleasing as it is functional.

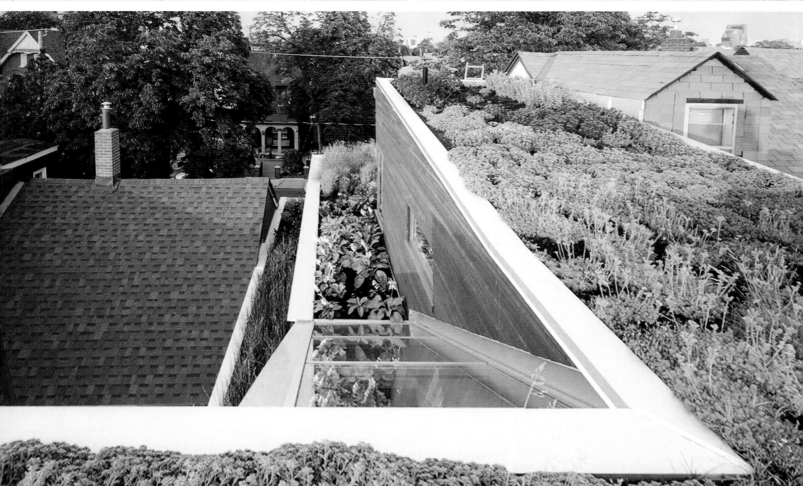

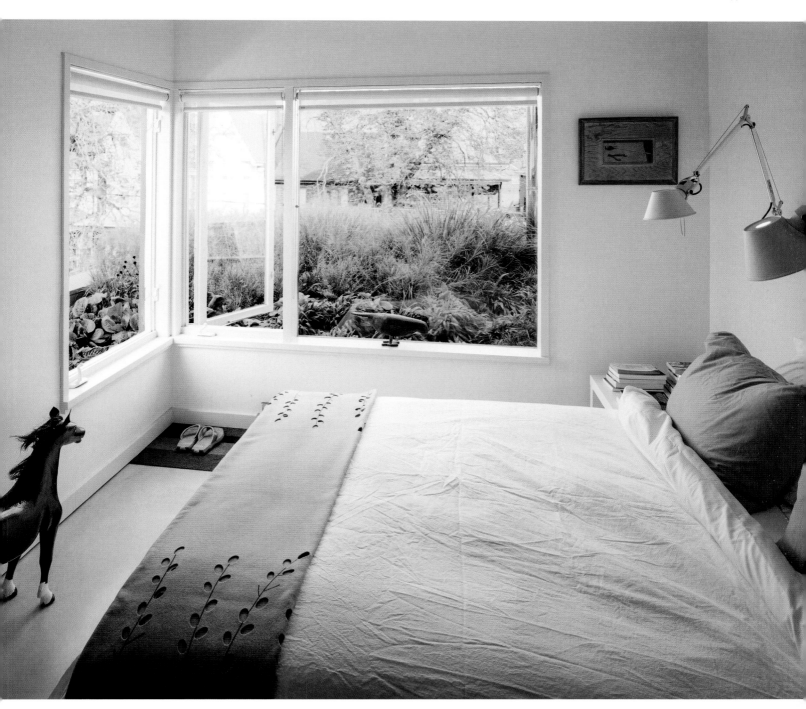

Climate
USDA Zone 6b (-20.6 to -17.8ºC / -5 to 0ºF)

Plants
Chives (*Allium schoenoprasum*)
Christmas fern (*Polystichum acrostichoides*)
Creeping juniper (*Juniperus horizontalis*)
English thyme (*Thymus vulgaris*)
Indiangrass (*Sorghastrum nutans*)

Lavender (*Lavandula*)
Little bluestem (*Schizachyrium scoparium*)
Marginal wood fern (*Dryopteris marginalis*)
Nodding wild onion (*Allium cernuum*)
Tasteless stonecrop (*Sedum sexangulare*)
White stonecrop (*Sedum album*)
Wild strawberry (*Fragaria vesca*)

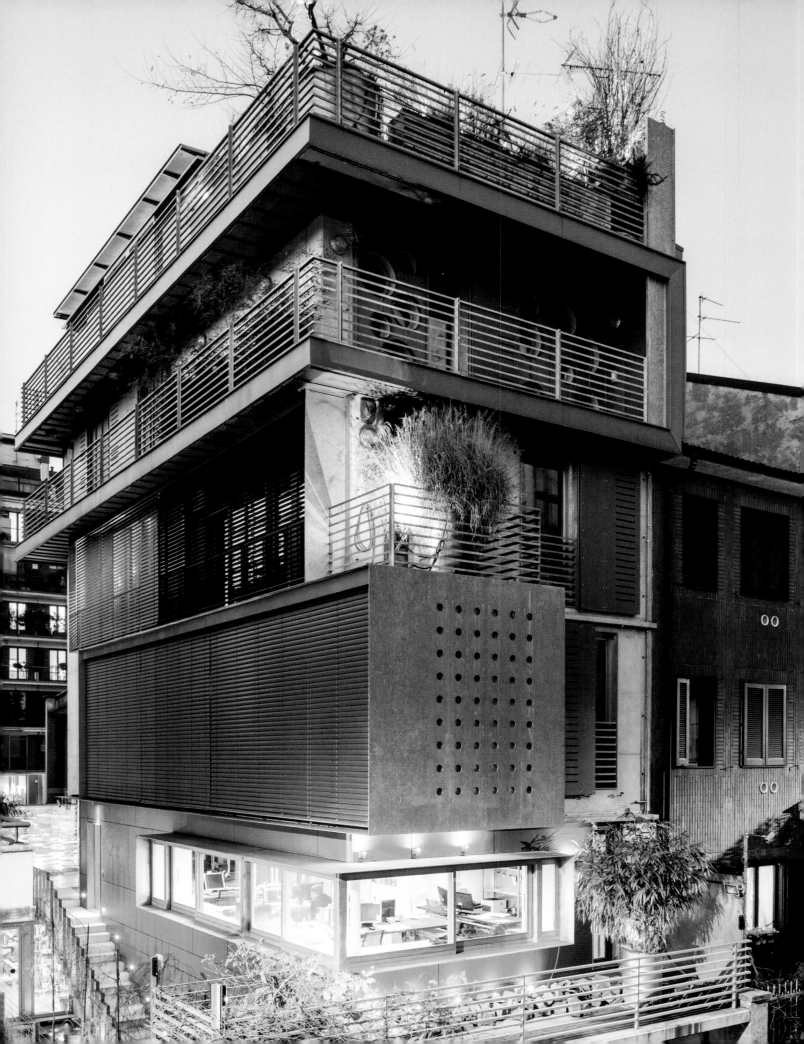

ARCHILABO

Milan, Italy

Category
Roof garden

Year
2012

Area
Entrance: 30 m² (320 sq. ft.)
First floor terrace: 45 m² (480 sq. ft.)
Fifth floor terrace: 30 m² (320 sq. ft.)

Landscape Architecture
Cristina Mazzucchelli

Architecture
Archilabo – Luca Salmoiraghi

Photography
Matteo Carassale

The series of three terraces at Archilabo make an intriguing roof garden with a striking post-industrial ambiance full of rich, contrasting textures. The building houses both private accommodations and the architect's studio.

The entrance is an exciting journey on circular concrete stepping stones that appear to be floating over a shallow pool engulfed in verdant textural foliage-rich planting of weeping birches that create a green tunnel. Underwater lights create dancing patterns of light during the evening.

The first floor terrace is an intimate space for the staff of the studio. A wall of cut-faced natural stone clearly bears the marks of quarry drilling, complementing the industrial feeling of the building. Japanese maple and bamboo provide height to the planting, while an overhanging neighboring tree lends its shade to the space.

The private fifth floor terrace is a moderately-sized deck surrounded by galvanized steel planters full of delicate-leafed herbaceous and woody perennial plants such as sweet fennel, Chinese fountain grass, and Mexican feather grass. The space includes a concrete kitchen area that is not only practical but also reinforces the industrial theme.

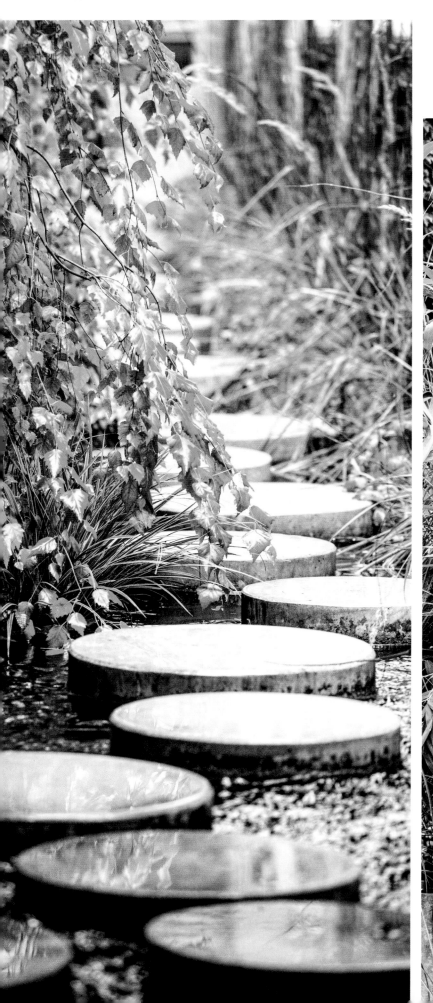

Opposite: The stepping stones over the pond create an exciting and dramatic entrance space through the weeping birch and Chinese fountain grass.

Below: The communal space for the architect's office creates a quiet oasis among the bamboo and Amur maple.

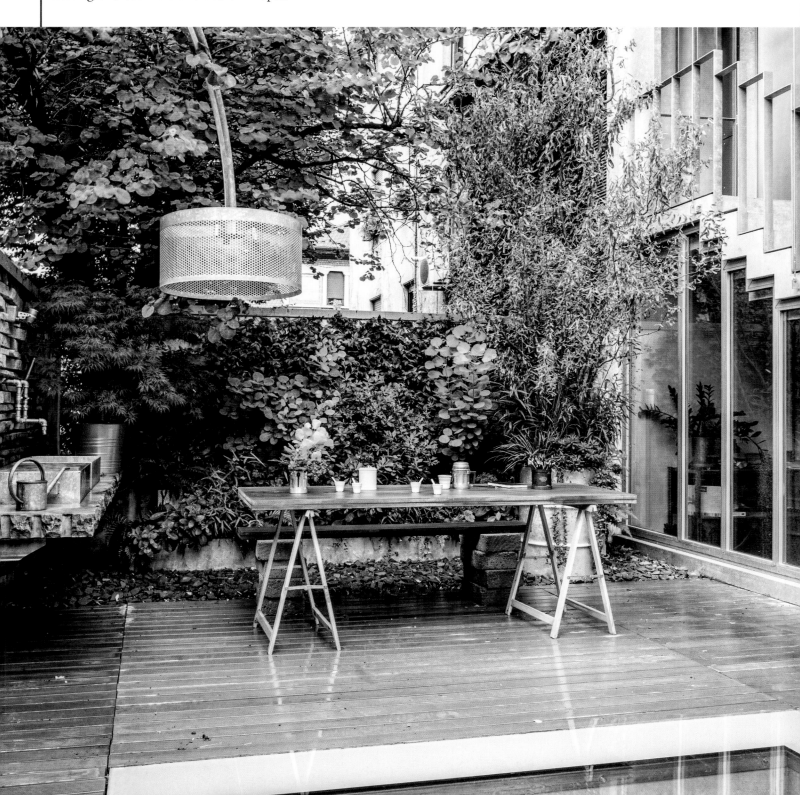

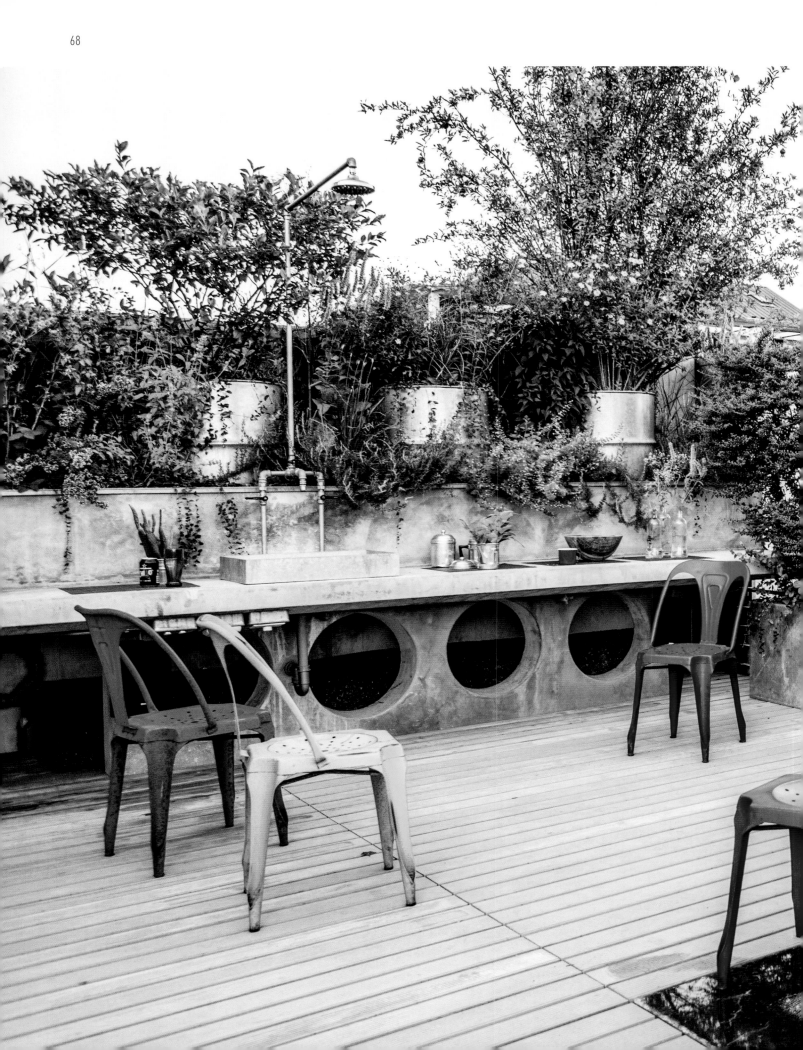

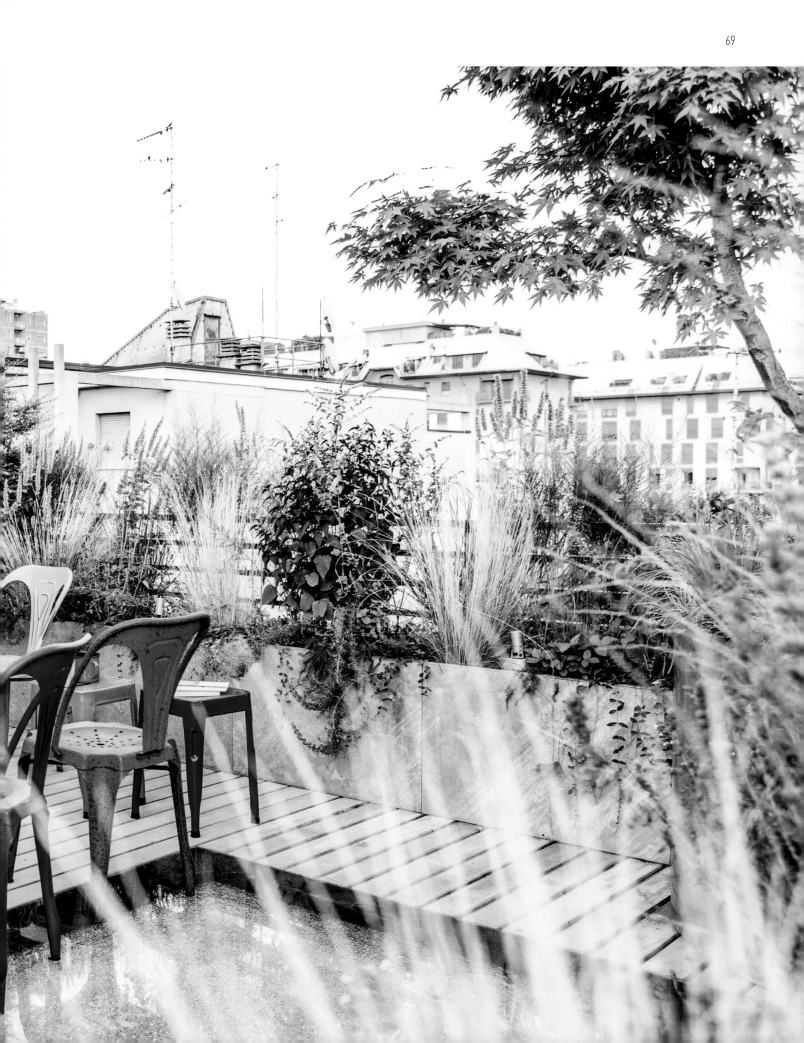

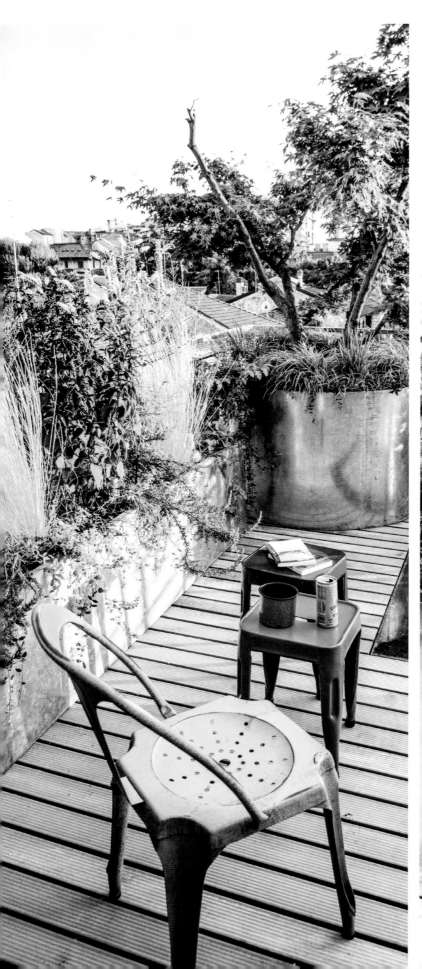

Previous page and left: The fifth floor concrete kitchen and the galvanized steel drums used as tree planters, reinforce the post-industrial aesthetic of the building.

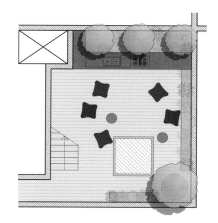

Fifth Floor Terrace

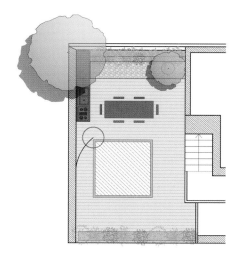

First Floor Terrace

Entrance

Climate
USDA Zone 9a (-6.7 to -3.9ºC / 20 to 25ºF)

Plants
Amur maple (*Acer japonicum*)
Chinese fountain bamboo (*Fargesia nitida*)
Chinese fountain grass (*Pennisetum alopecuroides*)
Confederate jasmine (*Trachelospermum jasminoides*)

Dragon's claw willow
 (*Salix babylonica* var. *pekinensis* 'Tortuosa')
Horsetail (*Equisetum hyemale*)
Mexican feather grass (*Stipa tenuissima*)
Rosemary (*Rosmarinus officinalis* 'Majorca Pink')
Sweet fennel (*Foeniculum vulgare*)
Young's weeping birch (*Betula pendula* 'Youngii')

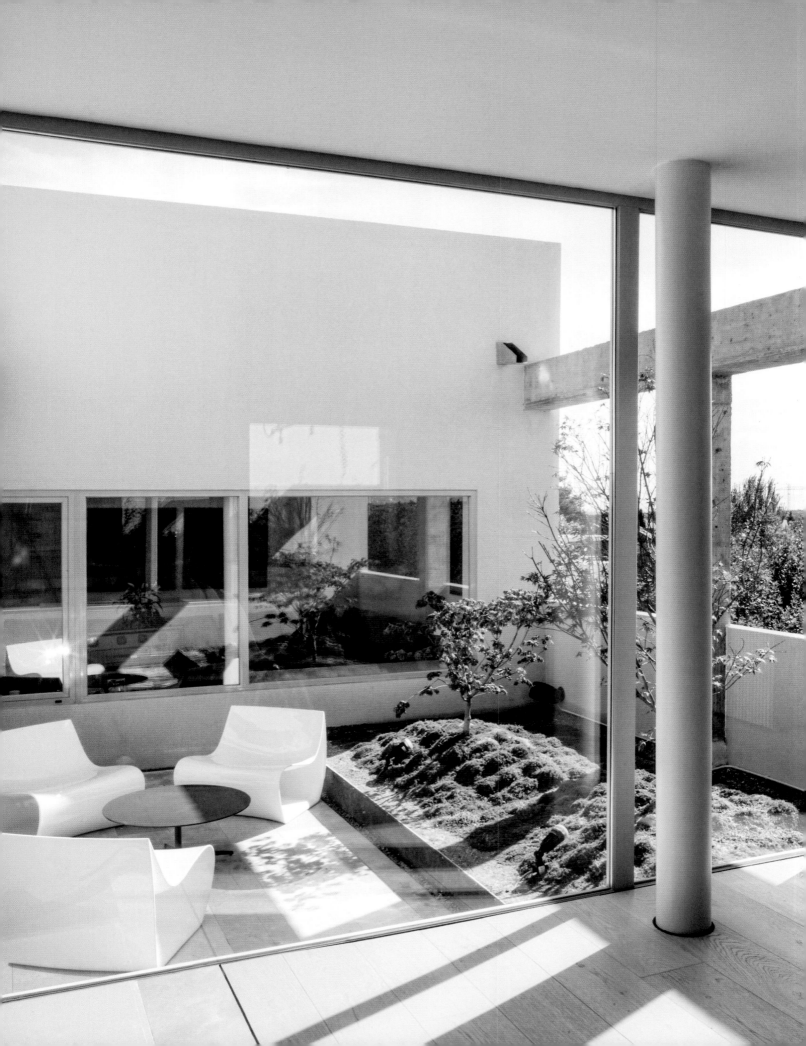

U PENTHOUSE

Madrid, Spain

Category
Intensive green roof

Year
2008

Area
Penthouse: 285 m² (3,065 sq. ft.)

Landscape Architecture / Architecture
Ábaton

Awards
Asprima-Sima Award

Photography
Belén Imaz

The roof terraces at U Penthouse are an arresting array of minimalist spaces designed with an attention to detail that belies their simple aesthetic. The larger terraces have been designed as a means of access that gives the apartments a sense of individual identity akin to that of a detached house.

The curved building complex contains the rectangular apartments, which rise above the circular parapet like castle keeps. This results in some challenging angular shapes on the terraces that have demanded some innovative solutions.

The hard materials are limited to unfinished and matte-white-painted concrete, which reduces glare from the strong summer Spanish sun. Simple gray crushed stone gravel, precast concrete slabs, and decking form the paving.

The planting is equally minimal, being limited to grass, moss, and occasional feature trees of Japanese maple, which accent areas and form focal points. One of the small private terraces reminds of Japanese *tsubo-niwa*, or courtyard gardens, containing the bare minimum elements needed to create a sense of nature within the small space.

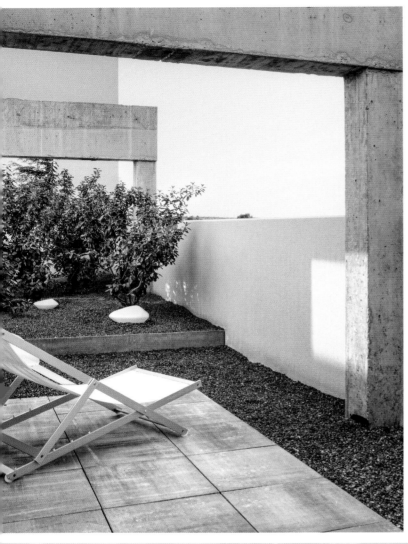

Bottom: One terrace houses a beautiful minimal communal swimming pool in the form of a partial annulus.

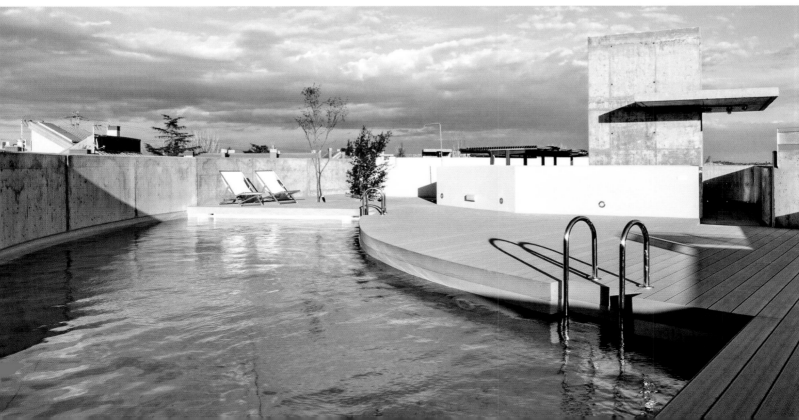

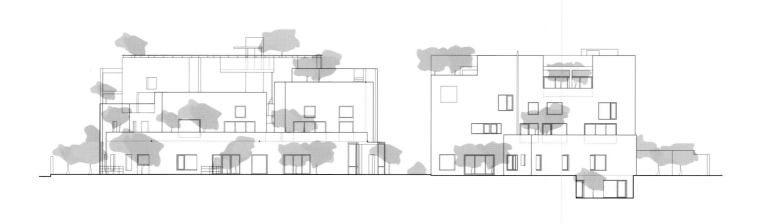

Climate
USDA Zone 9a (-6.7 to -3.9°C / 20 to 25°F)

Plants
Downy Japanese maple (*Acer japonicum* 'Aconitifolium')
Irish moss (*Sagina subulata*)
Japanese maple (*Acer palmatum* 'Osakazuki')

FOREST LODGE ECO HOUSE

Sydney, Australia

Category
Extensive green roof

Year
2014

Area
60 m² (645 sq. ft.)

Landscape Architecture / Architecture
Code Green Pty Ltd

Awards
International Gold Sustainable Awards
HIA GreenSmart Awards
Master Builders Environmental Award
HIA Energy Efficiency Award
BDA Awards
BPN Sustainability Award,
 Dwelling of the Year

Photography
Belinda Mason

The entire building of Forest Lodge Eco House seeks to achieve the very highest in eco-credentials. The extensive green roof is a major feature in the ecological approach to this project with a range of habitat types catering for a wide variety of wildlife, while maintaining an attractive appearance.

The two green roofs of Forest Lodge are relatively small, at a combined 60 square meters (646 square feet). The smaller of the two roofs is only 4 square meters (43 square feet) and yet manages to contain a small pond for birds and winged insects, areas of bare soil for birds to dust bathe in, and deadwood for an insect habitat, providing a food source for wild birds. Succulent plants like sedums and saxifrage demand very little maintenance and are very drought resistant.

The larger of the two terraces is a dynamic space for entertaining. A patio area of natural stone is large enough to accommodate guests, while the abounding walls offer privacy from neighbors. The surrounding green walls contain many species of plants including lilyturf, spider plant, bromeliad, Tahitian bridal veil, and bird's-nest fern. A central water feature that doubles as a table acts as the focal point.

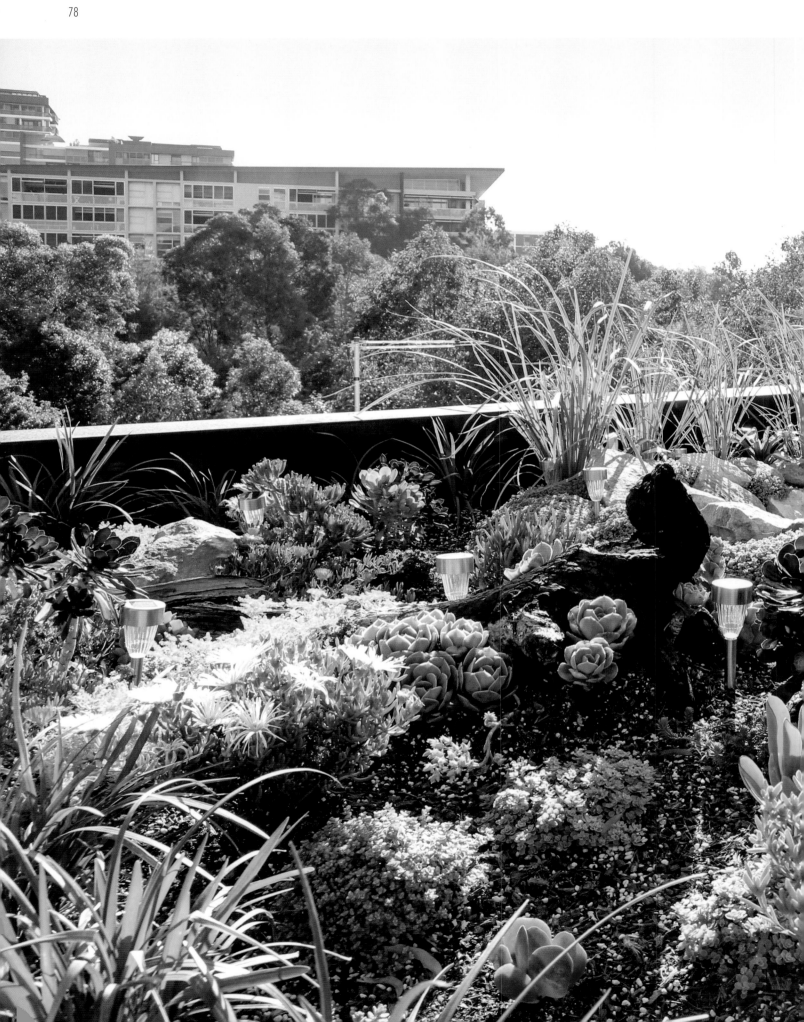

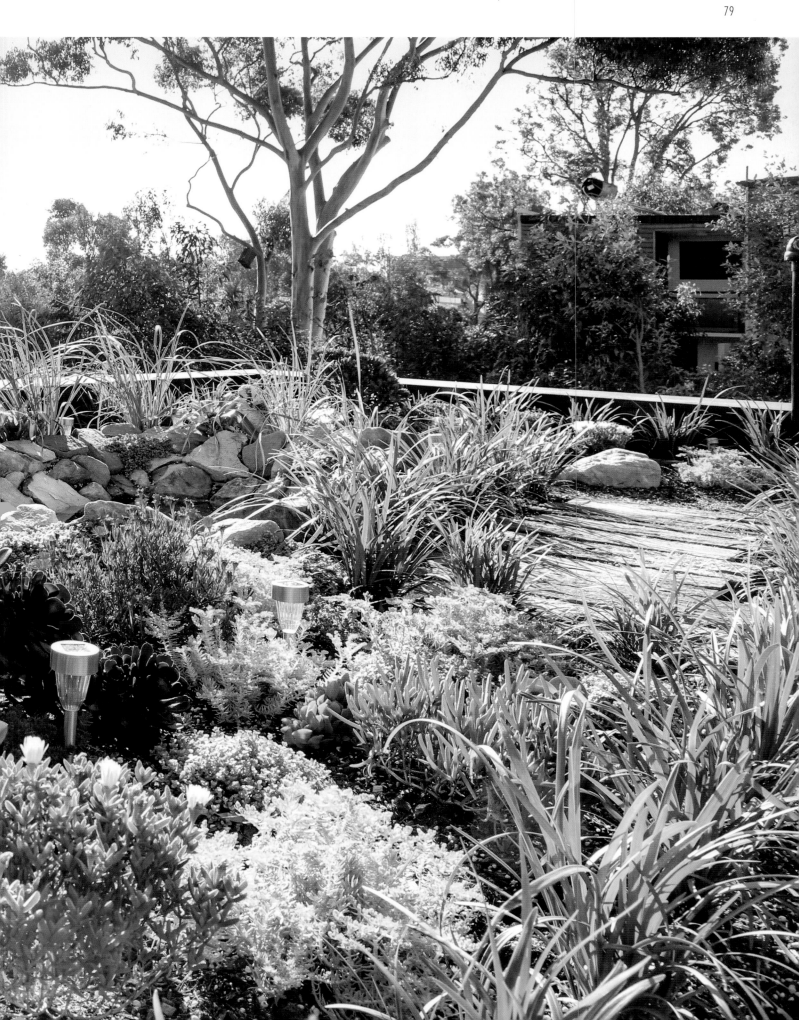

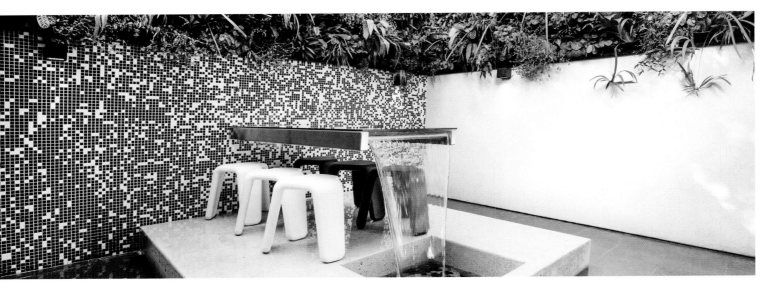

Left: The water feature naturally cools the air around it, while it's babbling masks the noise of the city and calms nerves.

Below: The plants in the green walls provide privacy and filter some of the noise from abounding properties.

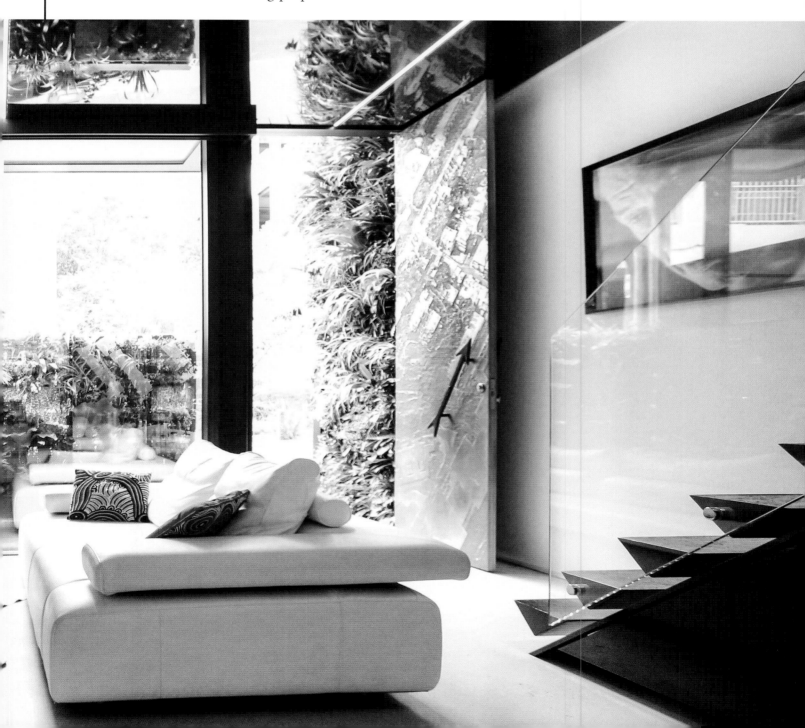

Left: The green wall or "vertical garden" by the front door filters particulate pollution from the air.

Below and bottom: Although small the extensive green roof contains a range of habitats.

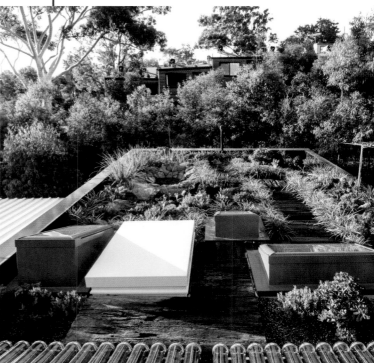

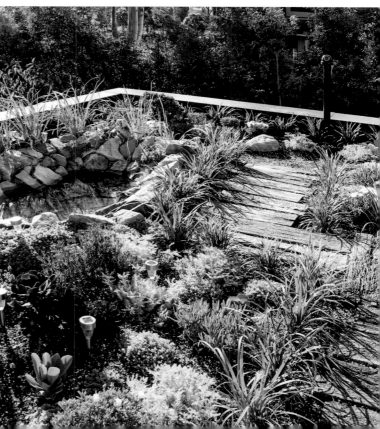

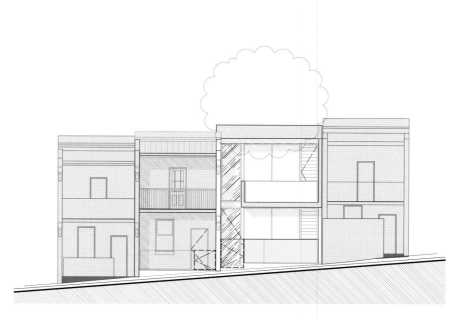

Front Elevation

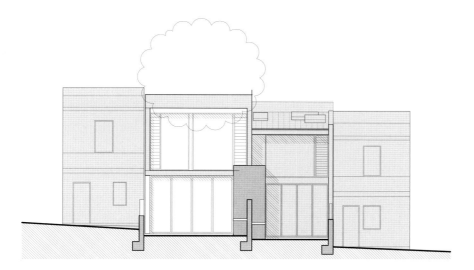

Rear Elevation

Climate
USDA Zone 11a (4.4 to 7.2ºC / 40 to 45ºF)

Plants
Bamburanta (*Ctenanthe burle-marxii* 'Amagris')
Bird's nest fern (*Asplenium nidus*)
Bromeliad (*Bromeliaceae sp*)
Delosperma (*Delosperma sp*)

Lilyturf (*Liriope muscari*)
Saxifrage (*Saxifraga sp*)
Sedum (*Sedum sp*)
Spider plant (*Chlorophytum comosum*)
Tahitian bridal veil (*Tradescantia multiflora*)
Walking iris (*Neomarica*)

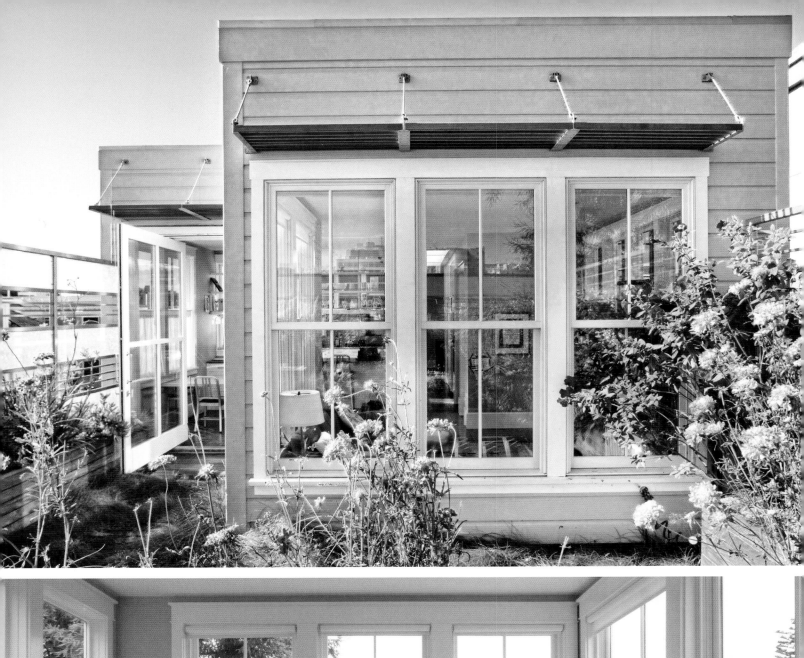
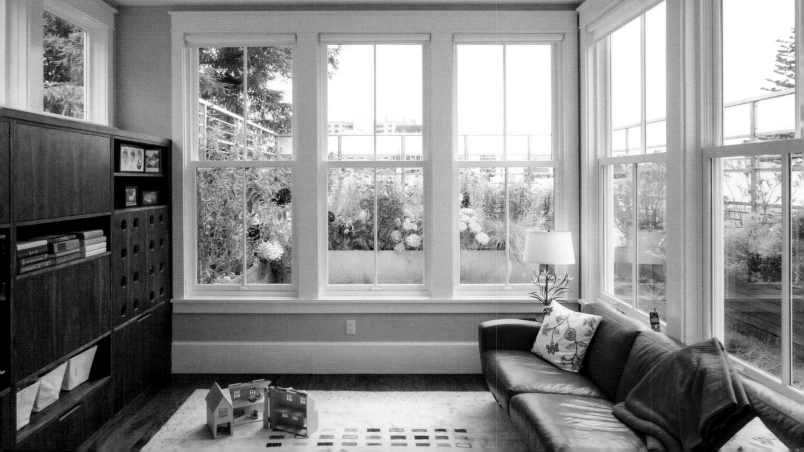

PACIFIC HEIGHTS ROOFTOP GARDEN

San Francisco, California, USA

Category
Roof garden

Year
2008

Area
58 m² (620 sq. ft.)

Landscape Architecture
Loretta Gargan Landscape + Design

Architecture
Feldman Architecture, Inc.

Awards
Marvin Architects Challenge, Winner

Photography
Paul Dyer, Loretta Gargan

Pacific Heights Rooftop Garden is a beautiful, intimate family garden designed to provide a space that is instantly accessible from the home. The garden uses raised planters of steel to elevate the rich floral tapestry of the planting to a height that can be seen from inside.

The garden is a marvel of engineering being carved out from the structure of the property. Originally the building occupied almost the entire plot, leaving no space for a garden. The present owners decided to sacrifice some of the indoor space on the first floor and build a roof garden to satisfy their horticultural needs. Here the designer has created a garden that is an integral part of the fabric of the building.

The main spaces of the garden include a children's play area, an adults' spa area, and a dining area. These spaces are separated by contemporary ipe wood and sandblasted steel planters. The garden is enclosed by steel frames, which contain custom panels of glass of varying opacity. These panels are made of two sheets of glass sandwiching hand-made Japanese rice paper, creating a beautiful translucent effect.

A central lawn of native fescue and mixed ornamental grasses winds around small areas of decking and paving. The rich herbaceous planting includes species such as yellow kangaroo paw and blue thimble flower.

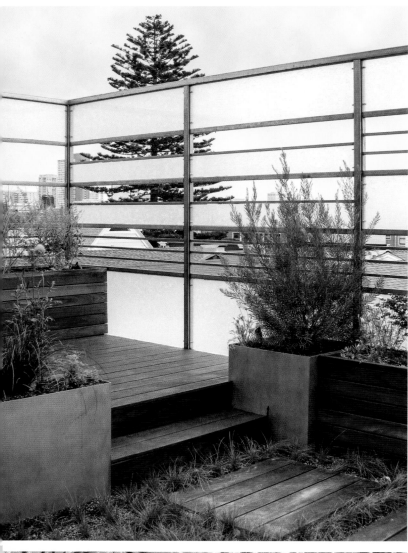

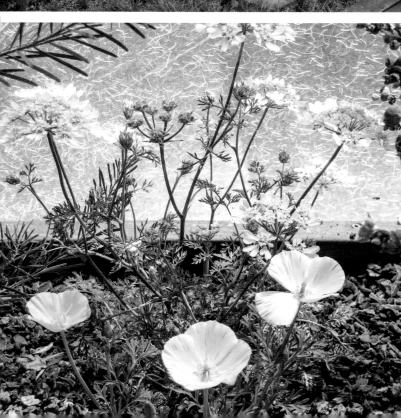

Below left: The beautiful white California poppy and white laceflower accent the lighter shades of the custom-made Japanese rice paper glass panel in the background.

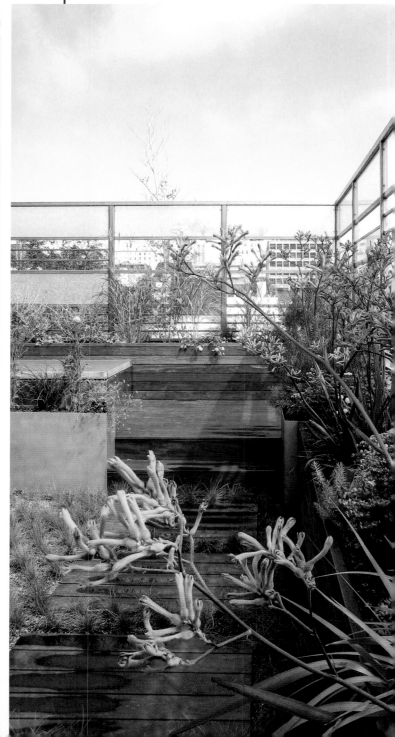

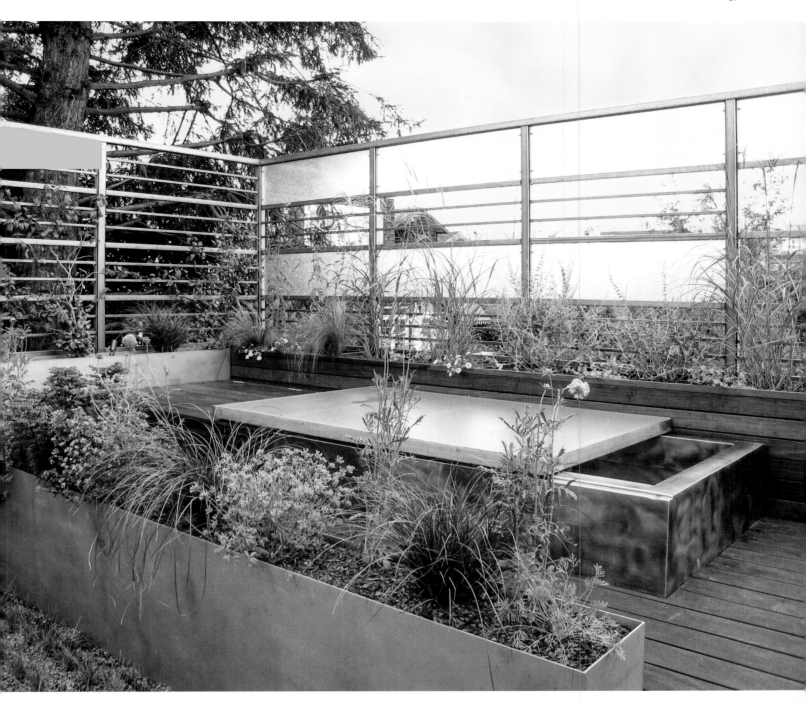

Climate
USDA Zone 10b (1.7 to 4.4°C / 35 to 40°F)

Plants
Acacia (*Acacia*)
Blue pincushion flower
 (*Scabiosa atropurpurea* 'Florist's Blue')
Blue thimble flower (*Gilia capitata*)
Creeping red fescue (*Festuca rubra*)

Russian sage (*Perovskia atriplicifolia*)
Slender veldt grass (*Pennisetum spathiolatum*)
Spurge (*Euphorbia*)
Toffee twist sedge (*Carex flagellifera* 'Toffee Twist')
White California poppy (*Eschscholzia californica* 'Alba')
White laceflower (*Orlaya grandiflora* 'Minoan Lace')
Yellow kangaroo paw
 (*Anigozanthos manglesii* 'Bush Dawn')

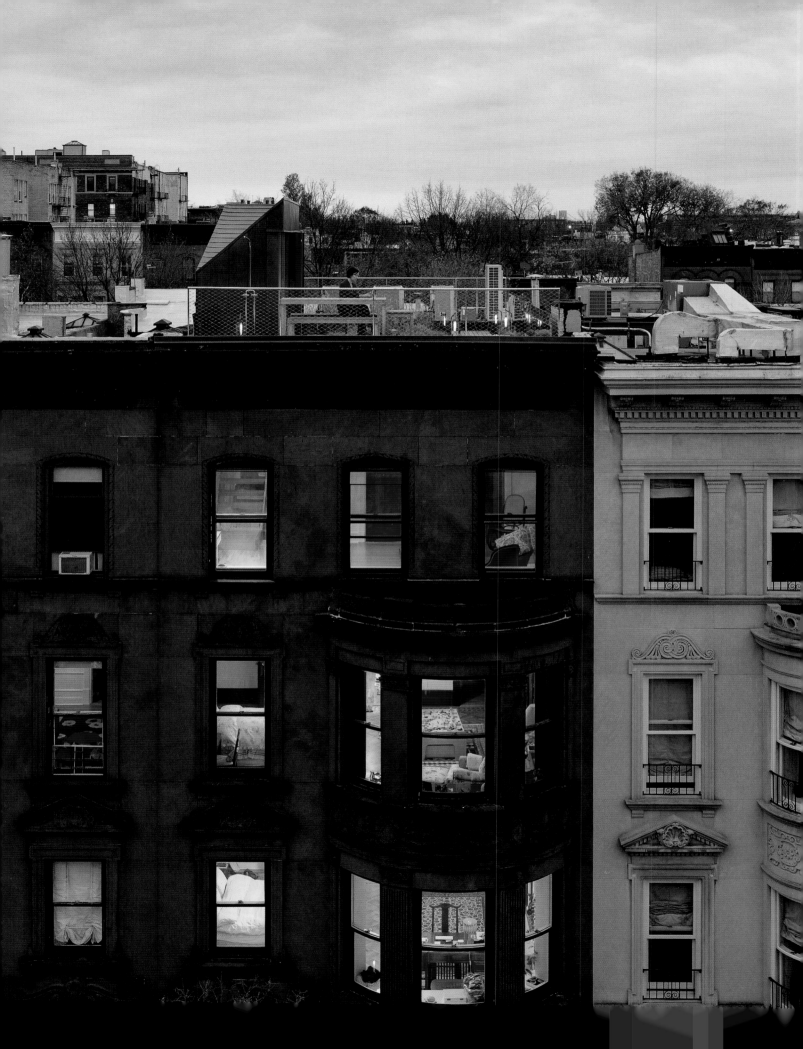

PERISCOPE HOUSE

New York City, USA

Category
Extensive green roof

Year
2011

Area
Roof: 100 m² (1,080 sq. ft.)
Occupiable roof: 65 m² (710 sq. ft.)

Landscape Architecture
Future Green Studio

Architecture
nARCHITECTS

Photography
Frank Oudeman

The Periscope House in Brooklyn takes full advantage of the expansive city views with a stair enclosure that acts as a periscope onto city skyline views from below and a roof terrace for entertaining and relaxing above.

The materials used for the roof terrace are limited to ipe decking, an extensive green roof system (into which grasses and sedums have been planted), and an outdoor shower. The planting is deliberately naturalistic, in contrast to the manicured garden below.

A second, smaller terrace overlooks the family garden. This terrace is also simple in form and provides space for children to play and relax. LED lighting is imbedded in the ipe decking to provide a constellation of light points in the evening, extending the usable time of the terrace.

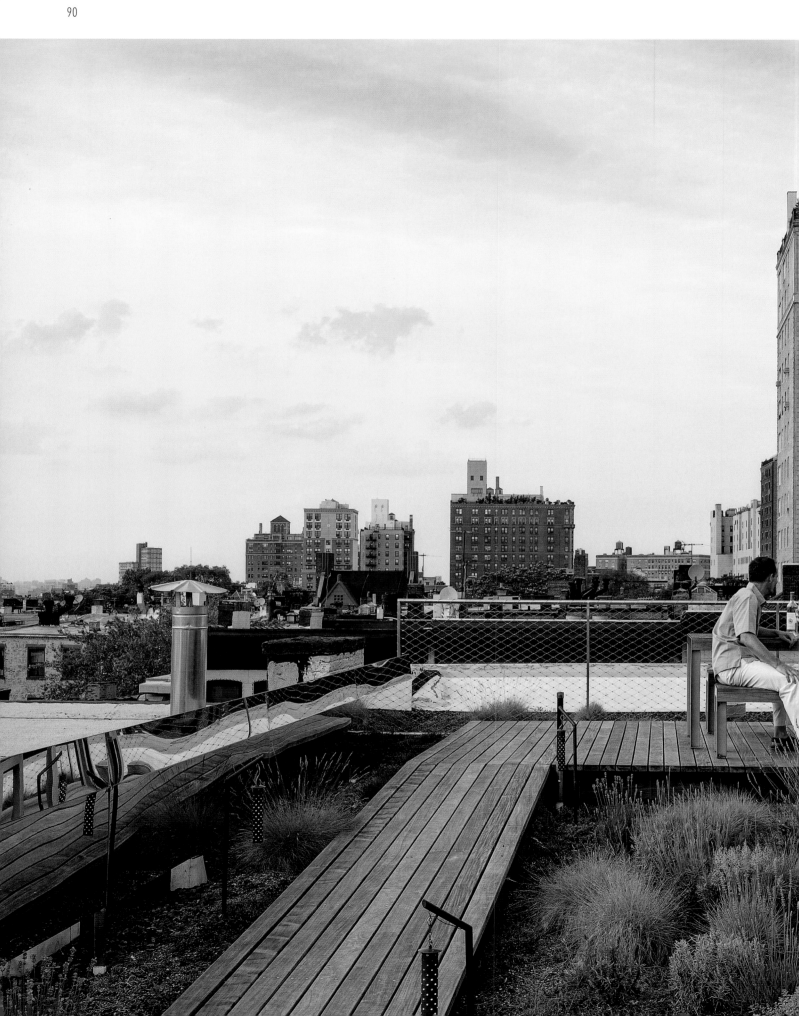

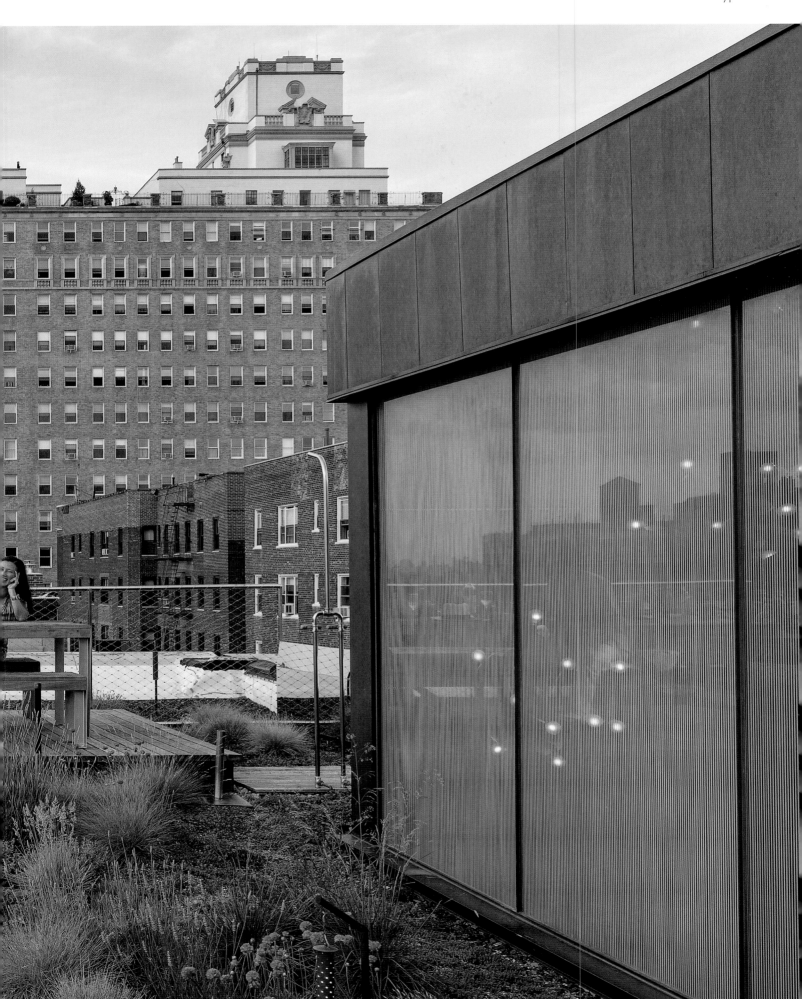

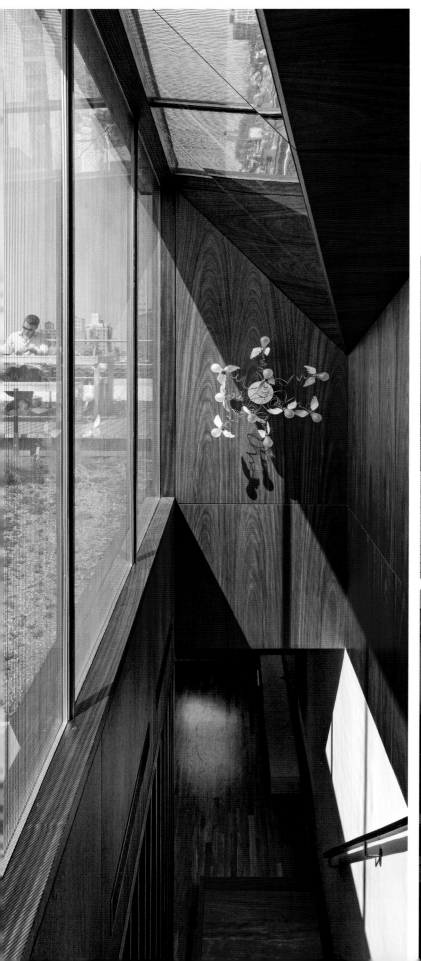

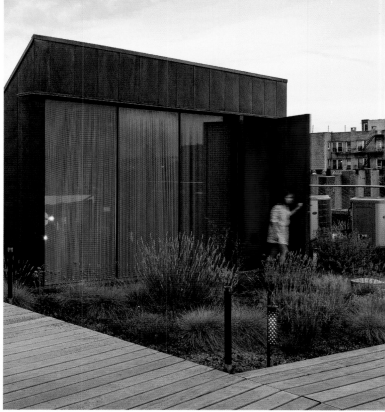

Previous page, left, and below: The property's stairwell rises up through a bulkhead with beautiful green colored glass that filters light down into the house, where it is reflected off a mirror in a periscope fashion.

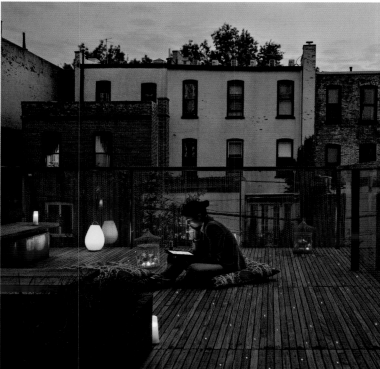

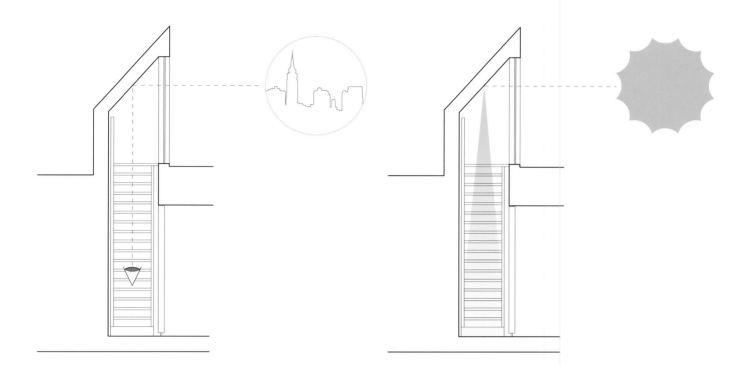

Climate
USDA Zone 7b (-15 to -12.2°C / 5 to 10°F)

Plants
Blue fescue grass (*Festuca glauca* 'Elijah Blue')
Cheddar pink (*Dianthus gratianopolitanus* 'Mountain Mist')
Chinese duncecap (*Orostachys furusei*)
Chinese fountain grass (*Pennisetum alopecuroides* 'Hameln')
Chives (*Allium senescens* subsp. *glaucum*)
English lavender (*Lavandula angustifolia*)
Fameflower (*Talinum calycinum*)
Fescue grass (*Festuca amethystina* 'Superba')
Flame grass (*Miscanthus sinensis* 'Purpurascens')
Houseleek (*Sempervivum sp*)
Pink muhly grass (*Muhlenbergia capillaris*)
Red silver maiden grass (*Miscanthus sinensis* 'Rotsilber')
Sea pink (*Armeria pseudarmeria* 'Bee's Ruby')
Sea thrift (*Armeria maritima* 'Rubrifolia')
Sedum (*Sedum sp*)
Spurge (*Euphorbia myrsinites*)
Trumpet vine (*Campsis radicans*)
Tunic flower (*Petrorhagia saxifraga* 'Lady Mary')

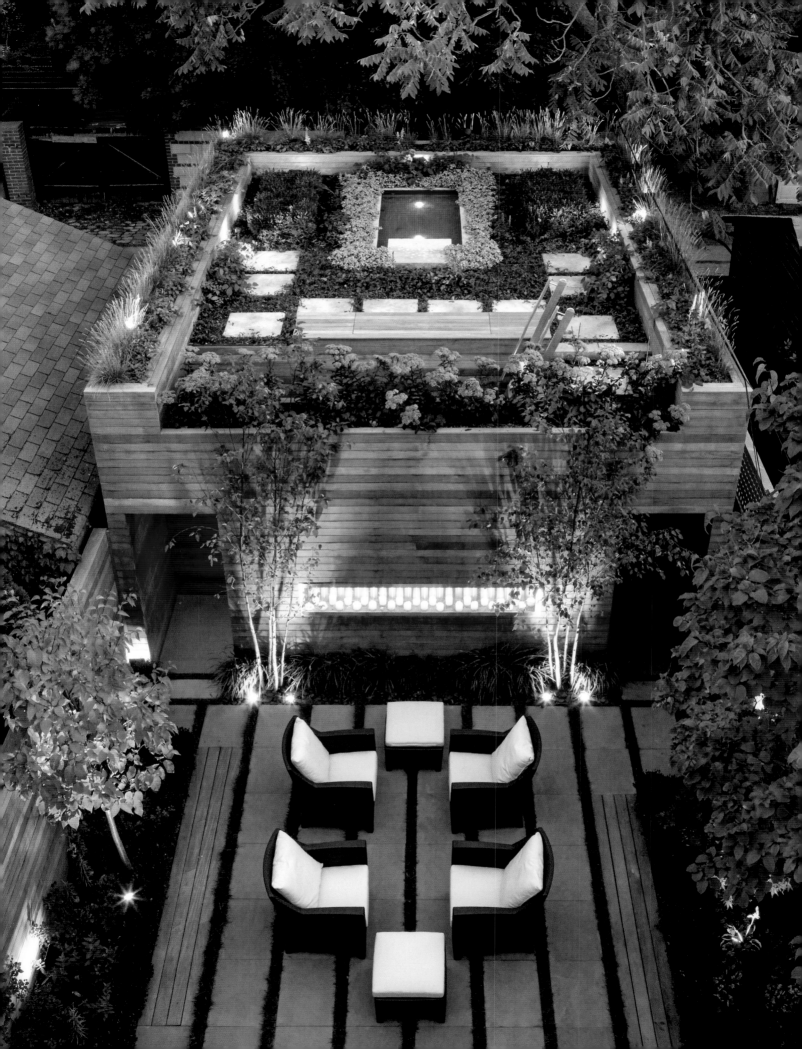

GREEN ROOF + GARDEN

Toronto, Canada

Category
Extensive green roof

Year
2007

Area
93 m² (1,000 sq. ft.)

Architecture
Cecconi Simone Inc.

Awards
ARIDO Awards, Award of Merit
DX Awards, Bronze, Landscape Design
Canadian Interiors magazine,
 Best of Canada, Landscape Design

Photography
Joy von Tiedemann

The designers of Green Roof + Garden have made the most of its small Toronto plot of only 6.5 by 18 meters (21 by 59 feet) by cleverly utilizing the roof above the garage to increase the amount of green space available to the owners of this stylish and contemporary garden.

The strong lines of the garden and the garage are softened by the greenery. For example, the contemporary limestone patio flooring is broken up by herbaceous planting and grasses. This linear pattern is also echoed in the horizontal slats of the untreated ipe wood fencing, which guide the eye towards the ipe-clad garage.

Above the garage is a lush green roof which doubles as entertaining space. Here the rectangular layout of the courtyard is restated in a calming reflection pool and the use of limestone paving slabs is repeated. The green roof planting is reminiscent of an English country garden with clipped boxwood, lose sedums, and ethereal periwinkle bordered by grasses, creating a low maintenance, yet attractive garden.

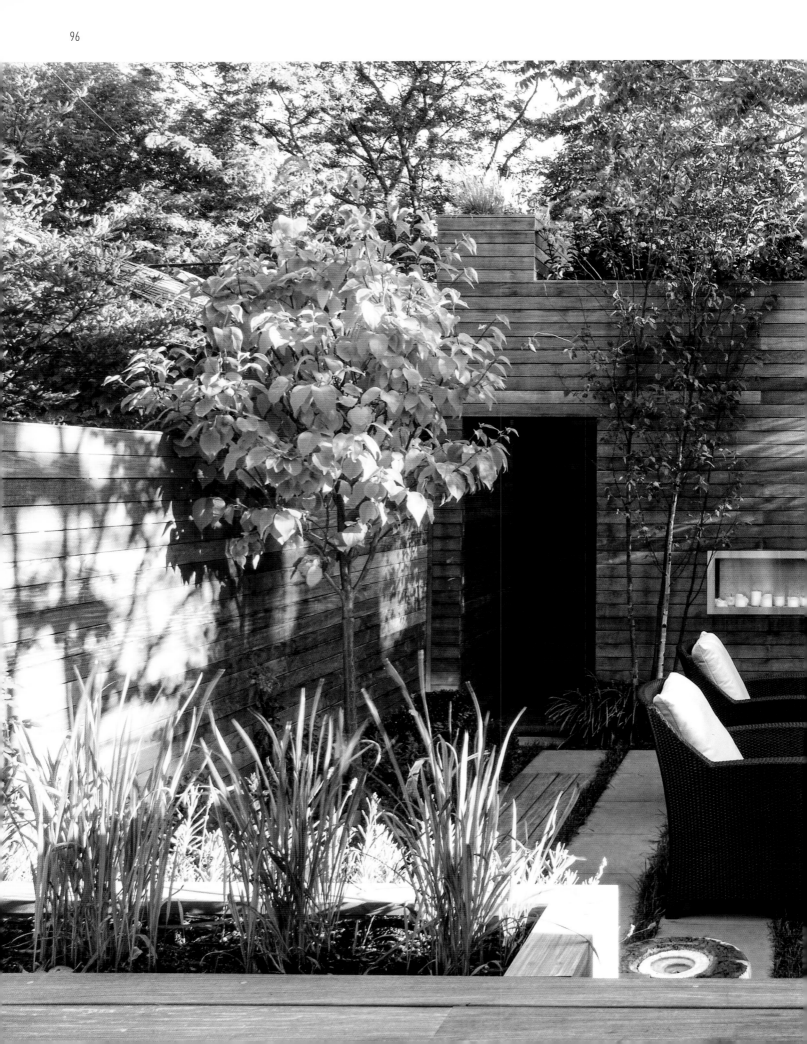

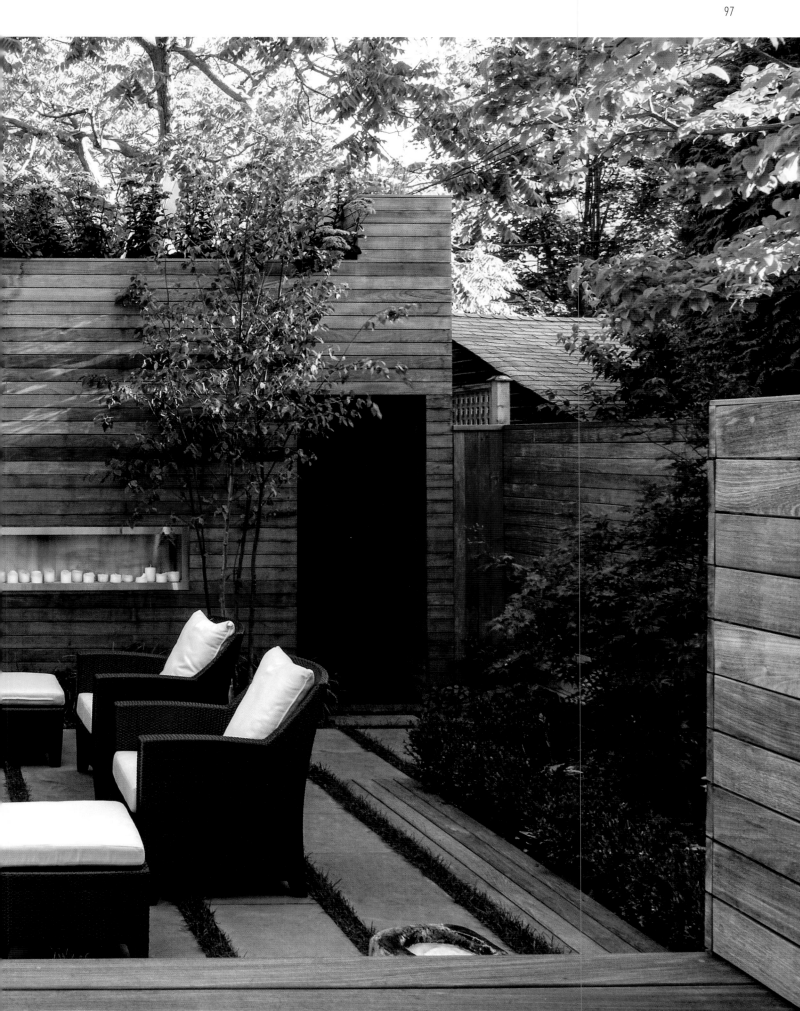

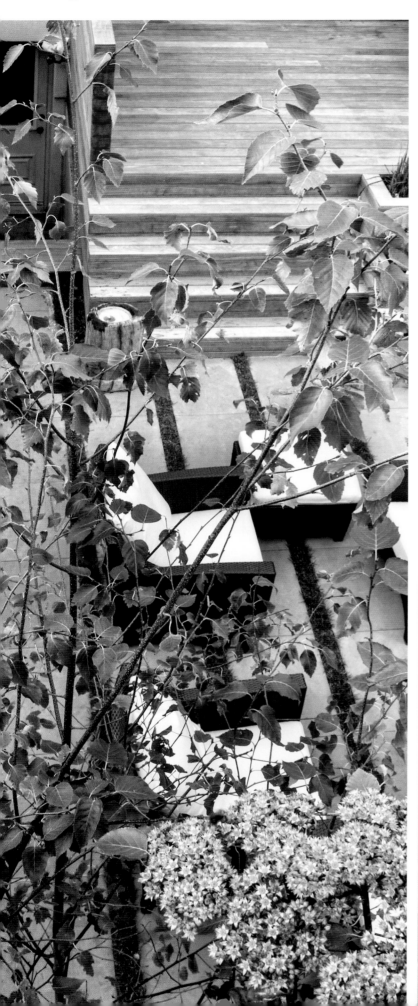

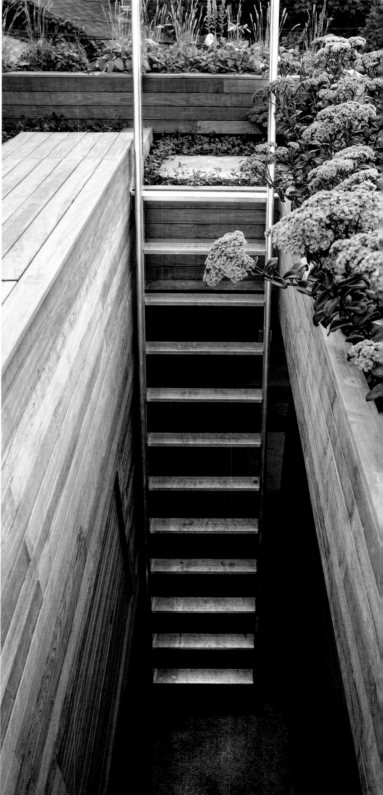

Opposite: The reflection pool is adorned in amber glass mosaic tiles and lit from beneath, creating a warm glow in the evenings that can be enjoyed from the view of the property's master bedroom.

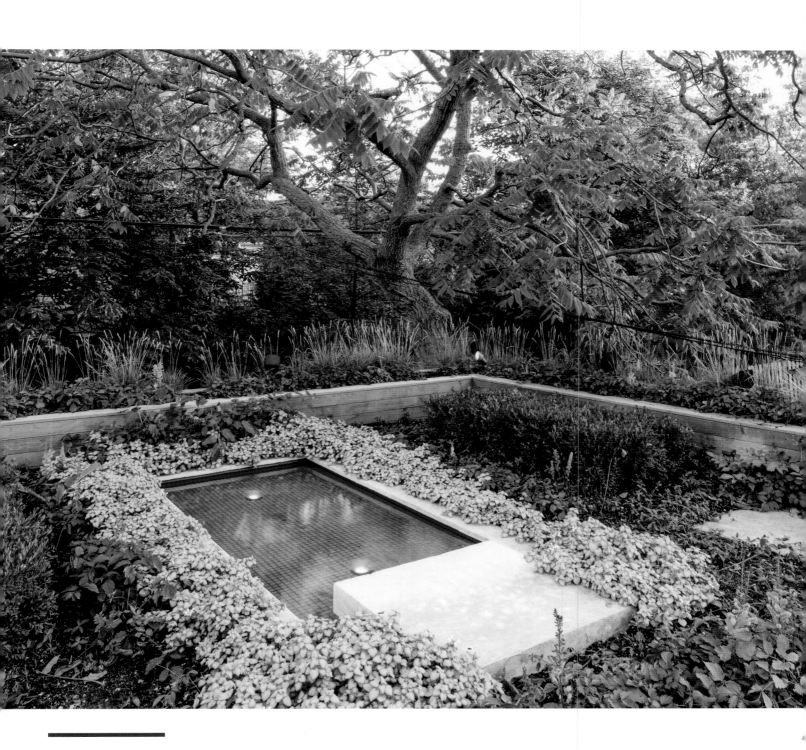

Climate
USDA Zone 6b (-20.6 to -17.8°C / -5 to 0°F)

Plants
Boxwood (*Buxus sempervirens*)
Periwinkle (*Vinca*)
Sedum (*Sedum sp*)

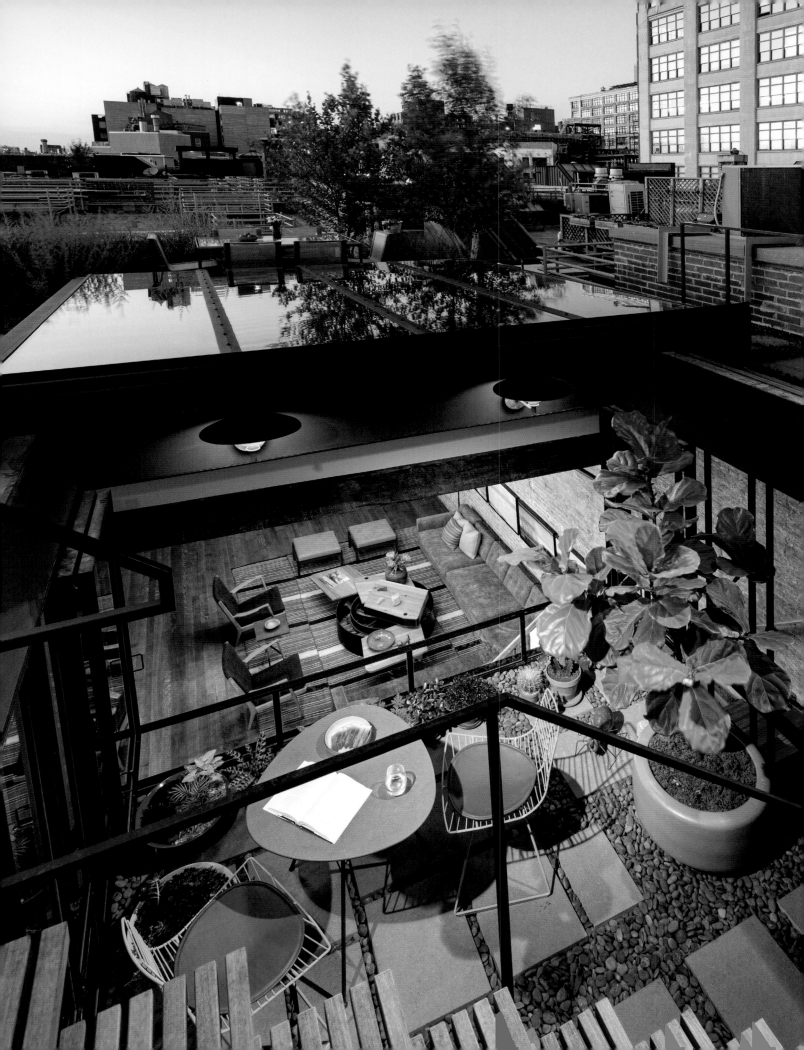

TRIBECA LOFT

New York City, USA

Category
Extensive green roof

Year
2014

Area
75 m² (800 sq. ft.)

Architecture / Landscape Architecture
Andrew Franz Architect, PLLC

Awards
WIN Awards, Winner Residential Interiors
SARA National Design Awards,
 Interior Architecture, Award of Excellence
SARA NY Design Awards,
 Interior Architecture, Bronze Award
Architecture Podium, International Design
 Awards, Residential Interiors, 1st Prize
Interior Design magazine, Best of Year,
 Honoree Residential Interiors

Photography
Albert Vecerka, Esto

The garden at the Tribeca Loft in New York is an innovative historic retrofit roof terrace that synergistically melds old and new elements into a contemporary, yet classically timeless design. This clever design is unique in that it blends the garden with the apartment through physically cutting the roof terrace into the interior space.

The most striking feature of the Tribeca Loft is the 14-square meter (150-square feet) interior garden with retractable glass roof. This area is sunken down from the roof terrace into the loft so that it is contiguous with a mezzanine level. The overall effect is of the roof terrace starting within the building.

Externally the roof terrace continues with a larger area of dinning and a smaller area for relaxing. The larger area is set close to the building for ease of access. The smaller seating area, complete with a miniature extensive green roof, is on a slightly raised area that allows commanding views over the Hudson River.

The planting is simple, yet soft and textural, with Scotch broom and Chinese juniper and climbing hydrangea ascending the wall.

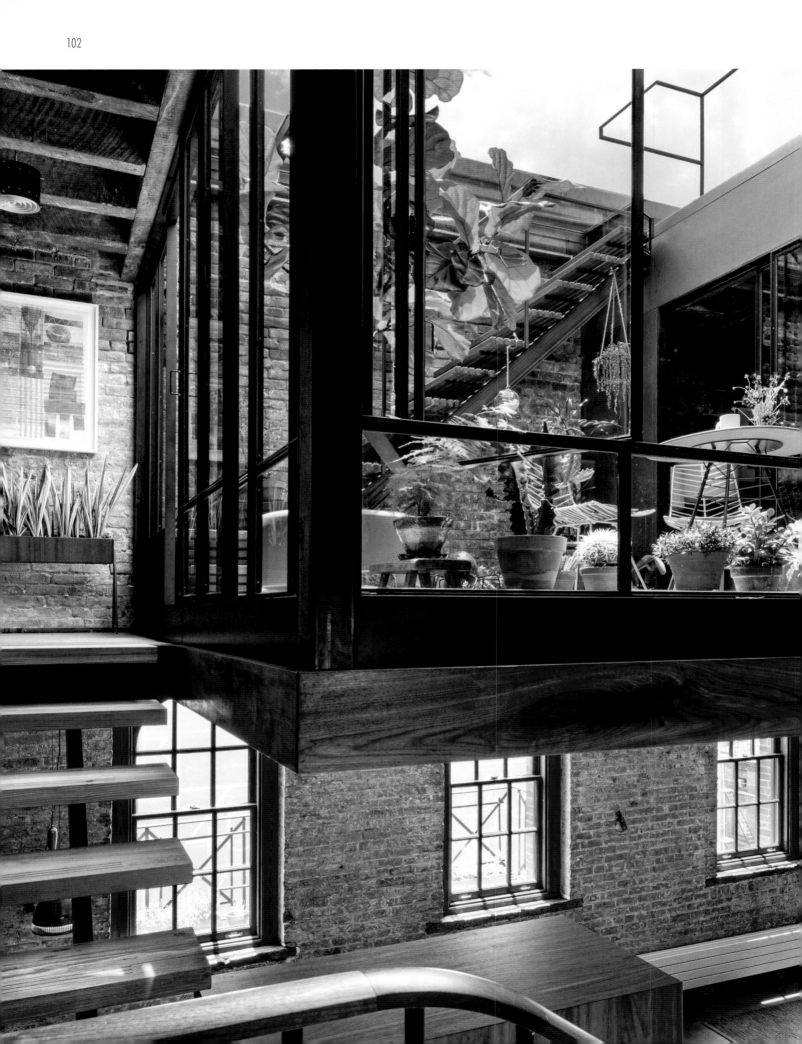

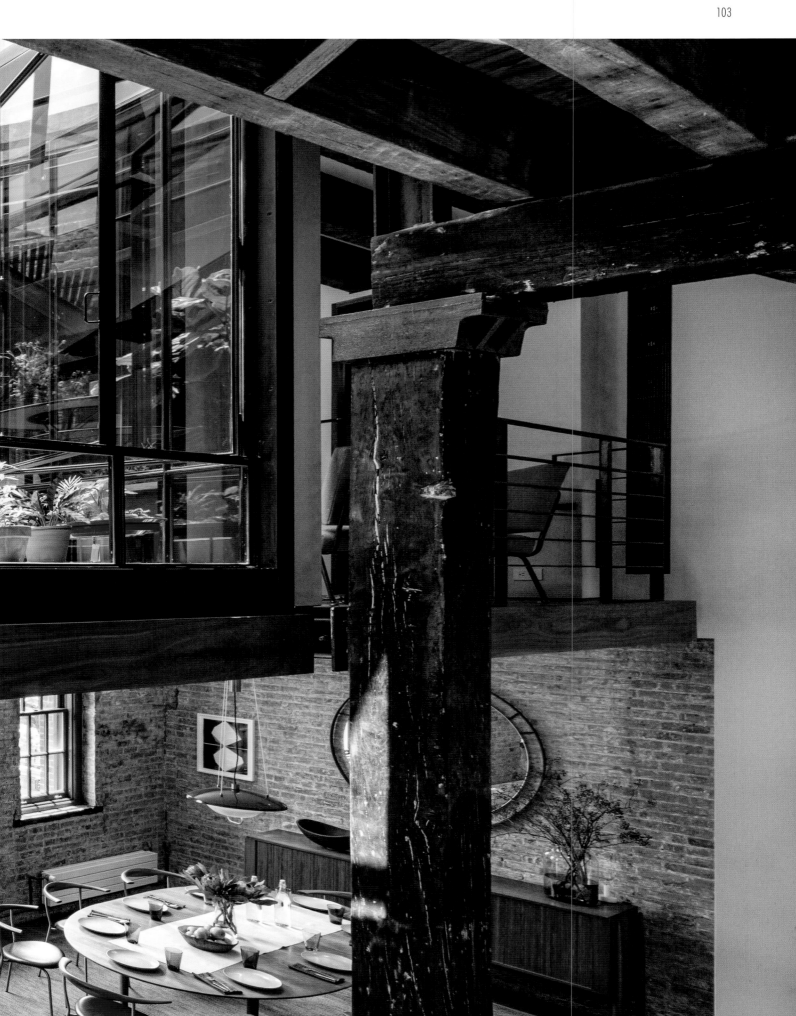

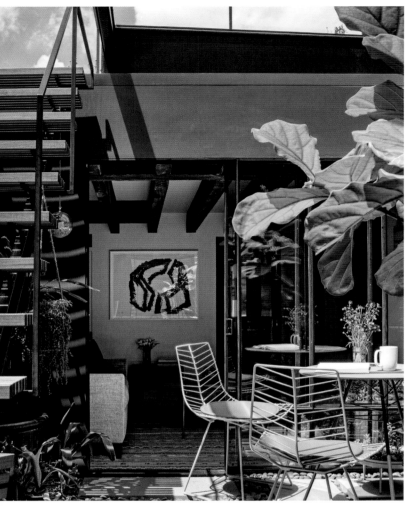

Previous page and left: The entertaining space is seen with its glass roof fully retracted, and windows open to allow fresh air to cascade into the space.

Bottom and opposite: Planting is deliberately kept low to allow unobstructed views of the Hudson River.

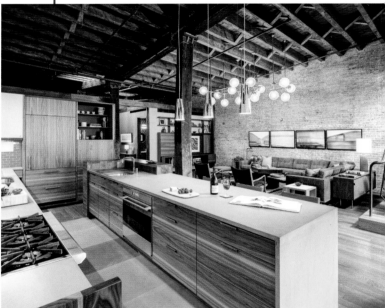

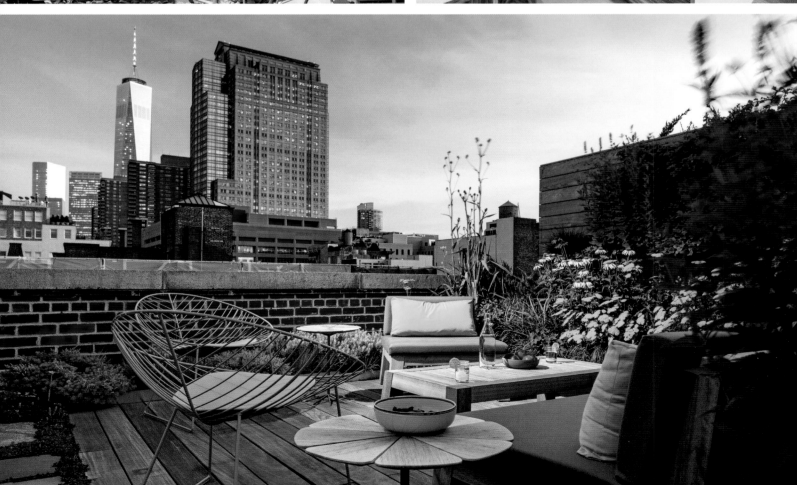

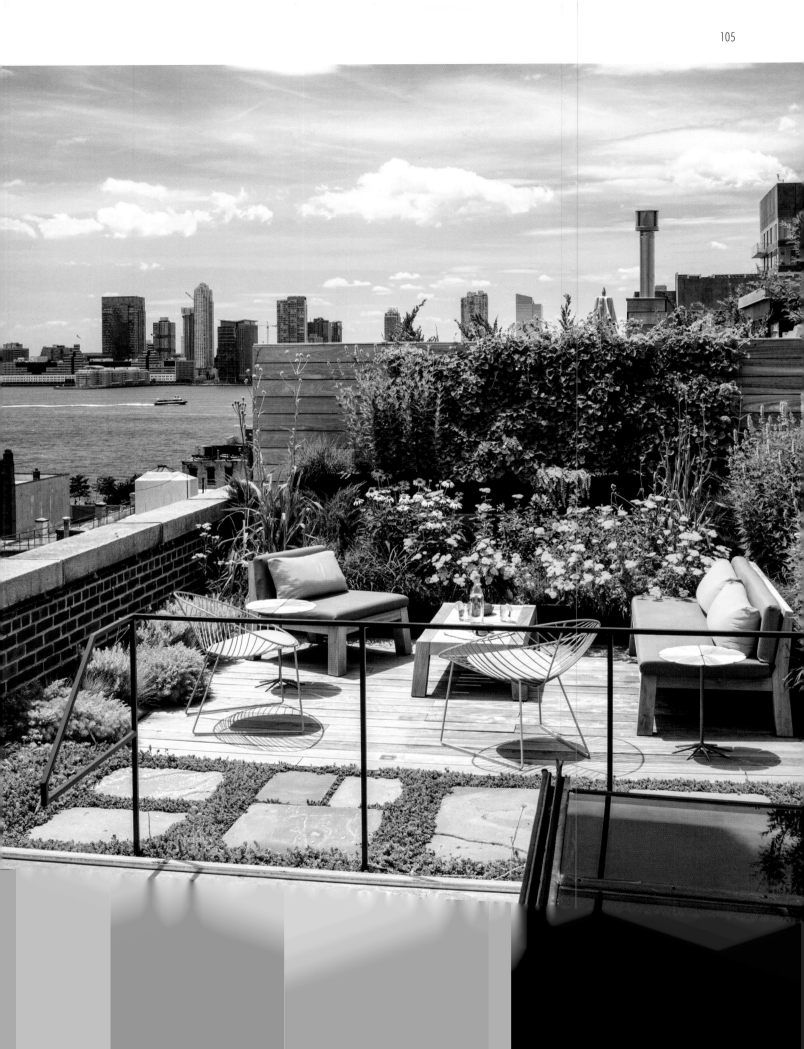

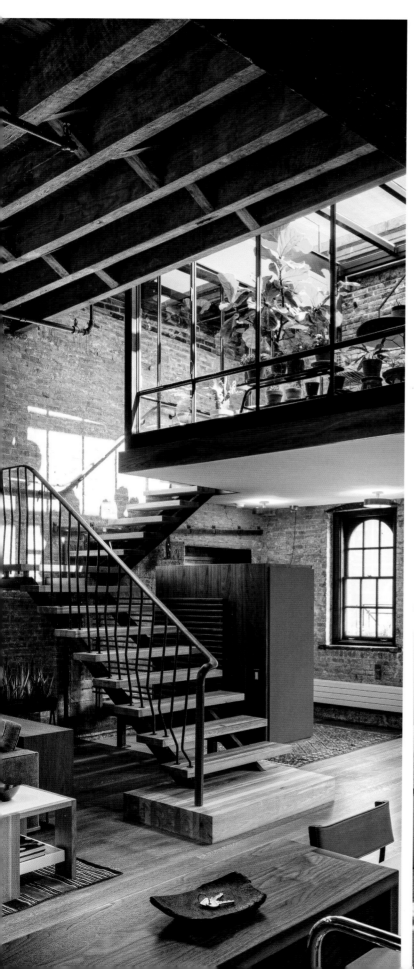

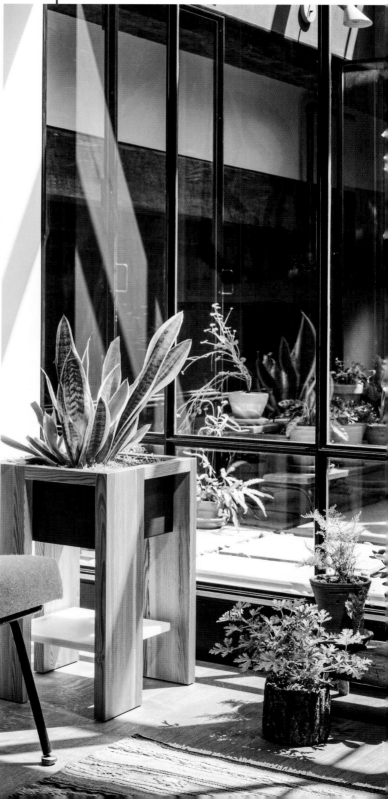

Left: The glass roof of the entertaining space protects the area from the coldest weather, allowing more exotic plants to flourish.

Below: The entertaining space as seen from the mezzanine lounge area.

Climate
USDA Zone 7b (-15 to -12.2°C / 5 to 10°F)

Plants
Appalachian barren strawberry (*Waldsteinia fragarioides*)
Austrian pine (*Pinus nigra*)
Blackeyed Susan (*Rudbeckia hirta*)

Chinese juniper (*Juniperus chinensis* 'Sea Green')
Climbing hydrangea (*Hydrangea anomala*)
Gentian speedwell (*Veronica gentianoides*)
Maidenhair (*Ginkgo biloba*)
Sand ryegrass (*Leymus arenarius*)
Scotch broom (*Cytisus scoparius*)
Shasta daisy (*Leucanthemum × superbum*)

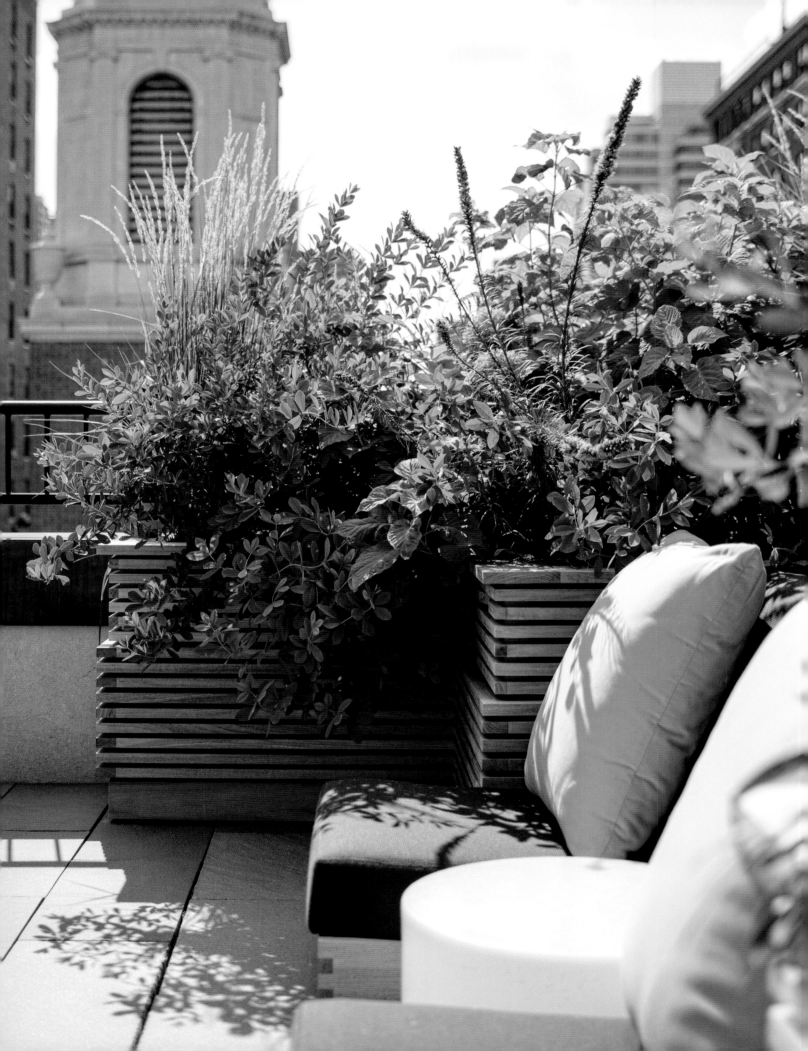

CARNEGIE HILL HOUSE

New York City, USA

Category
Intensive green roof

Year
2010

Area
95 m² (1,000 sq. ft.)

Landscape Architecture
Nelson Byrd Woltz Landscape Architects

Awards
ASLA, Honor Award
ASLA New York Chapter, Honor Award
AIA Virginia, Inform Award of Merit

Photography
Eric Piasecki, OTTO Archive

The design for the roof garden at Carnegie Hill House accounts a complex list of client criteria, site restraints, and ecological imperatives transformed into a beautiful multipurpose series of spaces, that perform a multitude of roles from family garden to wildlife habitat.

Split over a number of levels, the designers have created a garden that offers areas for children and adults to play and relax. Overlooking views from neighboring properties are averted by ethically sourced hardwood screens, creating a sense of intimacy throughout the garden.

One corner includes an over-sized family chair serving as a relaxing "nest" surrounded by lush woodland understory vegetation of ferns. In the background, Virginia creepers climb the garden wall, offering stunning autumnal colors.

A space dedicated to the owner's children contains a sandbox in front of a verdant wall of carefully selected non-toxic plants such as ladyfern, checkerberry, and candytuft, as well as edible plants, such as strawberry, basil, rosemary, sage, and thyme.

Structure in the planting comes from maidenhair trees, which tolerate urban environments well while providing beautiful yellow fall colors.

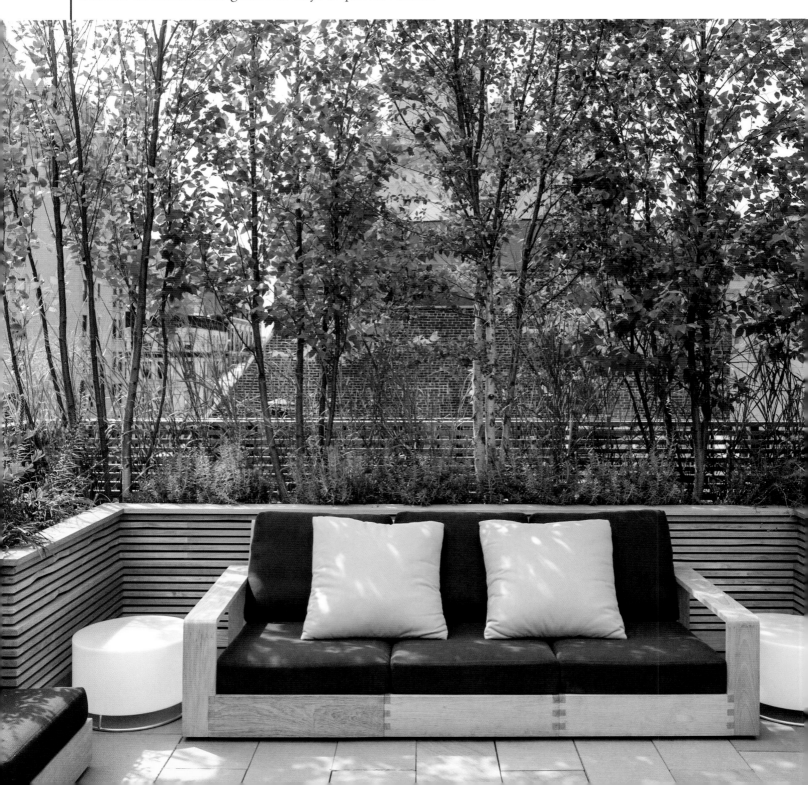

Below: The planting is a microcosm of a woodland glade, providing wildlife habitat.

Opposite, bottom: The movable hardwood screen opens up to reveal a carefully framed view of the adjacent church, but can be closed during sunnier days to provide shade.

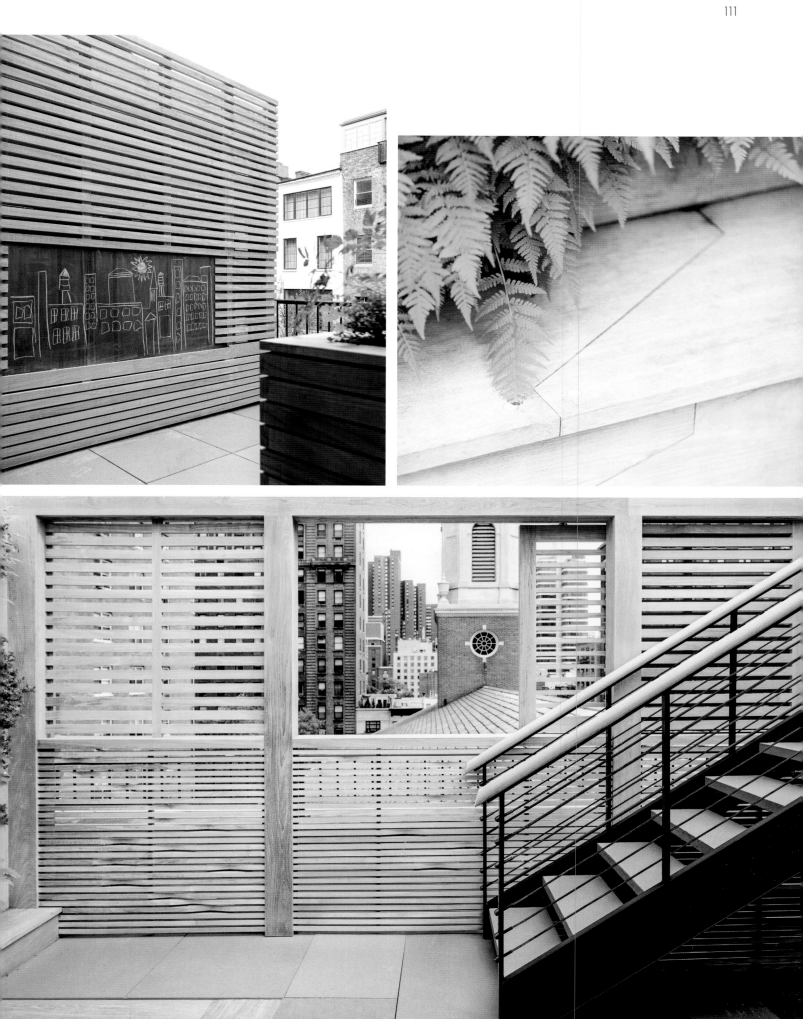

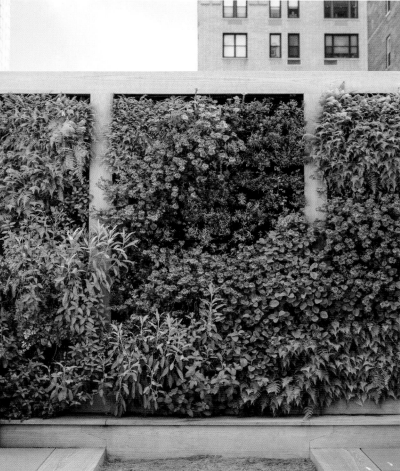

Below: The ferns used in the design were salvaged from the site before construction and replanted.

Bottom left: The green wall dramatically increases the amount of space available for planting.

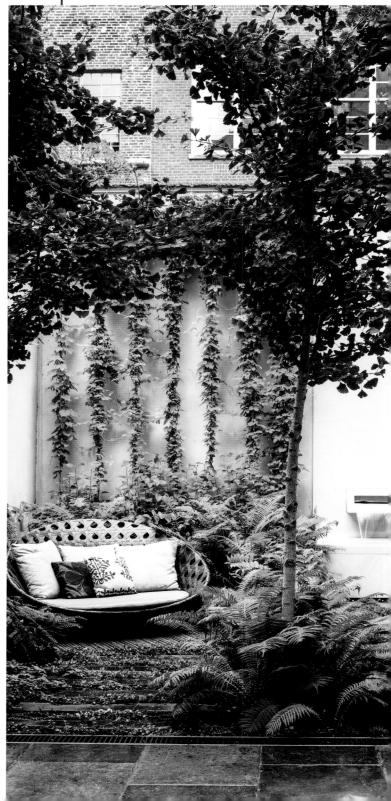

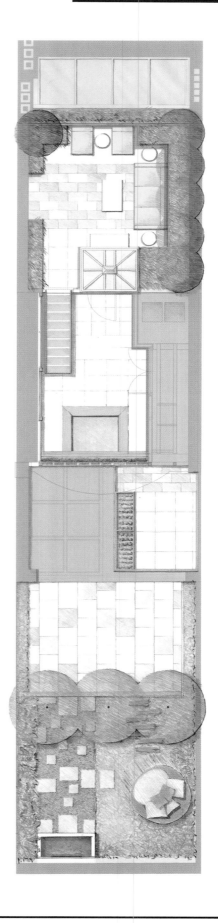

Climate
USDA Zone 7b (-15 to -12.2ºC / 5 to 10ºF)

Plants
Leucothoe (*Leucothoe sp*)
Maidenhair tree (*Ginkgo biloba*)
Ostrich fern (*Matteuccia struthiopteris*)
Virginia creeper (*Parthenocissus quinquefolia*)
GREEN WALL
Basil (*Ocimum basilicum*)
Candytuft (*Iberis umbellata*)
Checkerberry (*Gaultheria procumbens*)
Ladyfern (*Athyrium filix-femina*)
Rosemary (*Rosmarinus officinalis*)
Sage (*Salvia officinalis*)
Strawberry (*Fragaria × ananassa*)
Thyme (*Thymus vulgaris*)

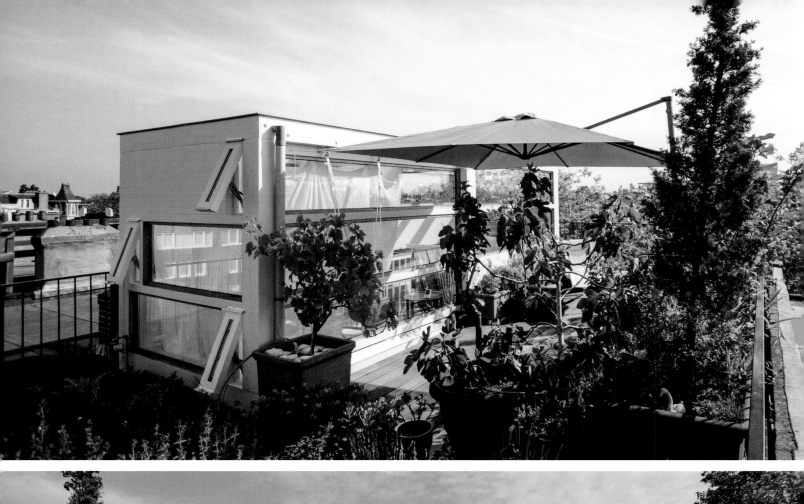
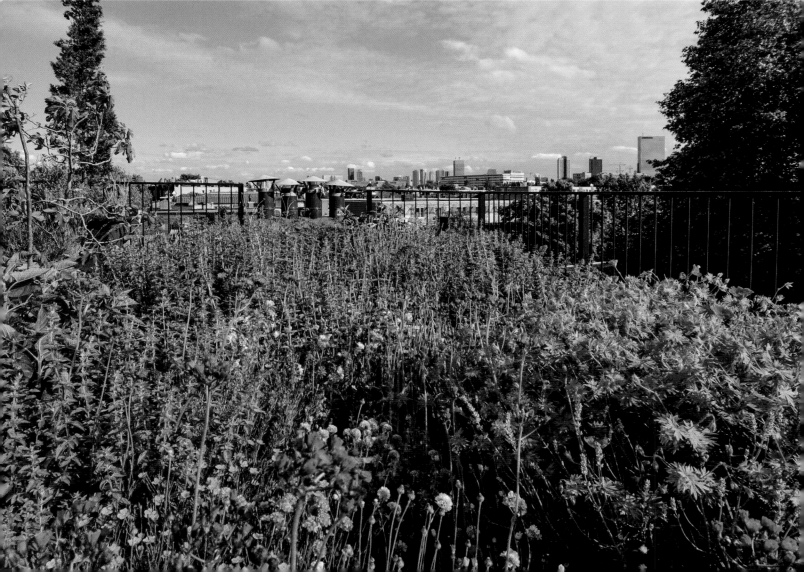

ROTTERDAM ROOFTOP OASIS

Rotterdam, The Netherlands

Category
Extensive green roof

Year
2005

Area
Garden and wood deck: 48 m² (520 sq. ft.)

Landscape Architecture / Architecture
Astrid Hölzer-Engelhard & Dirk Hölzer

Awards
Rotterdams Milieucentrum Garden Competition,
1st Prize Balconies and Rooftop Gardens

Photography
Astrid Hölzer-Engelhard

The Rotterdam Rooftop Oasis is a riotous mix of colors, forms, and textures that blends into a roof garden full of birds and bees 12 meters (39 feet) above the very heart of Rotterdam.

Spatially, the garden is simple with an ethically sourced hardwood deck off a central sunroom and stairwell from the property. Stunning 360-degree views of the city can be seen from the deck.

The planting is made possible through the use of specialist green roof material layers consisting of insulation, waterproofing, water reservoirs, and filters that allow a 12-centimeter (5-inch) depth of growing medium to be placed on the 100-year old roof. Due to the limited planting depth, the planting palette is a careful selection of low-growing shrubs like lavender, sub-shrubs like thyme and oregano, and perennials such as maiden pink. Larger shrubs like citron are accommodated in pots on the deck, providing a degree of privacy.

The mass of flowering plants like blue flag iris, hyssop, and gaura attract insects, offering a sustained nectar source throughout the season.

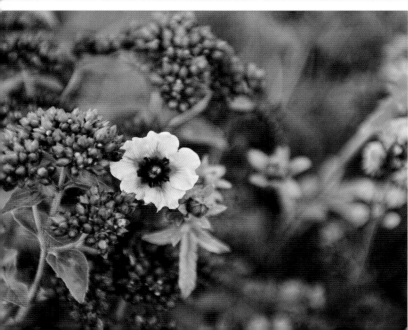

Opposite, top right: Flower heads can be left over the winter providing an architectural element and seeds for birds.

Below: A rocking chair on the deck provides the perfect place to sit and enjoy the sounds of the insects buzzing.

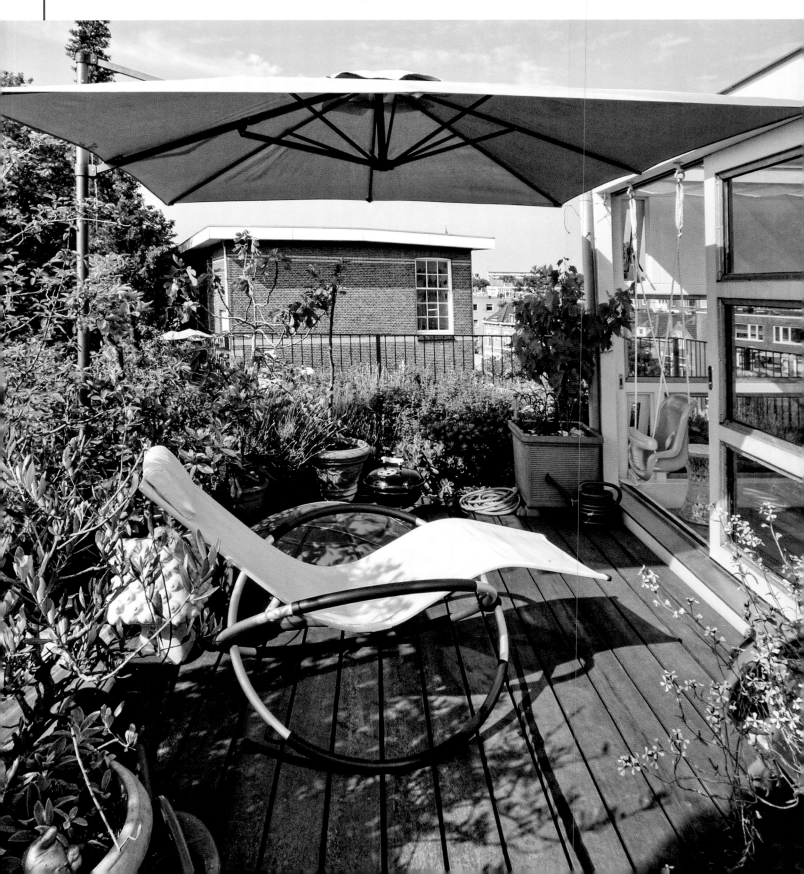

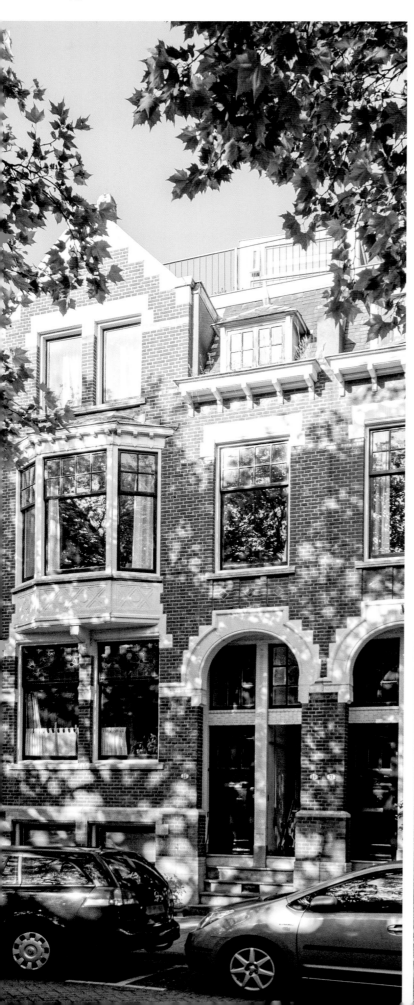

Left: The sunroom and garden has been retrofitted to an historic building, requiring expert advice from a structural engineer.

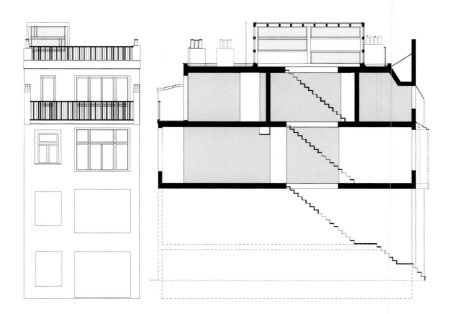

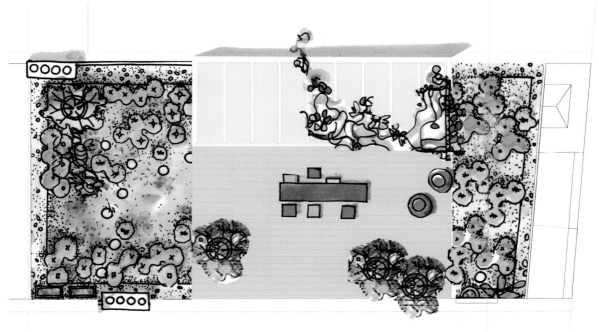

Climate
USDA Zone 9a (-6.7 to -3.9ºC / 20 to 25ºF)

Plants
Blue flag (*Iris versicolor*)
Cinquefoil (*Potentilla nepalensis* 'Miss Willmott')
Citron (*Citrus medica*)
Common myrtle (*Myrtus communis*)
Hyssop (*Hyssopus officinalis*)

Lavender (*Lavandula*)
Maiden pink (*Dianthus deltoides* 'Splendens')
Orange stonecrop (*Sedum kamtschaticum*
 var. *floriferum* 'Weihenstephaner Gold')
Oregano (*Origanum vulgare*)
Thyme (*Thymus vulgaris*)
White gaura (*Gaura lindheimeri* 'Whirling Butterflies')

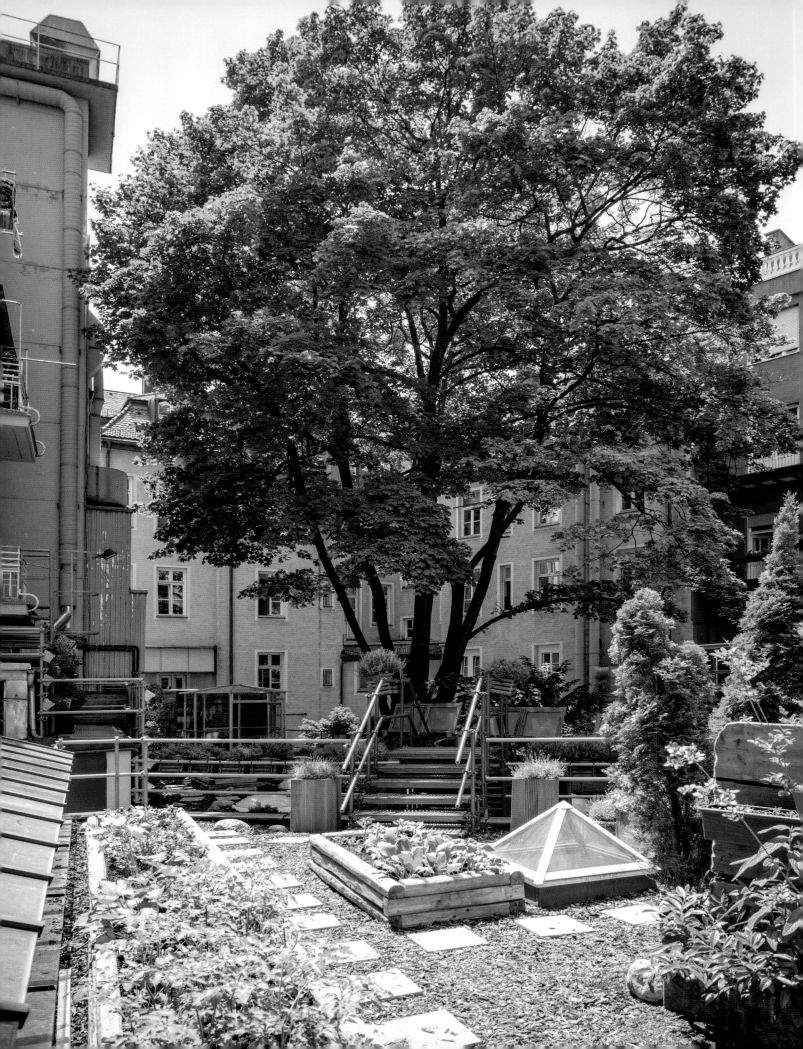

KÄFER ROOFTOP GARDEN

Munich, Germany

Category
Extensive green roof and roof garden

Year
2015

Area
100 m² (1,100 sq. ft.)

Landscape Architecture / Architecture
Käfer In-House Creative Team
(Mario Stock, Sabine Hörner)

Photographs
Cem Czerwionke, Enes Kucevic

The urban farming trend has made its way to rooftop gardens as well. Whether the food comes from expansive vegetable fields on factory roofs in Brooklyn or hotel herb gardens in Amsterdam, everyone enjoys eating fresh, local ingredients.

The same holds true at Feinkost Käfer—the long-standing Munich landmark connected two previously unused flat roofs on their headquarters building with a bridge and began growing fruits, vegetables, and herbs. Raised wooden garden boxes provide fertile ground for common varieties as well as heirloom and rare plants, which the chefs use to liven up the menu at the in-house bistro and restaurant. Even the edible flowers of the nasturtium, which thrive in perforated metal hanging baskets, beautify diners' salads.

But even those not dining at the bistro and restaurant can enjoy the rooftop harvest—customers can climb a spiral staircase to visit the garden, purchase freshly picked vegetables and herbs in the store's deli, and scoot home with them on your BMW Motorrad.

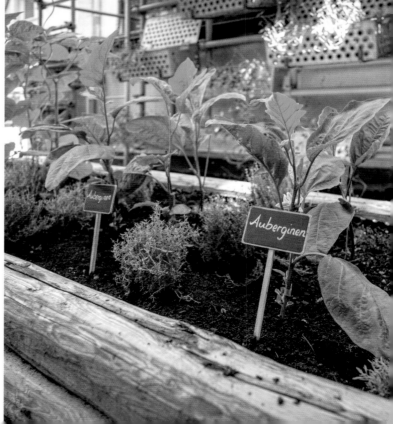

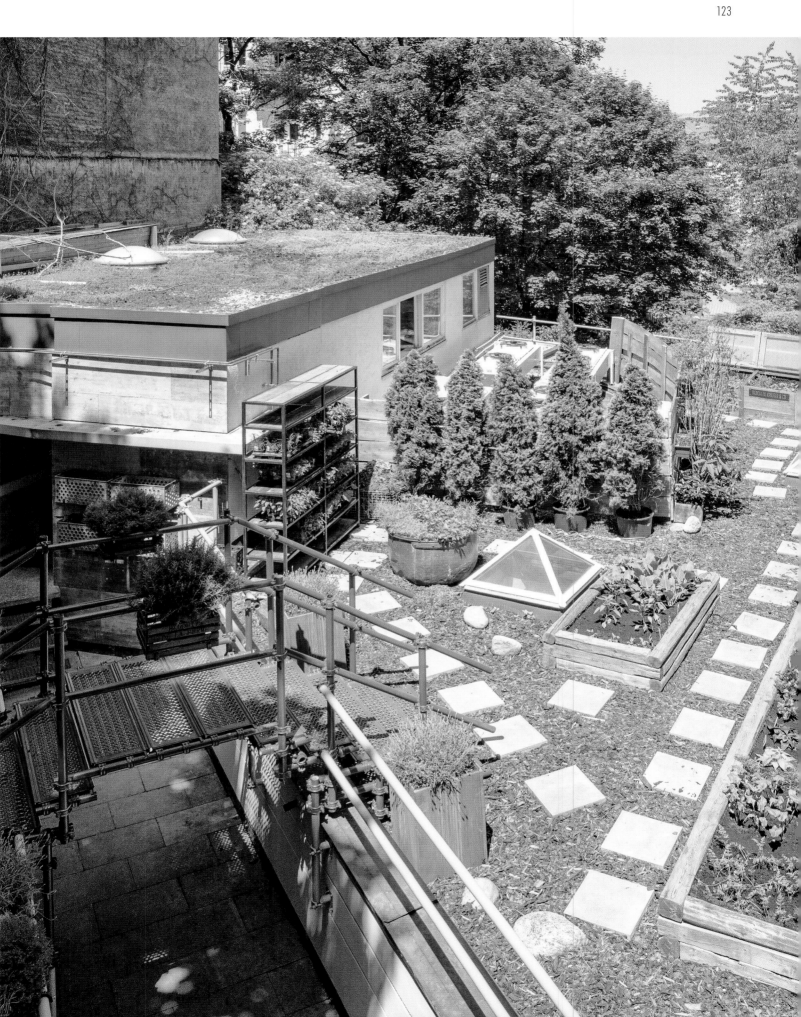

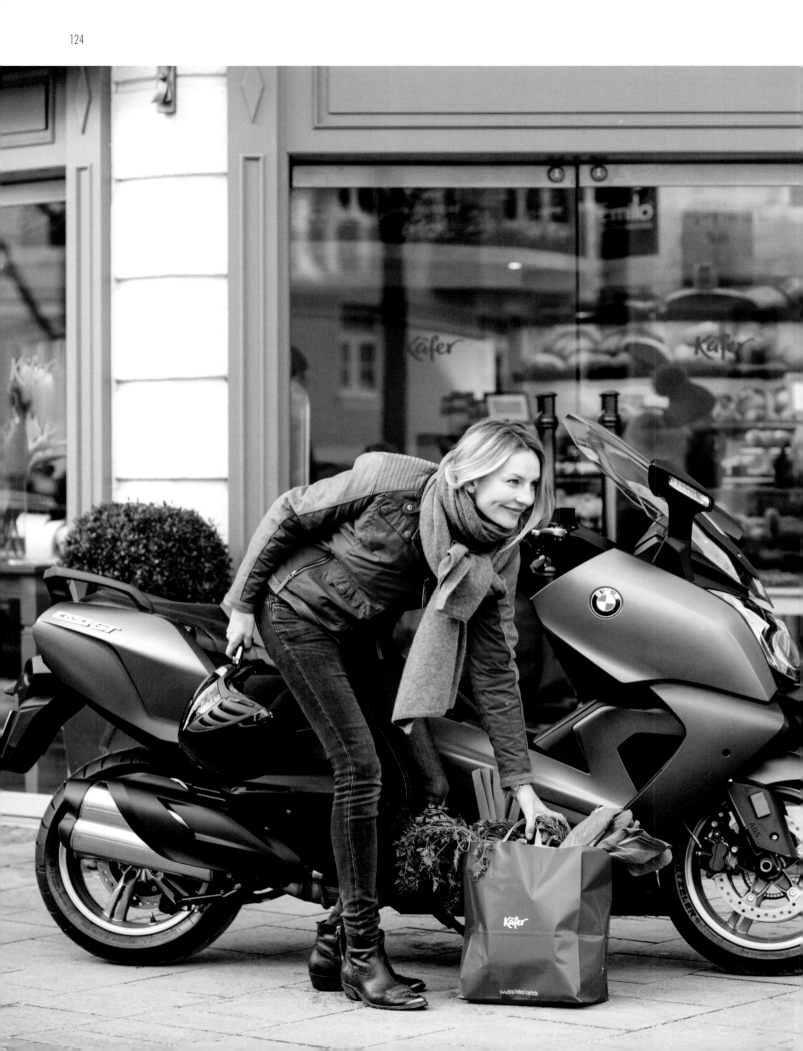

Climate
USDA Zone 8a (-12.2 to -9.4°C / 10 to 15°F)

Plants
Carrot (*Daucus carota*)
Cucumber (*Cucumis sativus*)
Eggplant (*Solanum melongena*)
Gooseberry (*Ribes uva-crispa*)

Groundcherry (*Physalis*)
Nasturtium (*Tropaeolum*)
Pepper (*Capsicum*)
Rhubarb (*Rheum*)
Squash (*Cucurbita*)
Tomato (*Solanum lycopersicum*)
Zucchini (*Cucurbita pepo*)
Various herbs

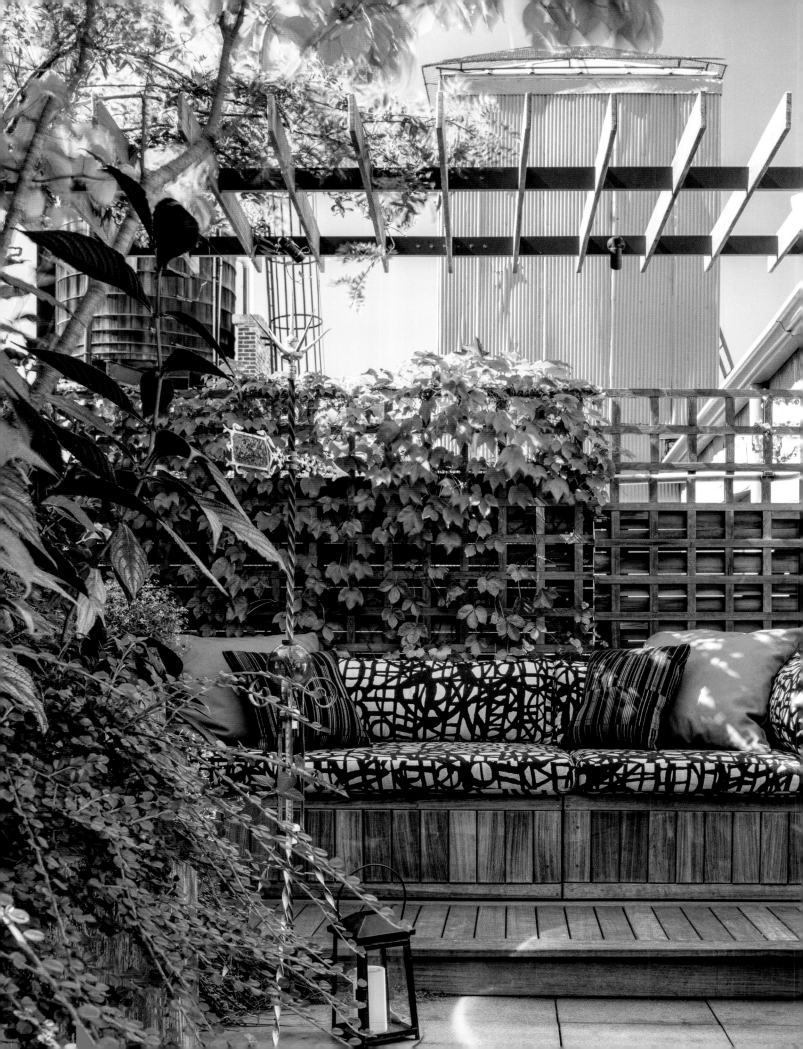

CENTRAL PARK WEST ROOFTOP TERRACE

New York City, USA

Category
Intensive green roof

Year
2013

Area
45 m² (460 sq. ft.)

Landscape Architecture
Gunn Landscape Architecture, PLLC

Architecture
Foley Fiore Architecture

Photography
Paul Warchol

This Central Park West rooftop terrace is a verdant, textural garden full of layers of fresh green foliage. Set against muted pastel shades of weathered hardwood and natural stone, it offers a natural oasis amongst the concrete of New York City.

Spatially, the layout of this intimate garden is simple with a small, soft lawn of Irish moss opening up onto a modest patio flanked by thickly layered planting.

In the far corner from the dwelling lies a cozy, soft furnished bench under a hardwood arbor. Immediately adjacent is a specially commissioned water feature lending its calming sounds to the garden.

Butt-jointed natural stone paving and ipe hardwood have been left untreated to gently weather over time to mellow into the garden's setting. Along one side of the patio, raised planters full of herbaceous planting create a sense of enclosure, while on the other, English and Boston ivies sprawling over a lattice screen offers privacy from the surrounding city. Korean dogwood and Manchurian lilac provide height to the planting and at the same time offer dappled shade and fragrance in spring.

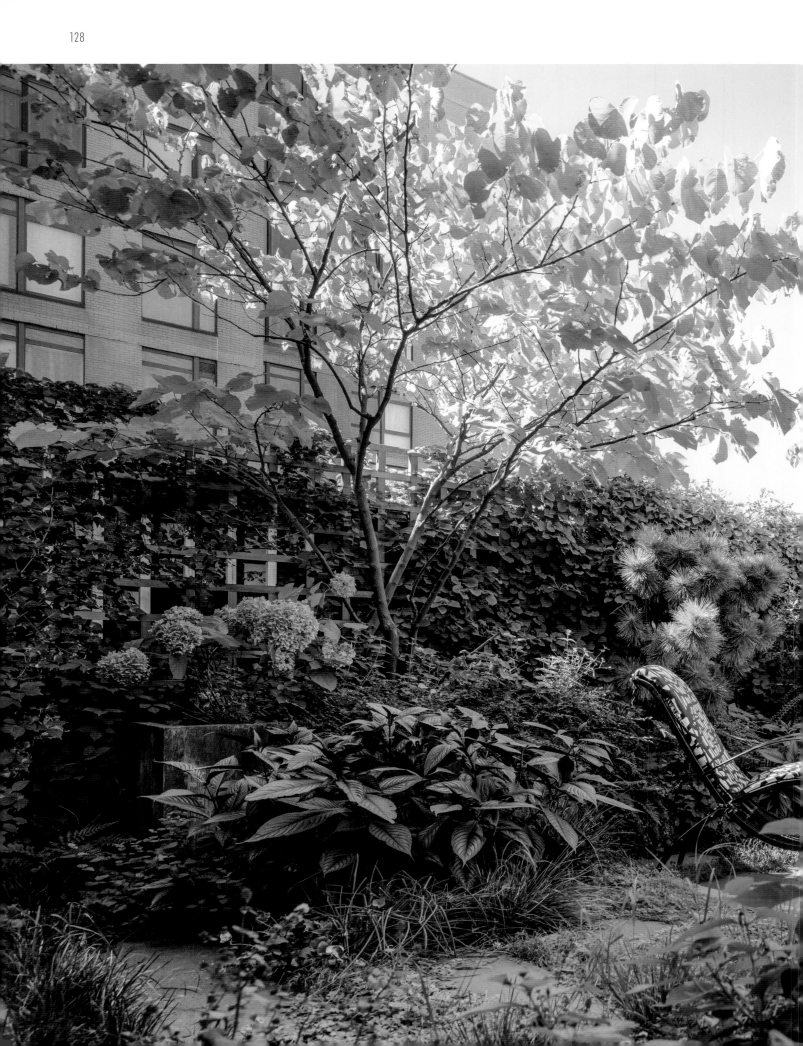

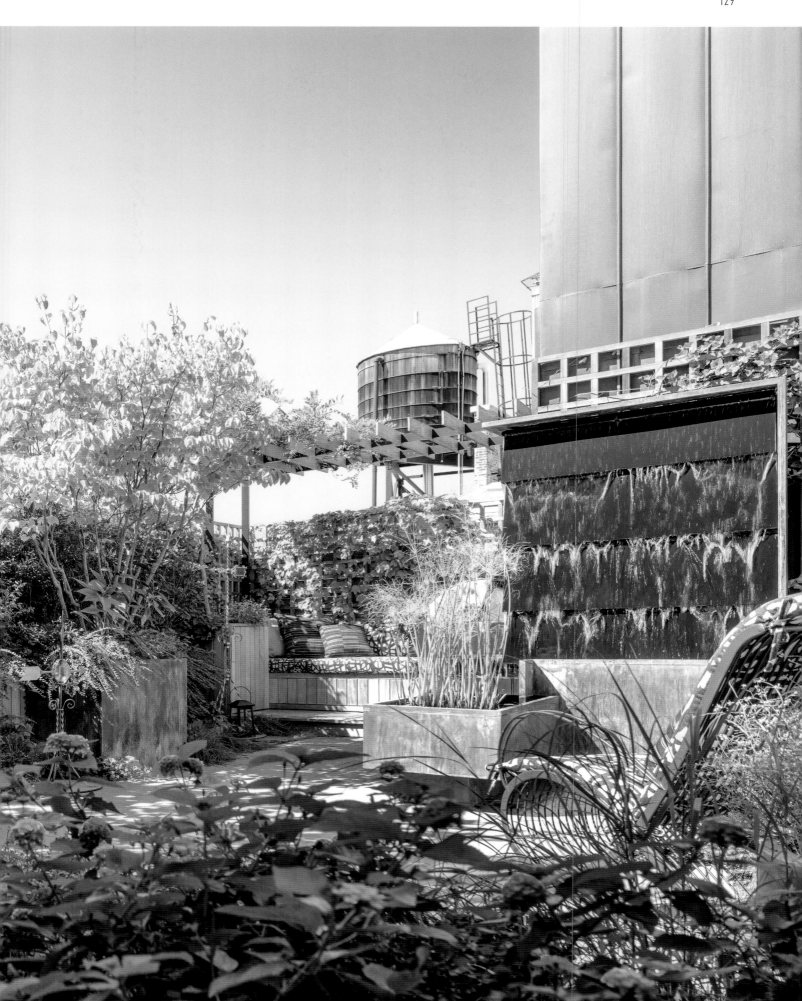

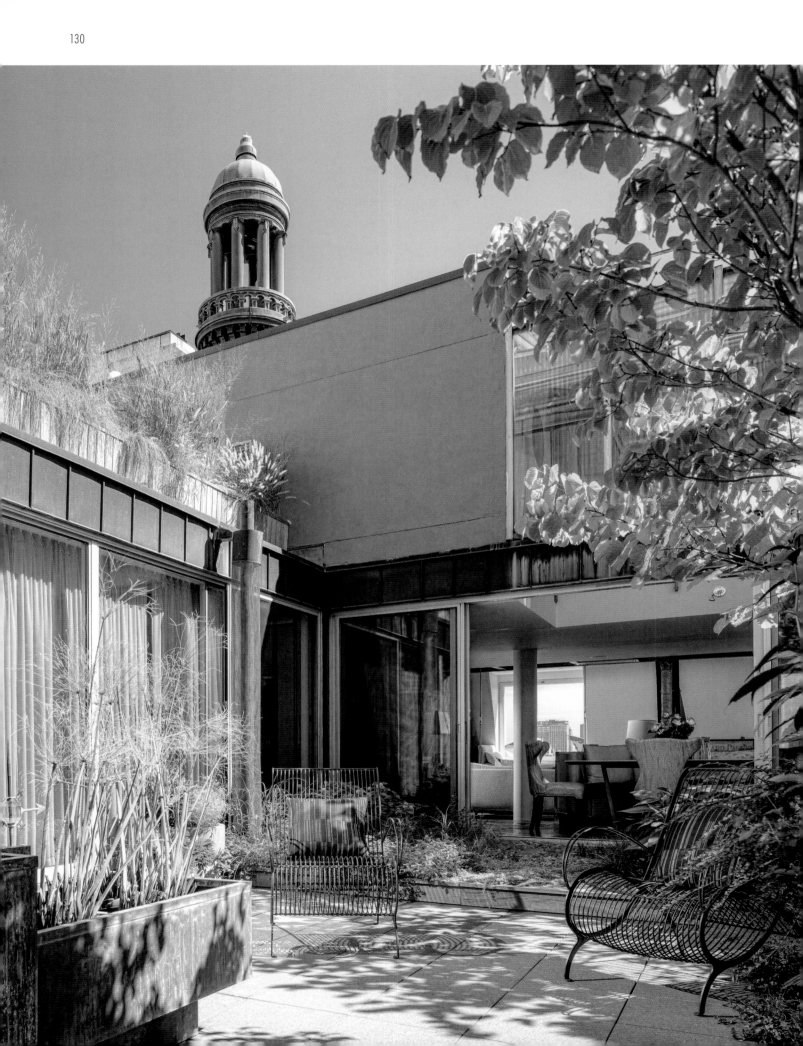

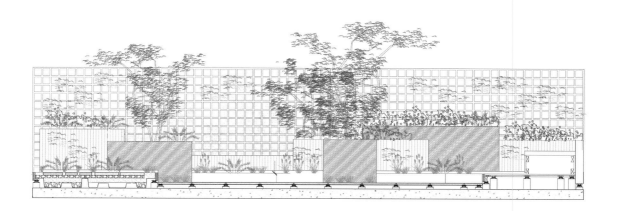

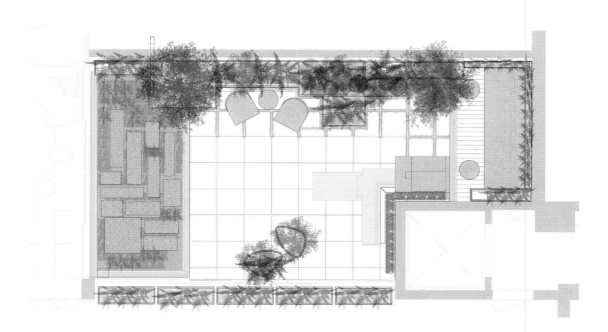

Climate
USDA Zone 7b (-15 to -12.2°C / -5 to 10°F)

Plants
Boston ivy (*Parthenocissus tricuspidata*)
Chinese fountain grass
 (*Pennisetum alopecuroides* 'Hameln')
Chives (*Allium schoenoprasum*)
Climbing hydrangea (*Hydrangea anomala*)
Clover (*Trifolium*)
Eastern redbud (*Cercis canadensis* 'Alba')
English ivy (*Hedera helix*)
Inkberry (*Ilex glabra*)

Irish moss (*Sagina subulata*)
Jackman's Clematis (*Clematis jackmanii*)
Japanese black pine (*Pinus thunbergii* 'Thunderhead')
Japanese meadowsweet (*Spiraea japonica*)
Korean dogwood (*Cornus kousa*)
Korean tassel fern (*Polystichum polyblepharum*)
Manchurian lilac (*Syringa pubescens patula* 'Miss Kim')
Mexican feather grass (*Nassella tenuissima*)
Prairie dropseed (*Sporobolus heterolepis*)
Rockspray (*Cotoneaster horizontalis*)
Sweet autumn clematis (*Clematis paniculata*)
Tufted hairgrass (*Deschampsia cespitosa*)

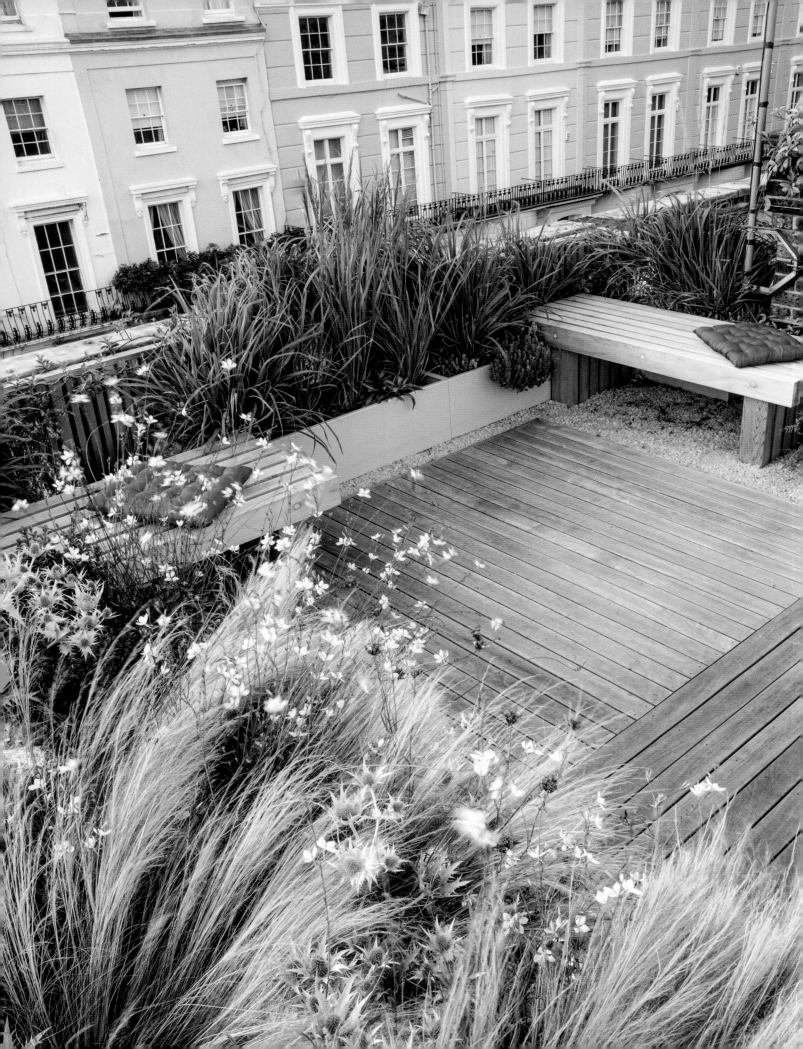

ROOF TERRACE IN HOLLAND PARK

London, United Kingdom

Category
Roof garden

Year
2007

Area
37.5 m² (400 sq. ft.)

Landscape Architecture
Charlotte Rowe Garden Design

Photography
Clive Nichols

This roof terrace in Holland Park, London, is a beautiful and subtly feminine garden for entertaining with soft, textural planting and mellow evening lighting. The challenge of retrofitting a roof terrace garden to an existing historic building has been met with innovative use of lightweight materials and careful plant selection.

The spatial layout of this modest-sized roof terrace is simple: a large central area of ipe decking is surrounded by predominantly herbaceous planting and western red cedar benches that are large enough to also be used as day beds. The decking is edged in a narrow border of crushed glass aggregate, which lends a chic, contemporary feel to the space. The decking is also inset with frosted glass panels that are lit from below.

Due to weight restrictions on the roof the planting is limited to those with shallow roots that can thrive on limited soil. Lush herbaceous perennials have been used to great effect with Alliums poking their spherical heads above billowing grasses, including Mexican feather grass and Korean feather reed grass. Tulips give an early splash of color in spring.

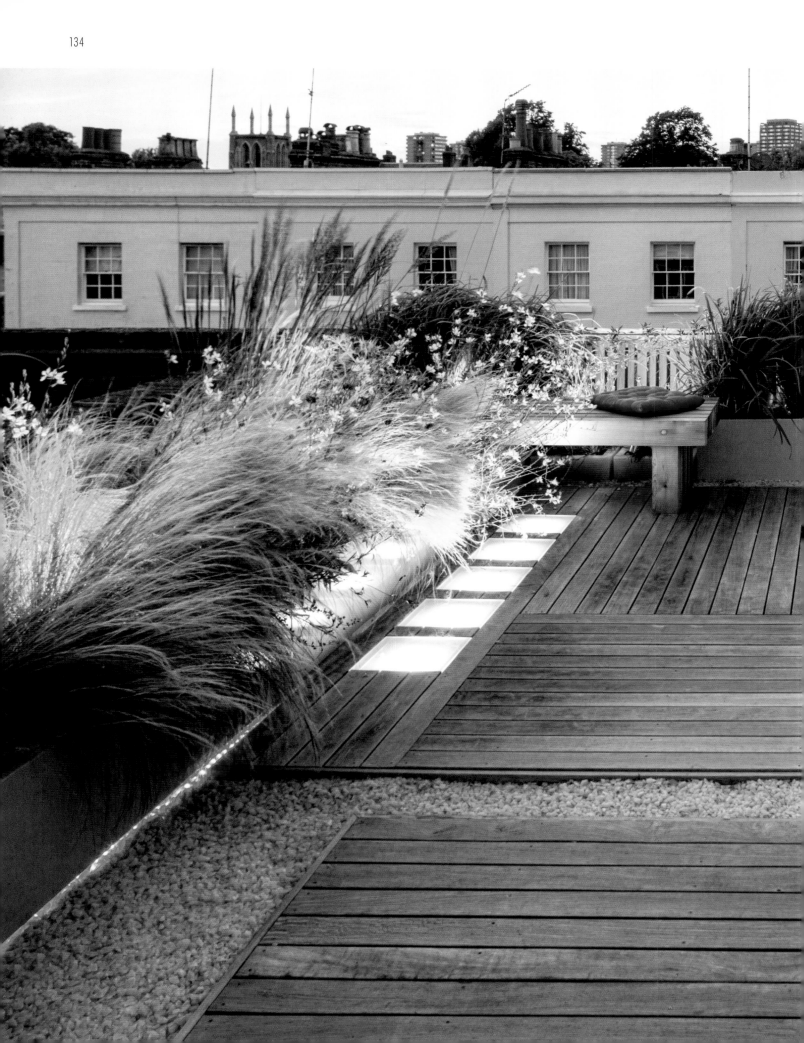

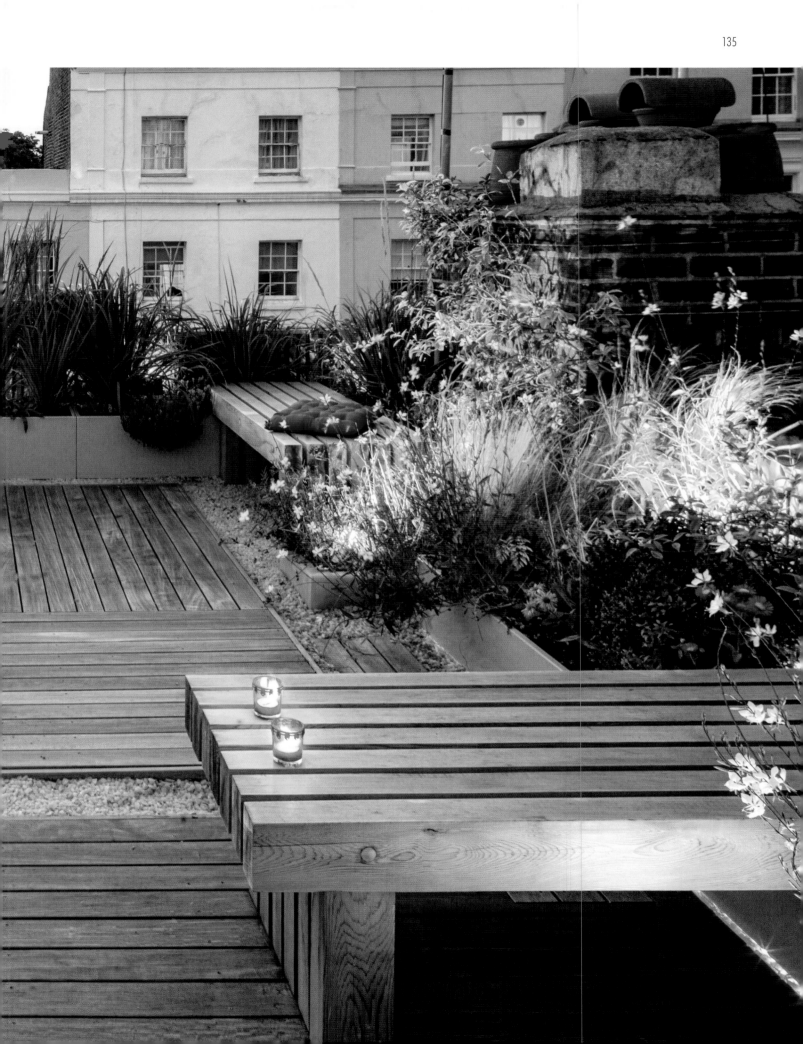

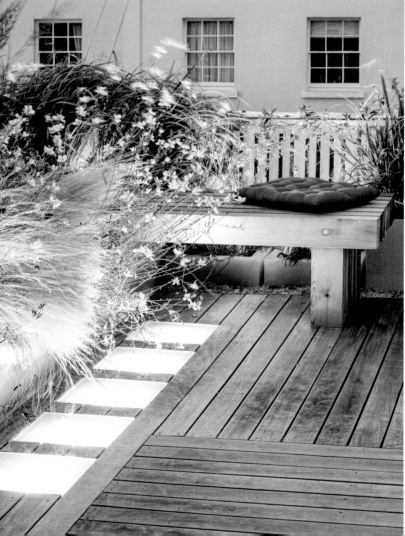

Previous page and bottom left:
Lighting extends the garden's usable time well into evening, after the owners have returned from work. Pink accent LED strip lighting defines the space, while soft natural spotlights highlight the planting.

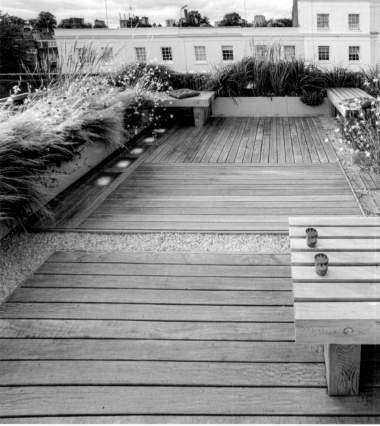

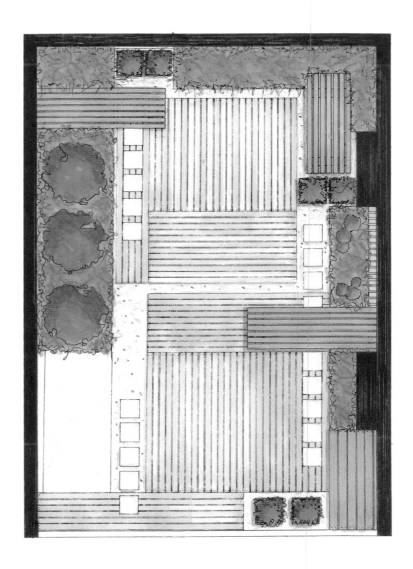

Climate
USDA Zone 9b (-3.9 to -1.1ºC / 25 to 30ºF)

Plants
Box (*Buxus sempervirens*)
Creeping thyme (*Thymus pulegioides* 'Purple Beauty')
Fleabane daisy (*Erigeron* 'Darkest of All')
Gaura (*Gaura lindheimeri* 'Whirling Butterflies')
German pink (*Dianthus carthusianorum*)
Korean feather reed grass (*Calamagrostis brachytricha*)
Macedonian scabious (*Knautia macedonica* 'Mars Midget')
Mexican feather grass (*Stipa tenuissima*)

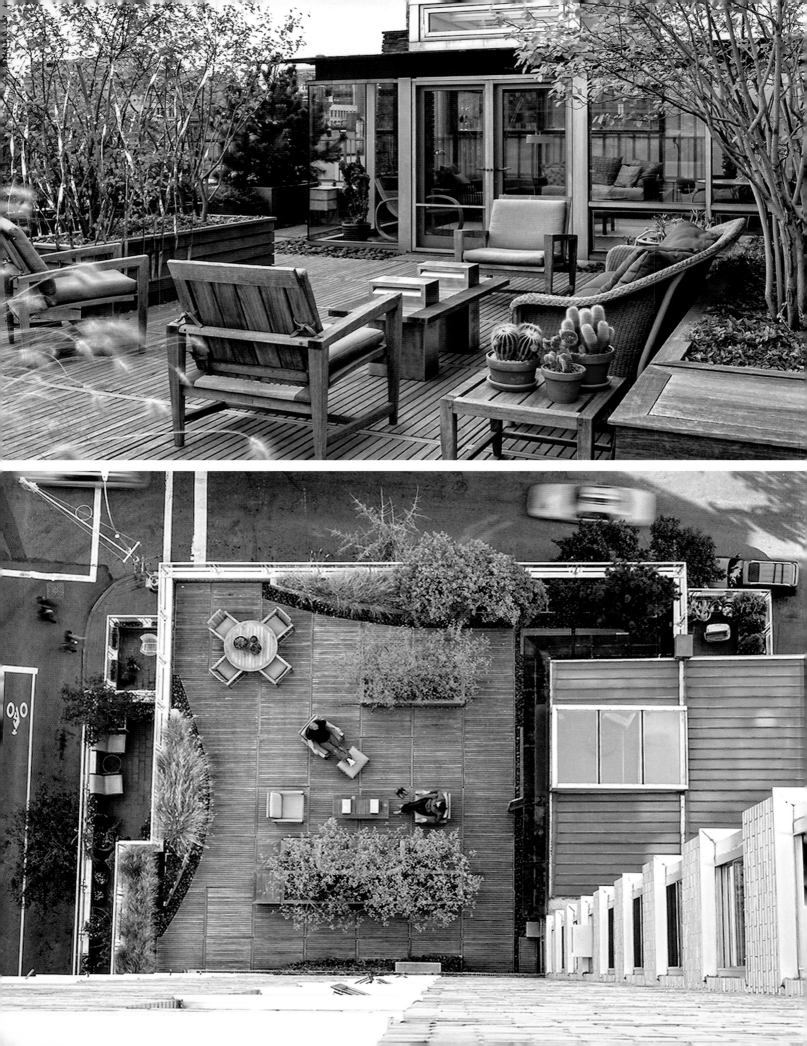

URBAN AERIE

New York City, USA

Category
Roof garden

Year
2013

Area
150 m² (1,600 sq. ft.)

Landscape Architecture
Dirtworks Landscape Architecture, PC

Architecture
Rogers Marvel Architects

Awards
ASLA New York Chapter

Photography
Andrew Bordwin, Dirtworks

Urban Aerie mitigates the most important challenge when designing a roof garden—the microclimate. At fifteen stories high, it is exposed to baking sunshine and glare during the summer and strong buffeting winds during the winter. With careful choice of hard and soft materials, the designers have managed to overcome these difficulties to produce a stylish city garden.

The garden contains separate spaces for eating, entertaining, and relaxing. All three spaces are brought together through the use of a single minimal palette of hard landscape materials. The natural hardwood decking is not only lightweight, but also minimizes glare from the sun during sunny days.

Curved raised beds guide the eye towards carefully framed views of the city, which can be seen over the minimalistic glass balustrade.

The plant palette has many New York native plants, which are more resilient than their non-native counterparts, while adding greater benefit for wildlife. Serviceberry has been used to break up the spaces and provide some mitigation from the wind, while winterberry and dwarf mountain pine are used to provide evergreen screening for year-round privacy.

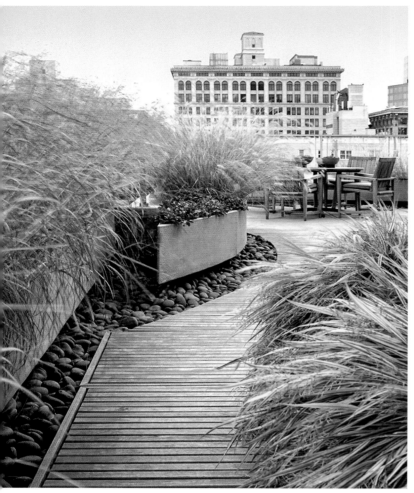

Left: The voluptuous Chinese fountain grass softens the crisp lines of the hard landscape, lending a cloud-like appearance to the edge of the garden.

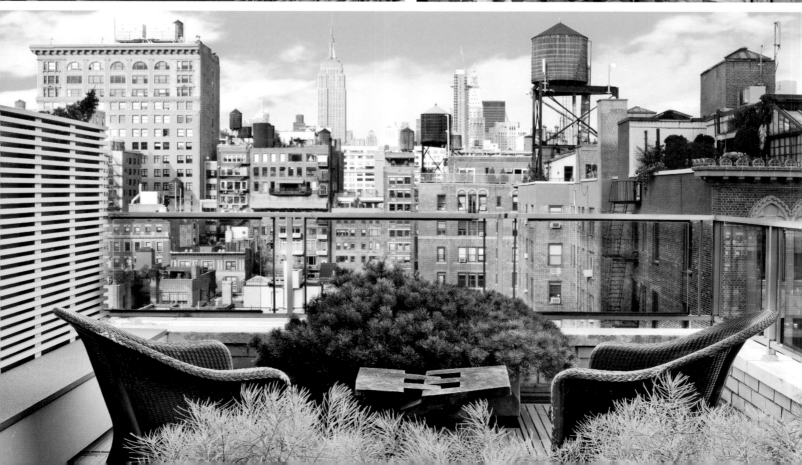

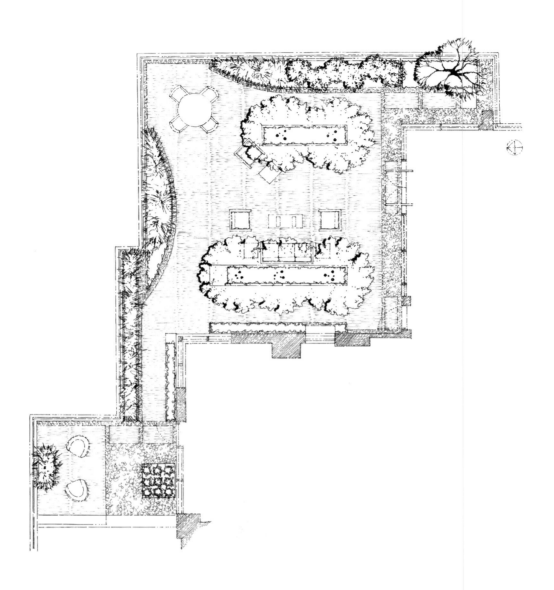

Climate
USDA Zone 7b (-15 to -12.2ºC / 5 to 10ºF)

Plants

TREES
Bosnian pine (*Pinus heldreichii*)
Dwarf mountain pine (*Pinus mugo*)
Serviceberry (*Amelanchier × grandiflora*)

SHRUBS
Arctostaphylos
 (*Arctostaphylos uva-ursi* 'Massachusetts')
Winterberry (*Ilex verticillata*)

PERENNIALS
Checkerberry (*Gaultheria procumbens*)
Chinese fountain grass (*Pennisetum alopecuroides*)
English ivy (*Hedera helix*)
Houseleek (*Sempervivum*)
Hubricht's bluestar (*Amsonia hubrichtii*)
Periwinkle (*Vinca minor*)
Red switch grass (*Panicum virgatum* 'Hänse Herms')

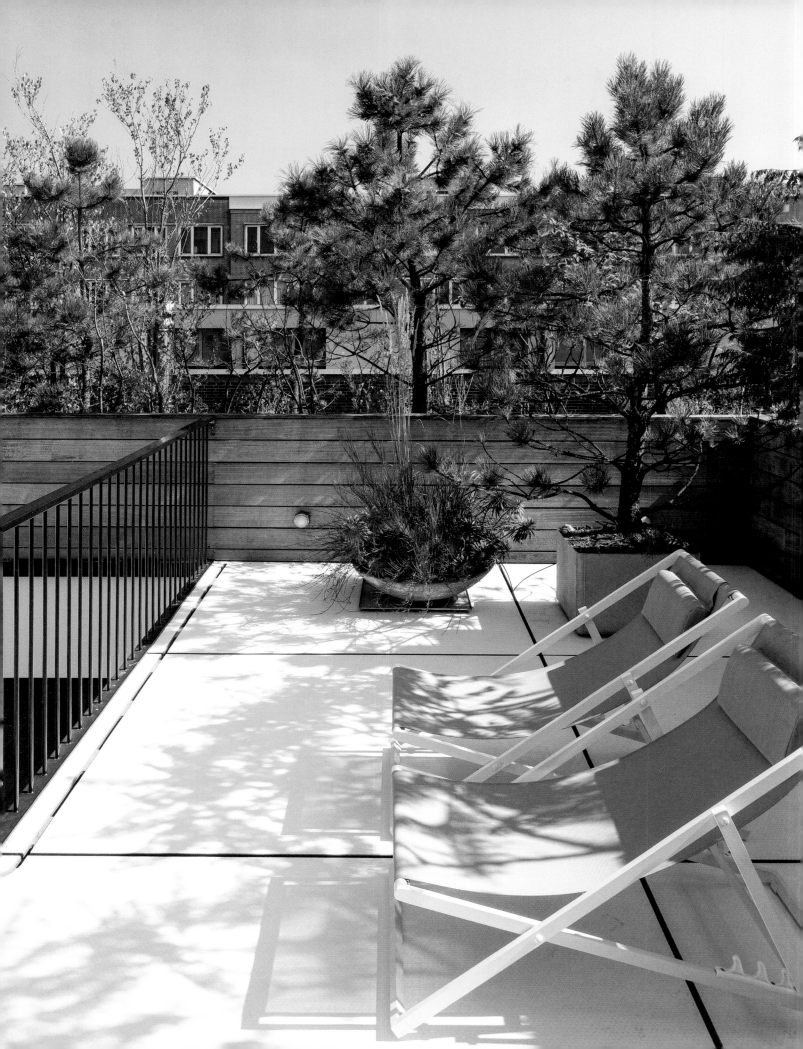

SPAIN ON THE ROOF

Antwerp, Belgium

Category
Roof garden

Year
2008

Area
90 m² (970 sq. ft.)

Landscape Architecture
Bart & Pieter Garden Architects

Architecture
Filip Deslee

Photography
Bart Kiggen, Studio Coffeeklatch

The roof terrace at Spain on the Roof in Antwerp is a plain roof deck inspired by the Mediterranean flora of Menorca. Spatially, the terrace is modestly simple with one central area containing a seating and dining area, surrounded by wooden planters with a mixture of deciduous and evergreen planting for screening.

The floor is decked in a pure white synthetic material designed for boats. Together with the white of the furniture and the sun awning, it creates a very contemporary minimal aesthetic that is contrasted by the varying textures of the planting.

The planting has been carefully selected to withstand the Belgium winter while retaining an exotic appeal. Species such as yucca and Mediterranean spurge are both hardy Mediterranean natives, while plants like stag's horn sumach and broom have a Mediterranean appearance to them. The small scale of dwarf mountain pine increases the feeling of space on the terrace, while also performing a screening role through its evergreen foliage.

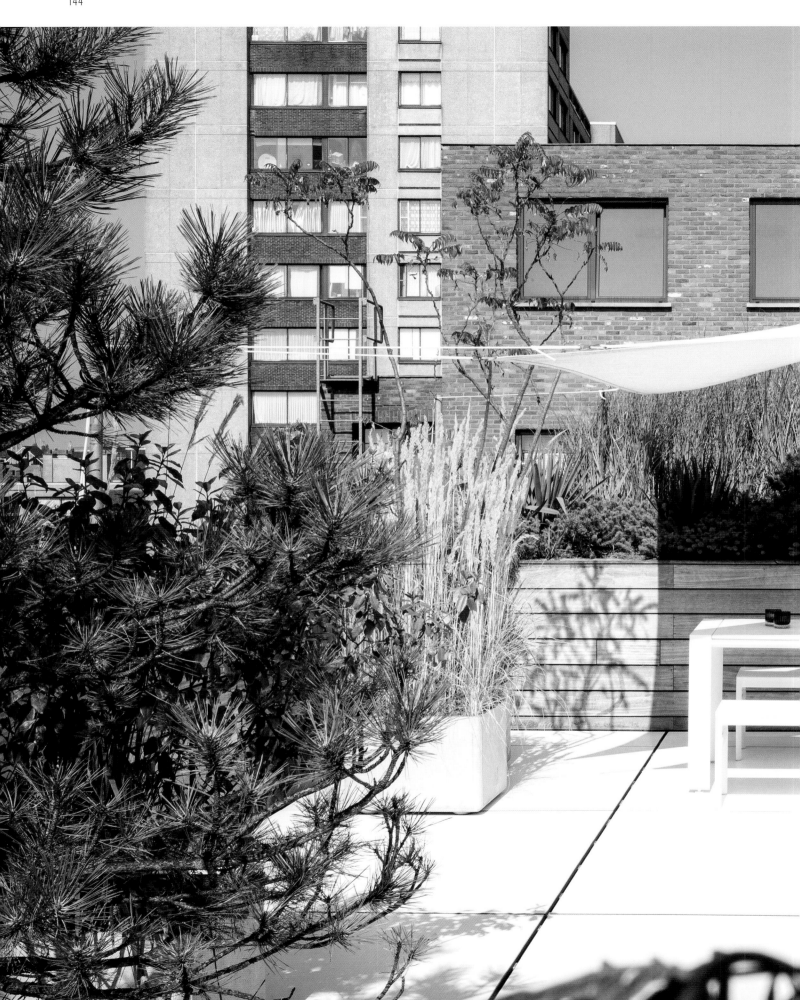

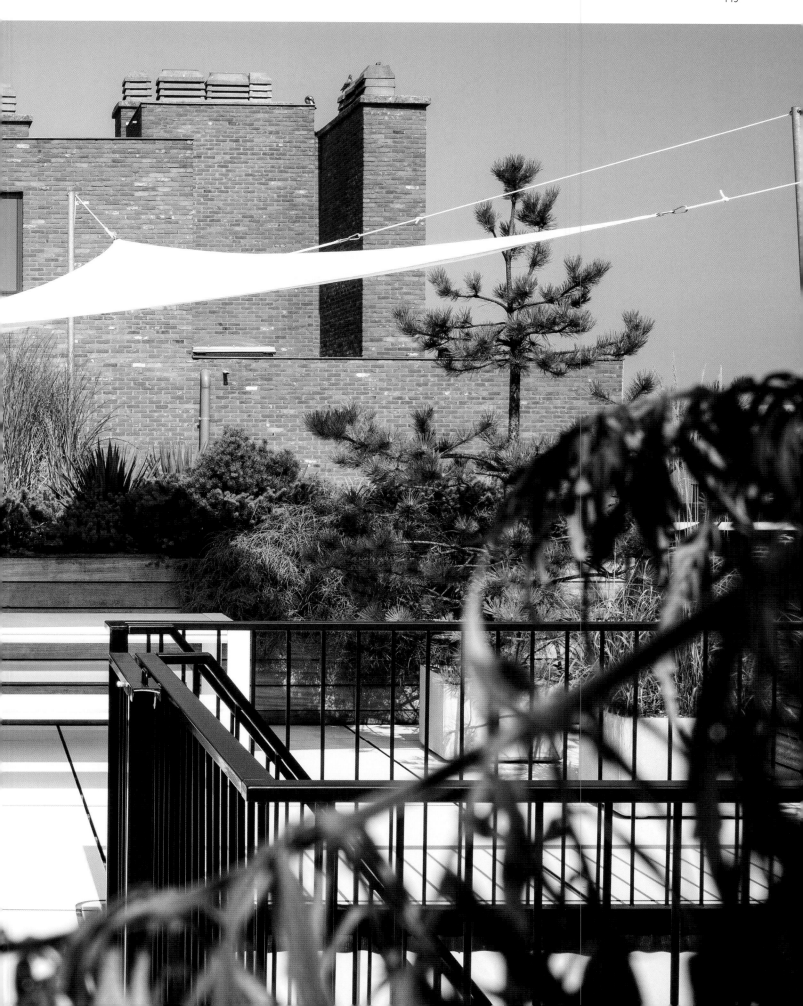

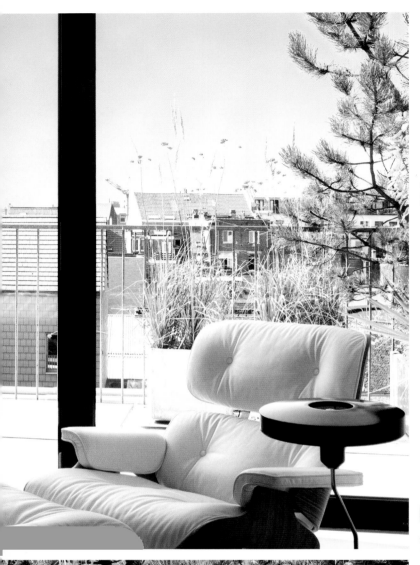

Opposite: The beautiful architectural quality of stag's head sumach's downy branches is silhouetted against the sky.

Bottom: The upright flowers of the feather-reed grass cut vertical lines through the horizontal forms of the immature Scot's pine.

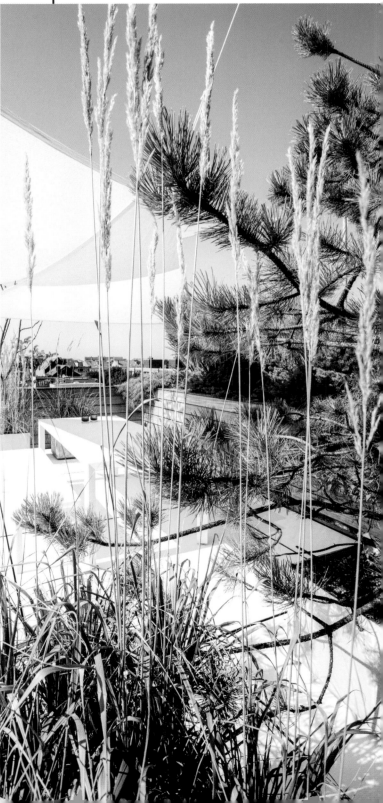

Climate
USDA Zone 8b (-9.4 to -6.7°C / 15 to 20°F)

Plants
Broad-leaved glaucous spurge (*Euphorbia myrsinites*)
Broom (*Cytisus* × *praecox*)
Dwarf mountain pine (*Pinus mugo*)

Feather-reed grass (*Calamagrostis* × *acutiflora*)
Mediterranean spurge
 (*Euphorbia characias* subsp. *wulfenii*)
Scot's pine (*Pinus sylvestris*)
Stag's horn sumach (*Rhus typhina*)
Yucca (*Yucca gloriosa*)

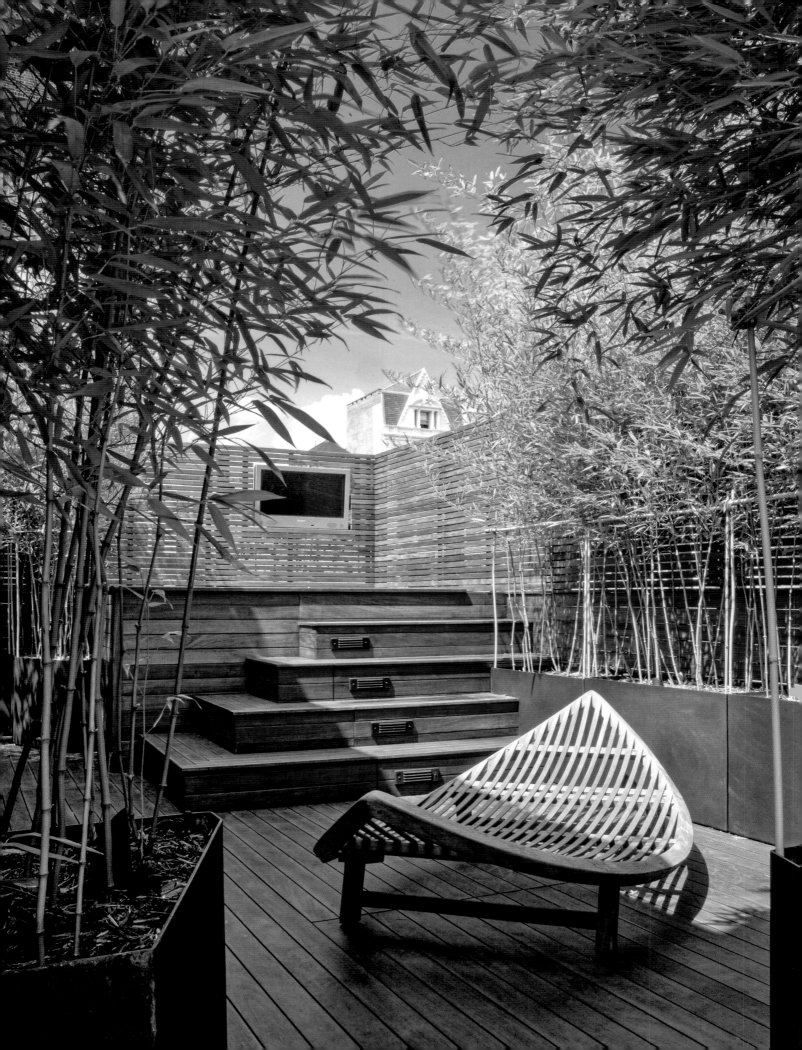

CROSBY STREET ROOFTOP TERRACE

New York City, USA

Category
Roof garden

Year
2008

Area
250 m² (2,700 sq. ft.)

Landscape Architecture
Gunn Landscape Architecture, PLLC

Architecture
Deborah Berke and Partners

Photography
Alexander Herring

This Crosby Street rooftop terrace provides a tranquil haven above the hustle and bustle of New York's Soho through the artful blending of Eastern-influenced aesthetics and sharp contemporary lines.

The roof garden contains everything you could wish for in a contemporary garden, including a kitchen, entertaining area, and even a spa. These separate areas are unified through the use of one single material palette for the whole garden. Natural materials such as ipe wood, Yangtzee limestone, and smooth beach pebbles contrast with the man-made materials of the surrounding city to create a sense of calmness and serenity.

A lawn of artificial grass provides soft relief to the limestone paving and is virtually maintenance free and also eliminates the need for irrigation on the roof.

The planting of Himalayan birch, Japanese maple, and Bisset's bamboo all provide architectural structure, while having light foliage to create gentle movement and dappled shade. The inclusion of an evergreen juniper hedge on one side of the site provides privacy from neighboring properties.

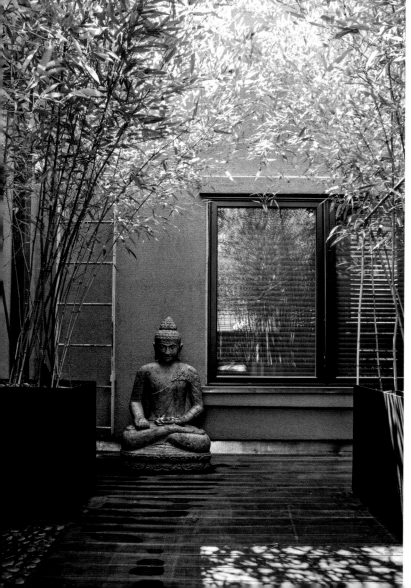

Opposite: The choice of high-end materials and attention to detail at the design and implementation stages affords this garden a luxurious atmosphere.

Below: Soft cushions blur the lines between interior and exterior.

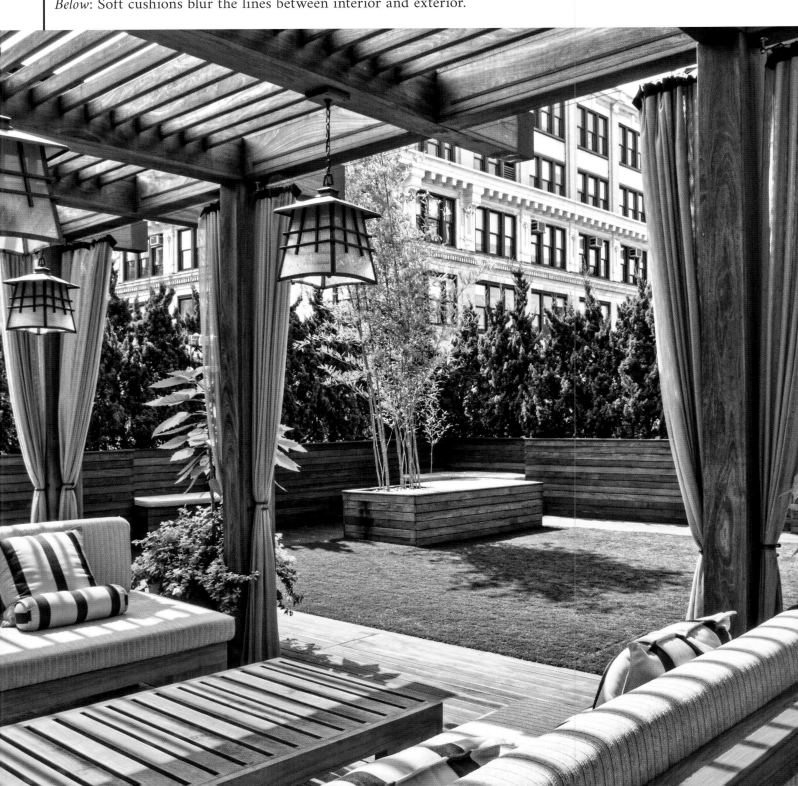

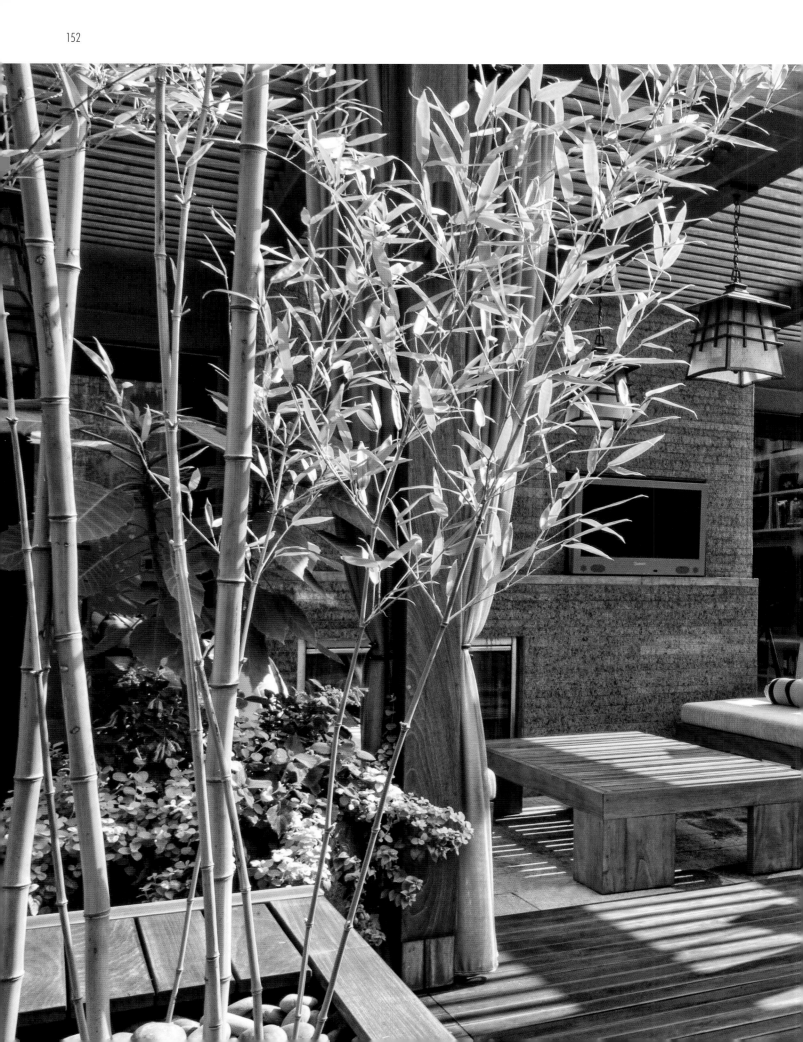

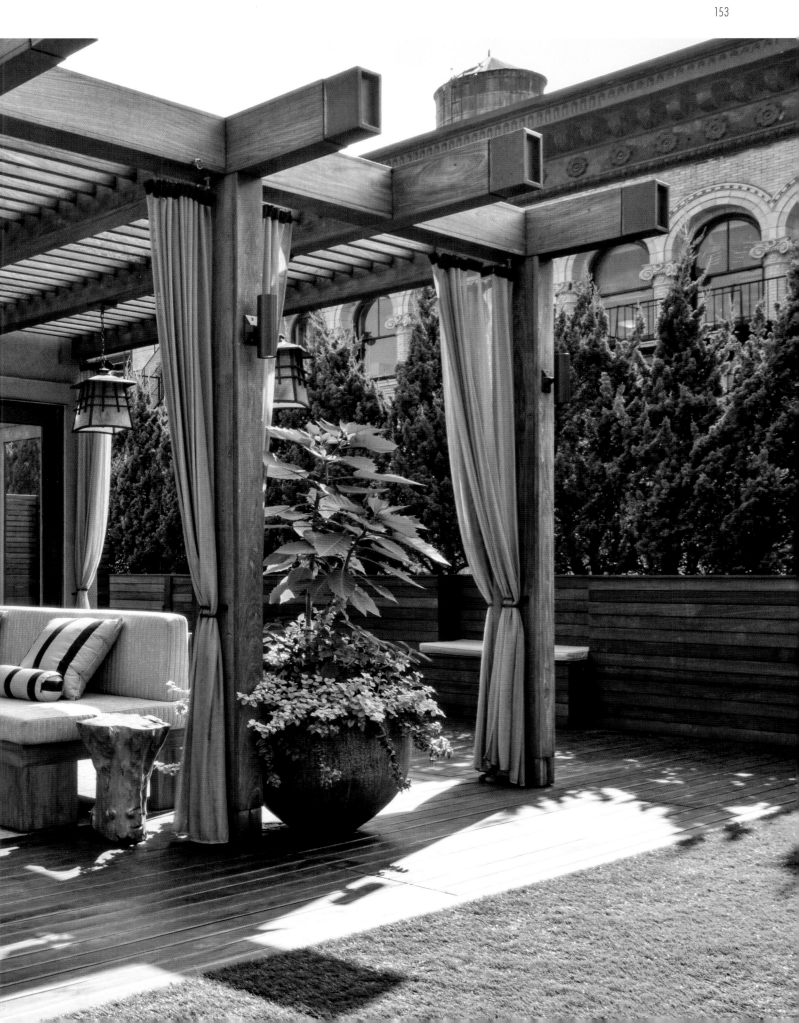

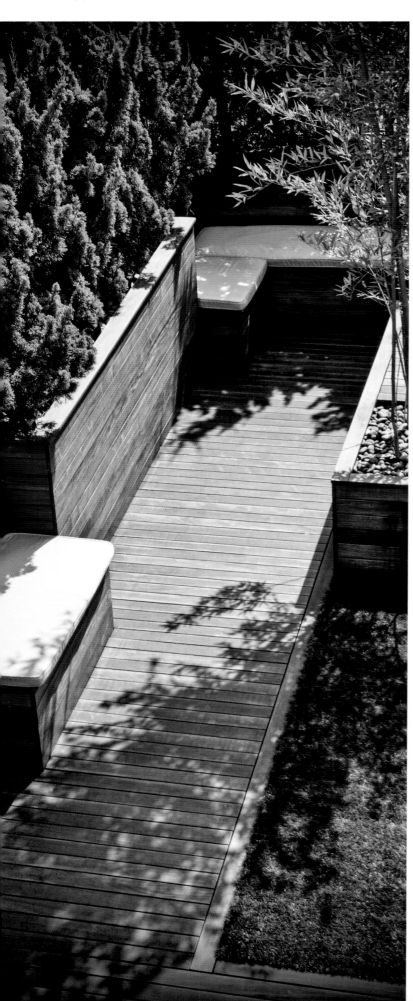

Left: Secluded seating nestled between the junipers and bamboo offers privacy and a chance to escape.

Below: Repeating rhythmic patterns of limestone paving, hardwood decking, and plant containers draw the eye down to the lawn area beyond.

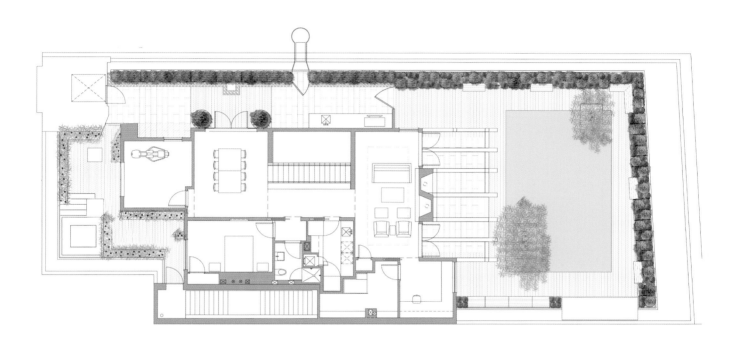

Climate
USDA Zone 7b (-15 to -12.2°C / -5 to 10°F)

Plants
Bisset's bamboo (*Phyllostachys bissetii*)
Cedar (*Thuja*)
Chinese juniper (*Juniperus chinensis* 'Robusta Green')
English ivy (*Hedera helix*)
Himalayan birch (*Betula utilis*)
Japanese maple (*Acer palmatum* 'Sango-Kaku')

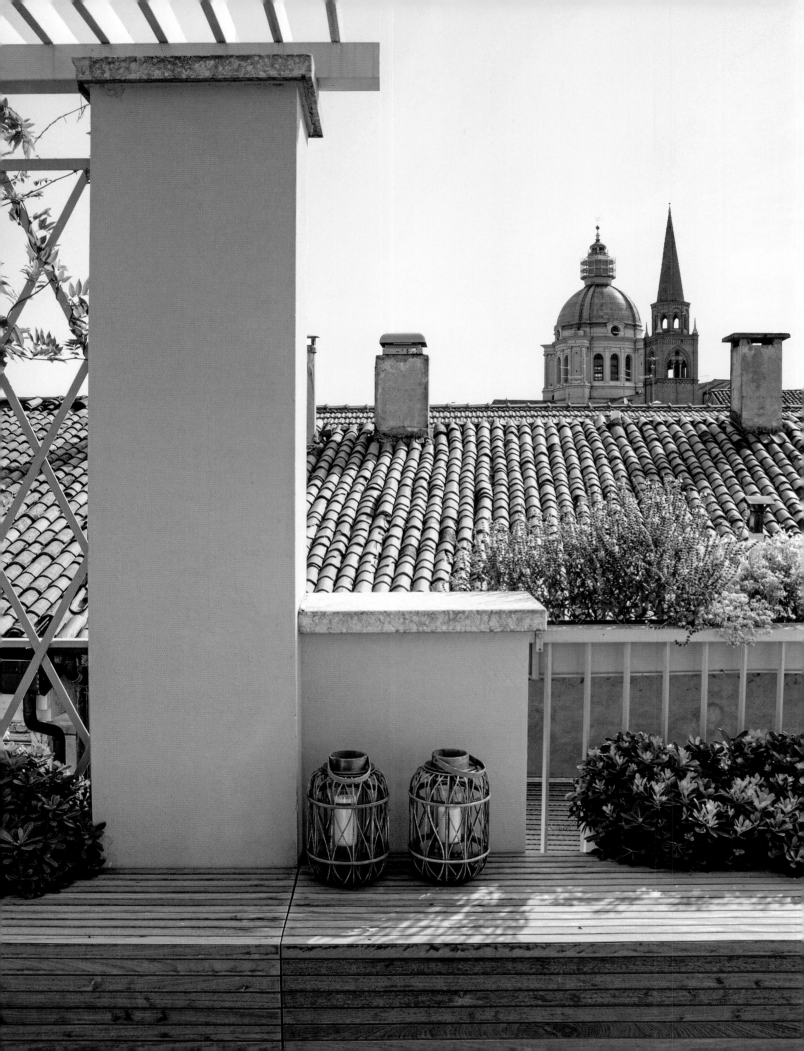

OUTSIDE URBAN

Mantua, Italy

Category
Roof garden

Year
2013

Area
78 m² (840 sq. ft.)

Architecture
Archiplan Studio Associate

Photography
Martina Mambrin

The timeless elegance of Outside Urban perfectly suits its seventeenth-century rooftop setting, providing a beautiful minimalist garden from which to enjoy the expansive views of the city of Mantua and it's classic Italian architecture.

This simple roof terrace has the ideal functionality of a family garden with separate areas for entertaining, sitting, dinning, and relaxing all unified by a long ipe wooden bench that also acts as shelving for cushions and candles.

Adjacent to the house is a simple white pergola that provides a place to entertain. Chinese wisteria is encouraged to grow over the pergola which will, in time, provide shade during hot summer days and an exuberance of pendulous flowers in spring.

The clean contemporary lines of the ipe deck, long bench, and pergola complement the minimal color palette of white and natural wood, marrying together contemporary and classic Mediterranean styles.

Planting is also of a minimal white palette with hydrangea, Chinese wisteria, and star jasmine being the only structural planting among few potted herbaceous plants.

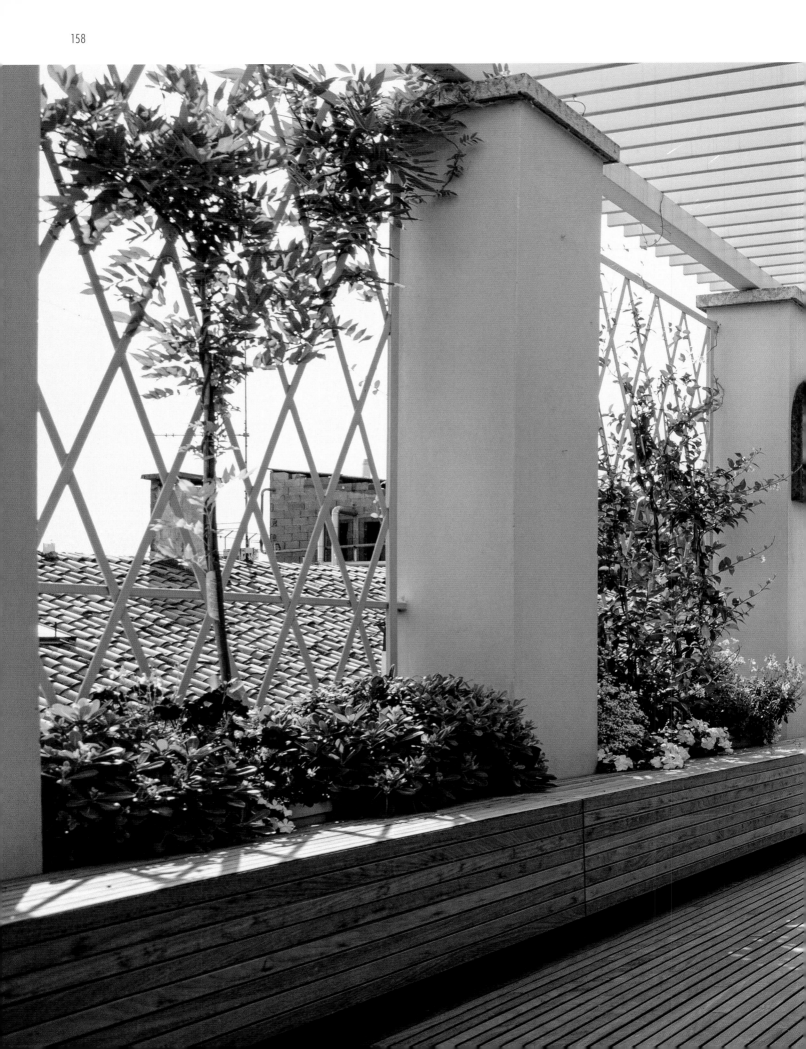

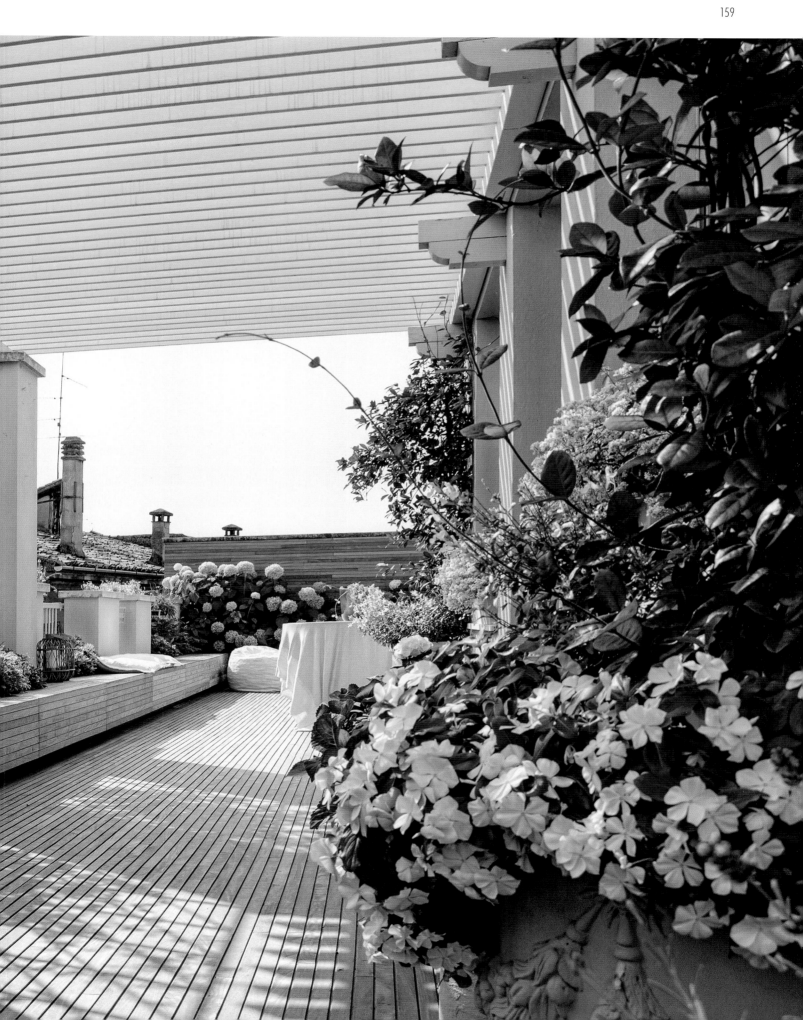

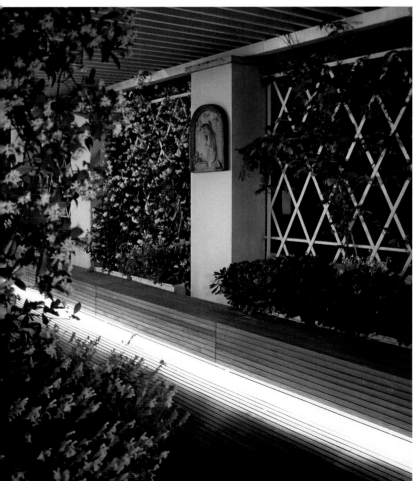

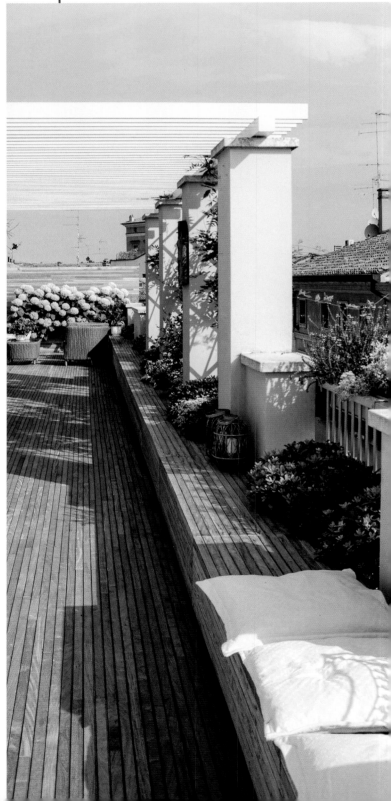

Bottom left: The only artificial lighting in the garden comes from LED strips under the long bench, which gives the impression of the whole bench elegantly floating. Other lighting comes from candles, adding the garden's timeless appeal.

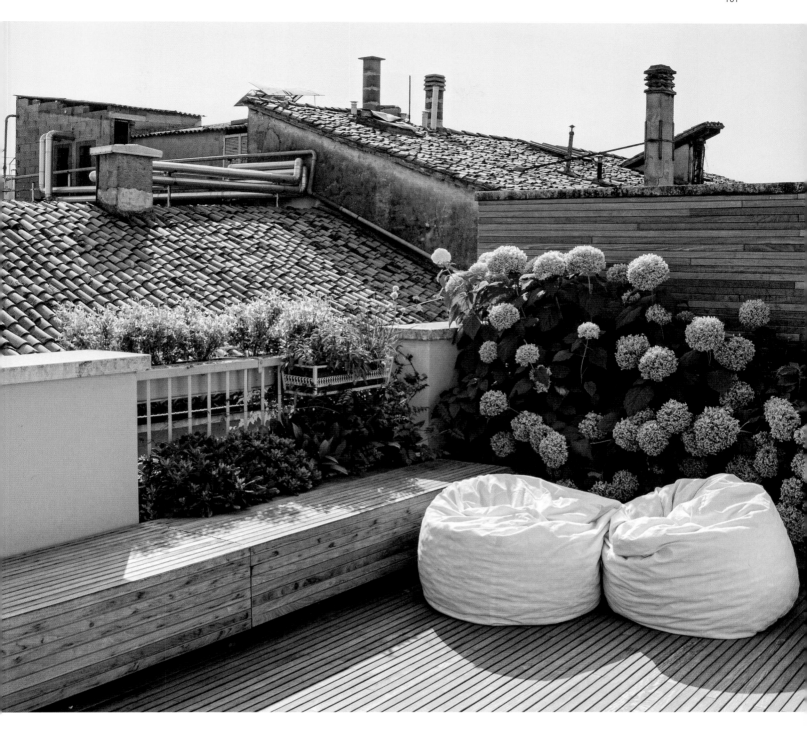

Climate
USDA Zone 8b (-9.4 to -6.7ºC / 15 to 20ºF)

Plants
Chinese wisteria (*Wisteria sinensis*)
Hydrangea (*Hydrangea*)
Star jasmine (*Trachelospermum jasminoides*)
Herbaceous potted plants

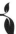

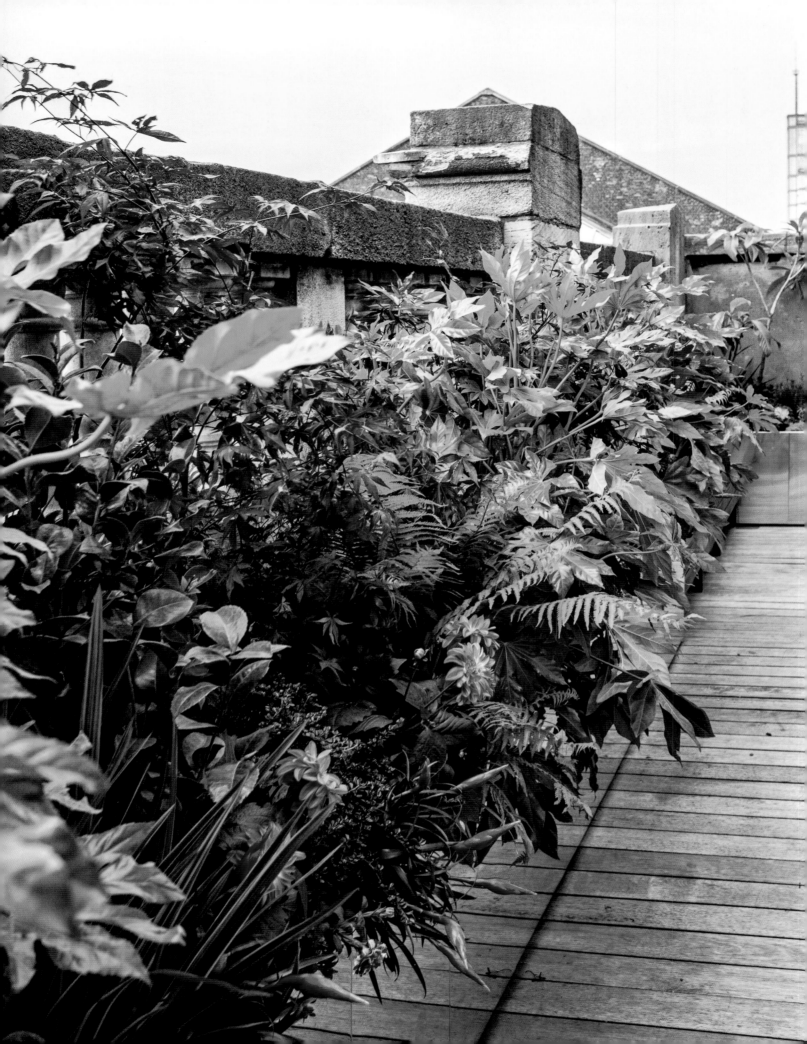

COPACABANA DE LUXE

Antwerp, Belgium

Category
Roof garden

Year
2014

Area
12.6 m² and 35 m²
(136 sq. ft. and 377 sq. ft.)

Landscape Architecture
Bart & Pieter Garden Architects

Photography
Bart Kiggen, Studio Coffeeklatch

The two roof terraces of Copacabana de luxe create an exotic atmosphere full of year-round flourishing attractions in a challenging location and climate.

The garden is split into two small terraces that flank the property's kitchen. On one side lies a narrow terrace of 1.4 x 9 meters (4.6 x 30 feet) in which the owners have created a long raised planter clad in copper. On the other side of the kitchen lies a larger terrace of 5 x 7 meters (16 x 23 feet), with raised planters of black clad aluminum.

The planting in both planters is mostly hardy evergreen, providing a lush, tropical feeling that lasts all year round, despite the location's northern temperate climate. The copper planter is used mainly as a visual backdrop to be enjoyed from within the property through its large windows. The large palmate leaves of the Japanese aralia especially evoke a tropical feel.

On the larger terrace, the black planters are arranged together so as to have the appearance of one continuous planter. Here a Burkwood osmanthus hedge provides some structure, while loquat loosely breaks up the space with their thick waxy foliage.

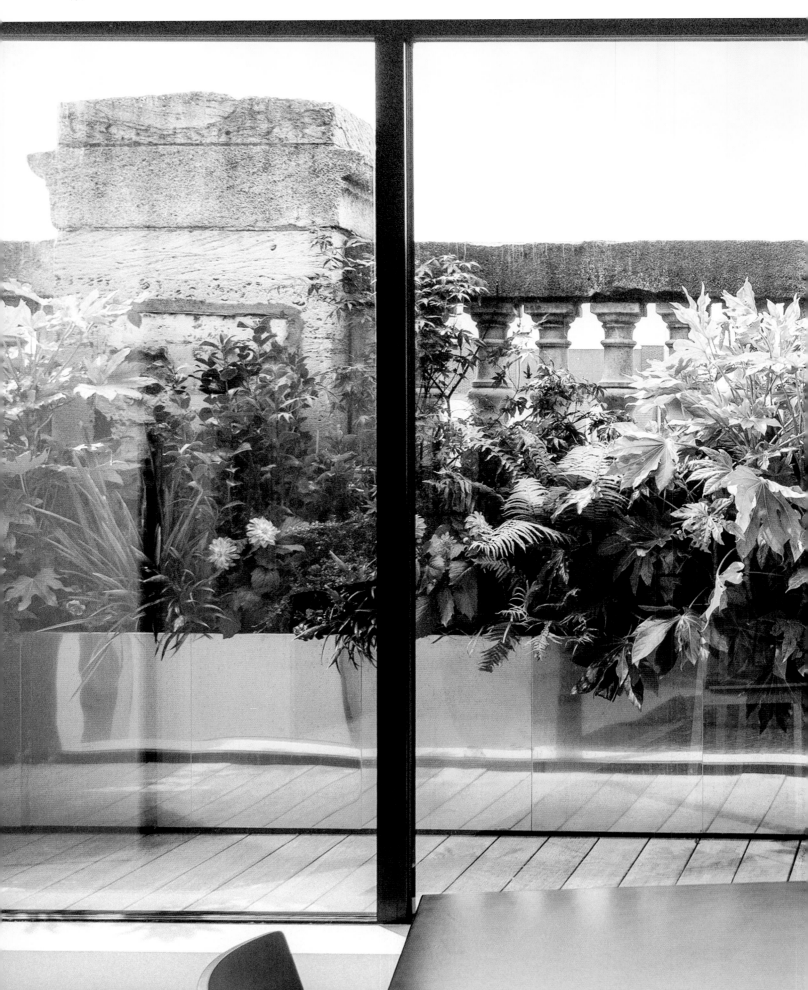

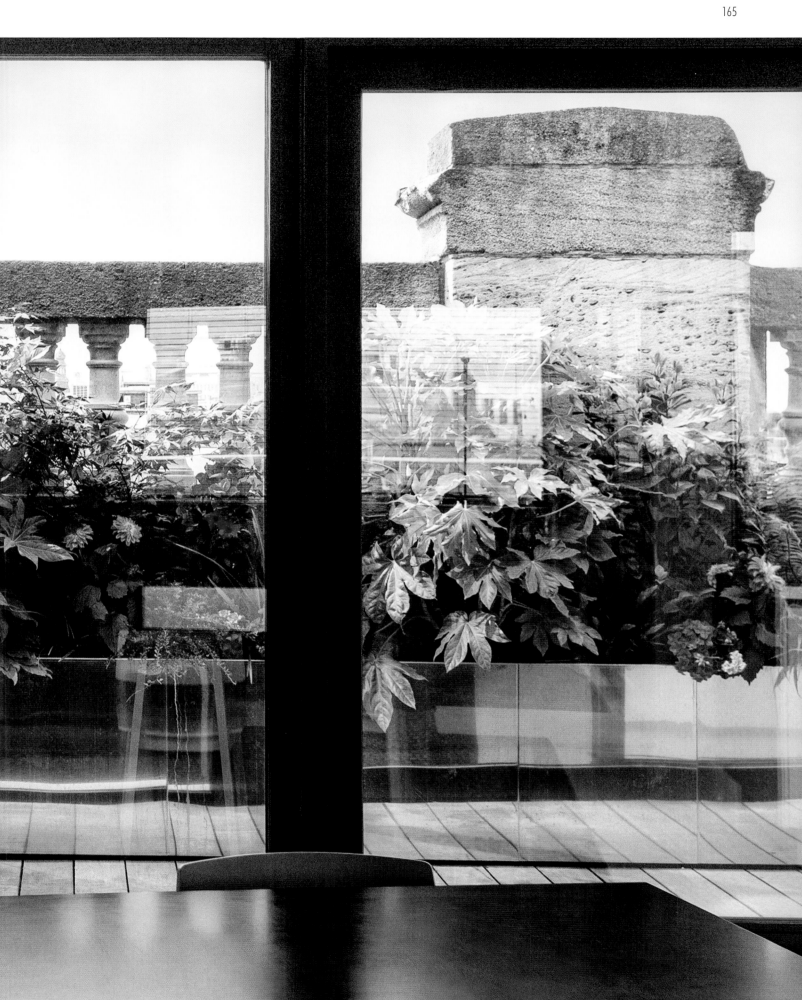

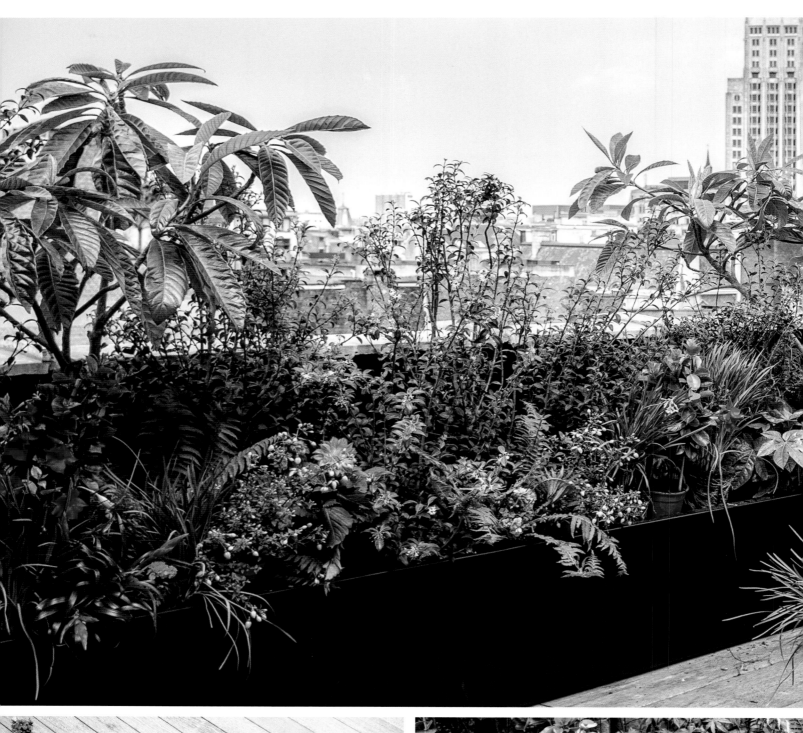

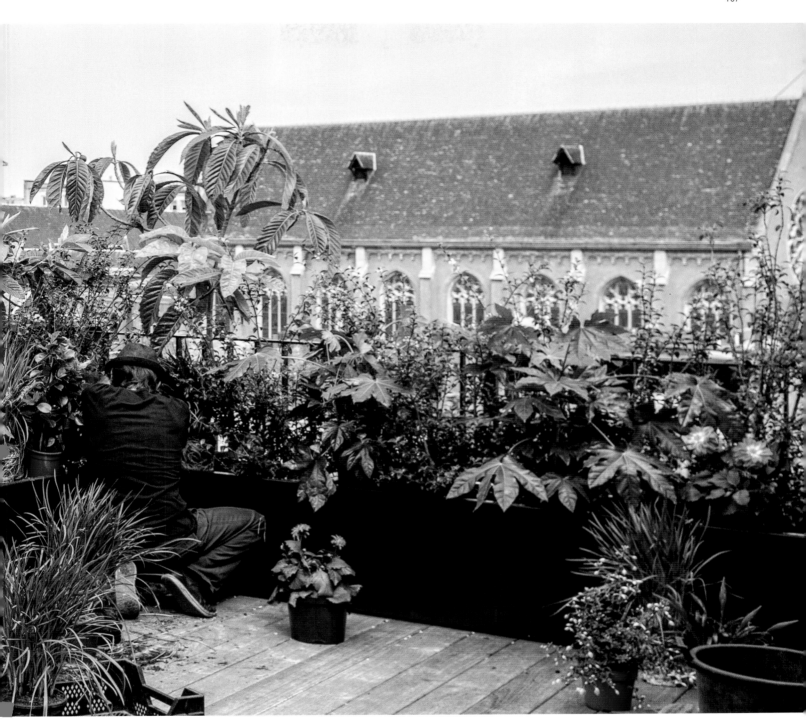

Climate
USDA Zone 8b (-9.4 to -6.7ºC / 15 to 20ºF)

Plants
Bromelia (*Bromelia*)
Burkwood osmanthus (*Osmanthus × burkwoodii*)
Dahlia (*Dahlia*)
Fuchsia (*Fuchsia*)

Loquat (*Eriobotrya japonica*)
Japanese aralia (*Fatsia japonica*)
Japanese camellia (*Camellia japonica*)
Japanese maple (*Acer palmatum* 'Atropurpureum')
Male fern (*Dryopteris filix-mas*)
New Zealand flax (*Phormium tenax purpureum*)
Rockspray (*Cotoneaster horizontalis*)

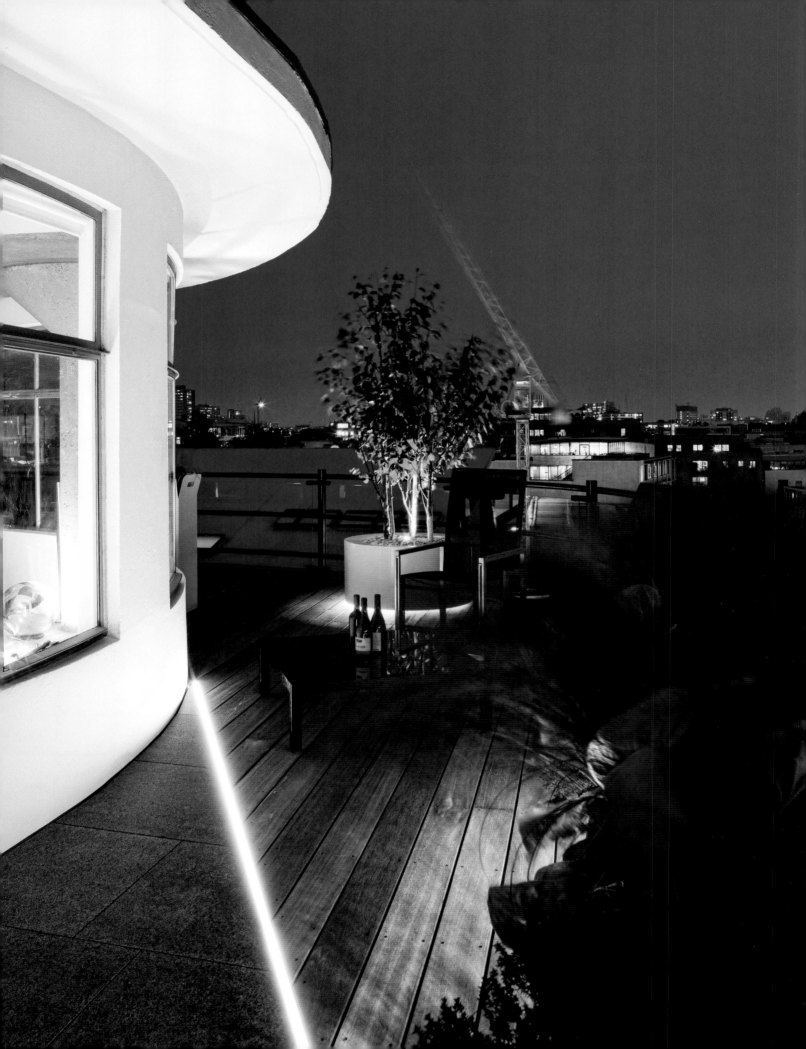

ZIGGURAT ROOFTOP TERRACE

London, United Kingdom

Category
Roof garden

Year
2013

Area
30 m² (320 sq. ft.)

Landscape Architecture
MyLandscapes Garden Design –
 Amir Schlezinger

Photography
Clive Nichols, Amir Schlezinger

This cutting-edge contemporary roof terrace is a beautifully conceived and expertly executed design that displays attention to detail throughout the design process and construction.

The Art Deco building of Ziggurat in Clerkenwell, London demands a competent design solution for which the terrace exhibits high-end materials and strong, masculine lines. The dominating lines of the balau hardwood deck deliberately cut across the space, visually pushing the boundaries back, making the area appear larger than it really is. Where the deck meets the textured crystalline black granite paving the threshold is accented by inset LED lighting.

Two planters have been especially designed for the terrace adding a touch of bespoke luxury. The planters contain a mix of herbaceous species, such as bergenia and mountain flax. A large tree planter containing a multi-stemmed red birch has been designed with castors set into a recessed base so that it can be easily moved, offering versatility in this small space. The underside of the planter is also lit by LEDs. The overall effect of the lighting makes a chic and stylish contemporary entertaining space, perfect for the young city dweller.

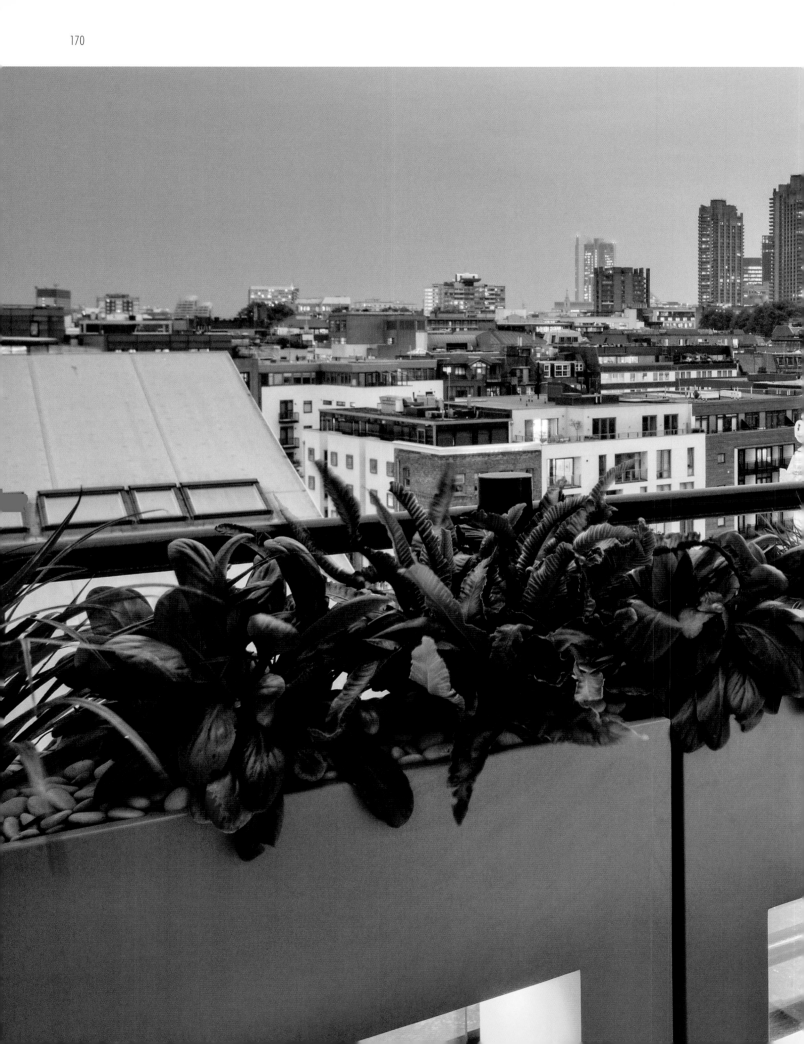

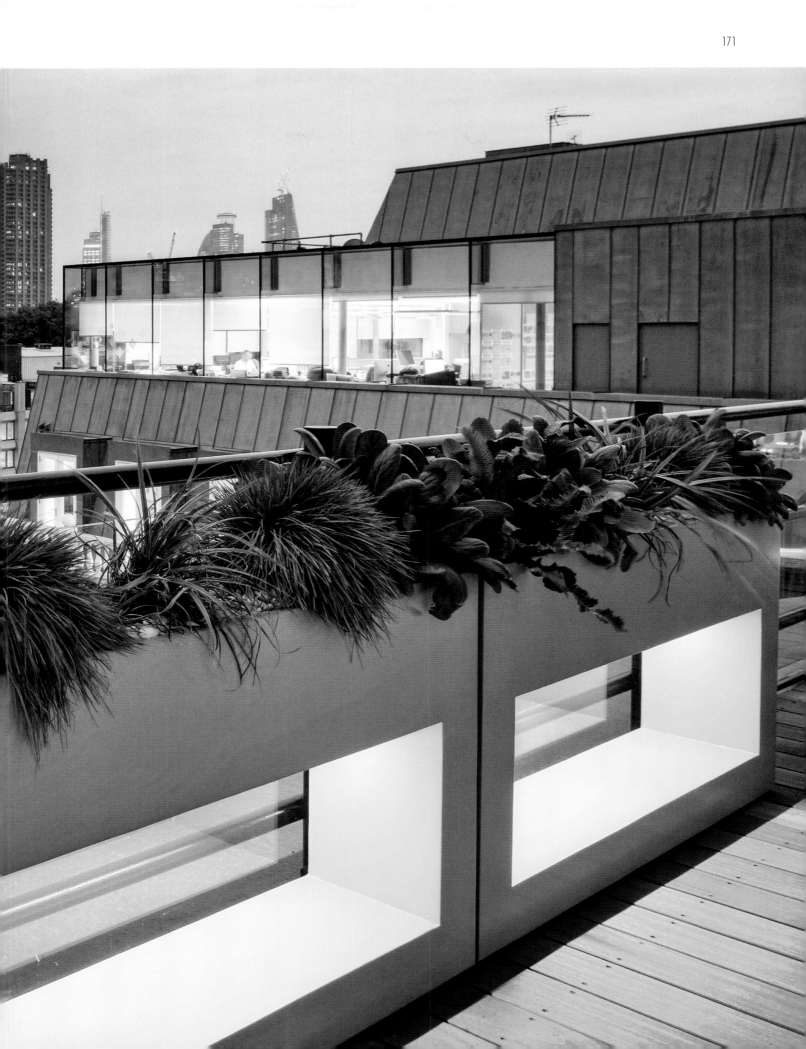

Previous page: The bespoke planters are equipped with LED lighting underneath, so that they mimic the light and forms of the cityscape beyond.

This page: The stunning attention to detail in the construction creates a terrace of high quality.

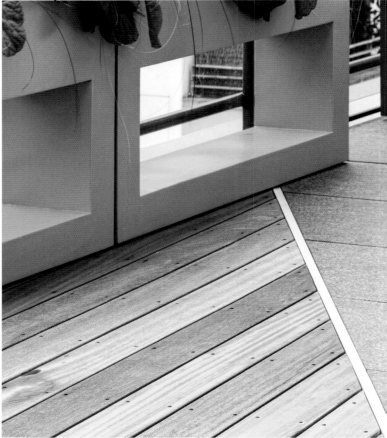

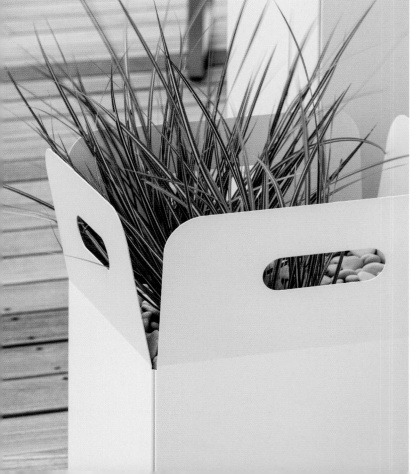

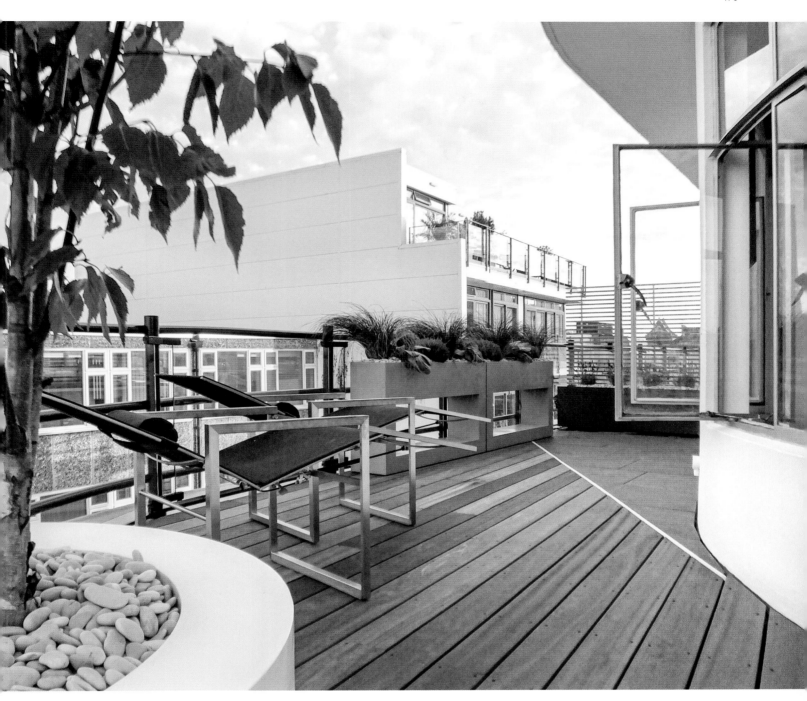

Climate
USDA Zone 9b (-3.9 to -1.1°C / 25 to 30°F)

Plants
Bush flax (*Astelia nervosa* 'Red Devil')
Chilean iris (*Libertia ixioides* 'Goldfinger')
English lavender
 (*Lavandula angustifolia* 'Twickel Purple')
Grey-blue koeleria (*Koeleria glauca*)
Hairy bergenia (*Bergenia ciliata* 'Dumbo')

Hart's tongue fern (*Asplenium scolopendrium*)
Heart-leaf bergenia
 (*Bergenia cordifolia* 'Bressingham White')
Mountain flax
 (*Phormium cookianum* 'Cream Delight')
Orange New Zealand sedge
 (*Carex testacea* 'Prairie Fire')
Red birch (*Betula albosinensis* 'Fascination')
Thyme (*Thymus vulgaris* 'Compactus')

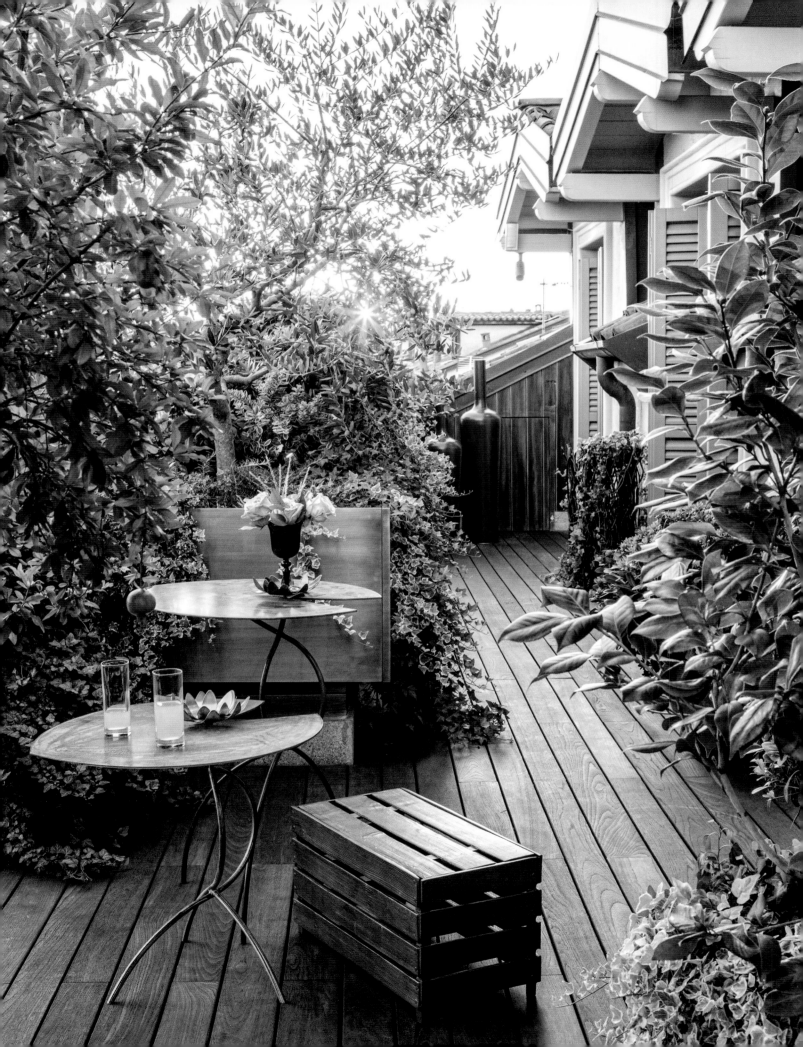

MILAN
ROOFTOP TERRACE

Milan, Italy

Category
Roof garden

Year
2015

Area
100 m² (1,075 sq. ft.)

Landscape Architecture / Architecture
Patrizia Pozzi Landscape Architect

Photography
Matteo Carassale

This is an exciting and dynamic cruciform roof terrace that blends modern and traditional elements to create a contemporary terrace that respects its historic environment.

A series of small intimate spaces have been carefully crafted to extend the living space of the apartment to the outside. Rustic materials like the dark wood of the decking and recycled wooden crate furniture create an instant sense of age in this newly-built roof terrace.

A covered alcove has been painted with the skyline of the old city on two sides, while on the third a stunning feature wall has been created with sheets of bronze that are back-lit, washing the area in a sumptuous orange glow. The sheets of bronze have been given different finishes from highly polished through satin to matte effect, adding depth to the composition.

The planting is rich and textural with many mature plants having been installed, so that the terrace instantly blends in with the historic architecture around it. The plants have been selected to minimize maintenance with the majority of them not needing pruning. Plants like heavenly bamboo and the prostrate rosemary are forms of their parent plants that are lower growing and won't dominate the space.

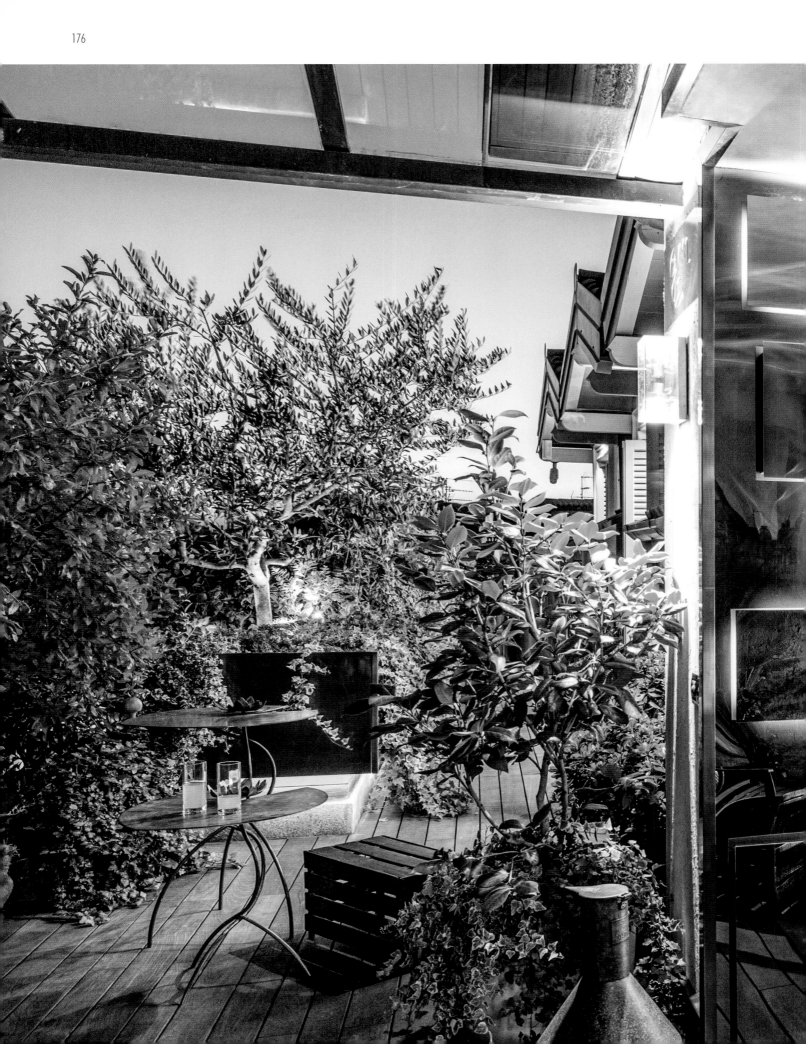

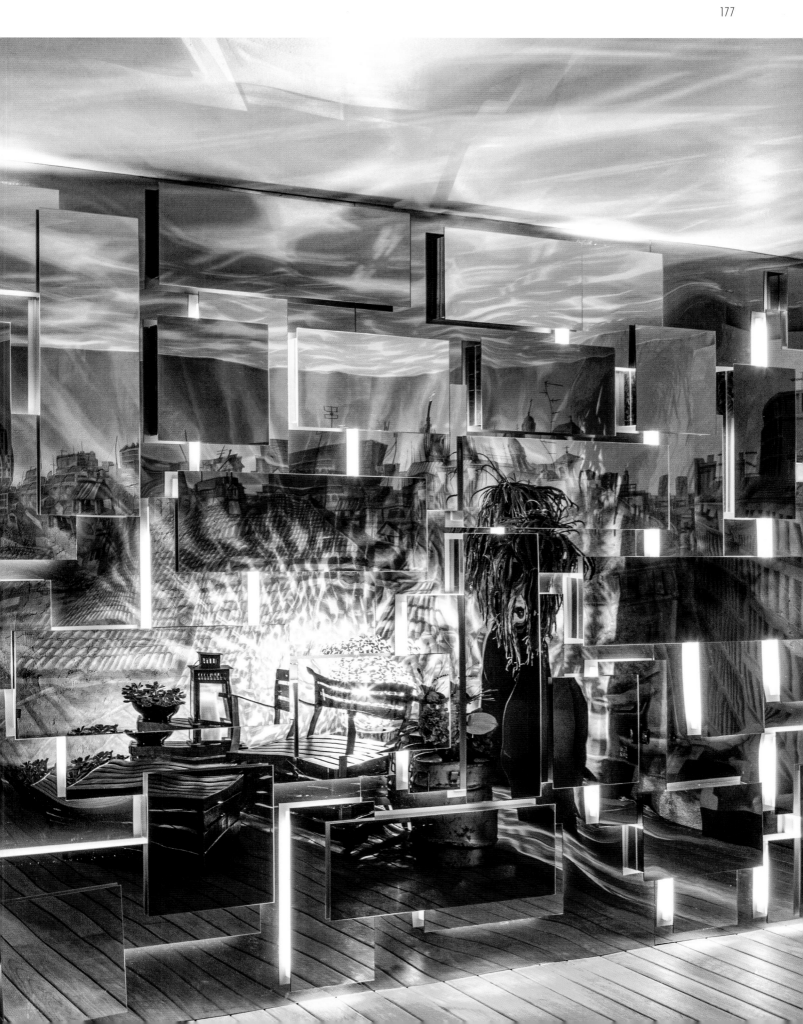

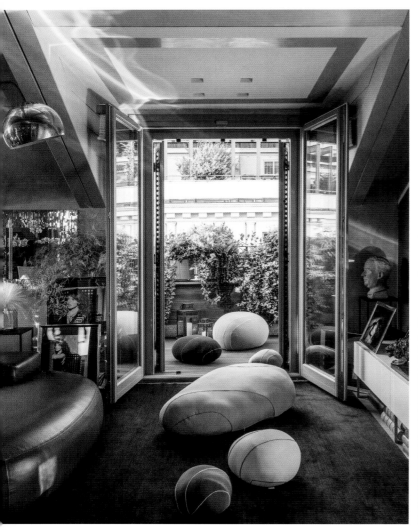

Bottom: A fashionable retrospective aesthetic has been created through the use of a sepia tone to the city backdrop and the shabby chic recycled and repurposed furniture and found objects.

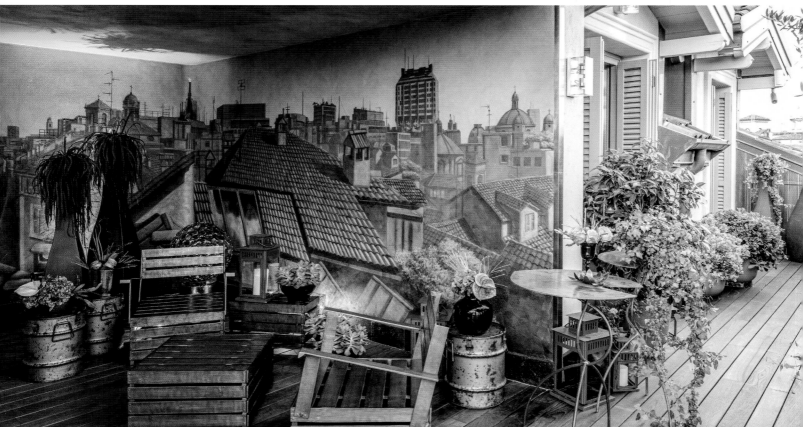

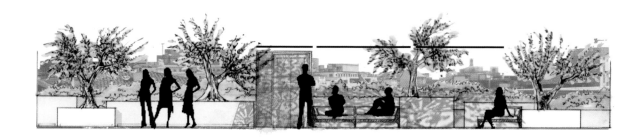

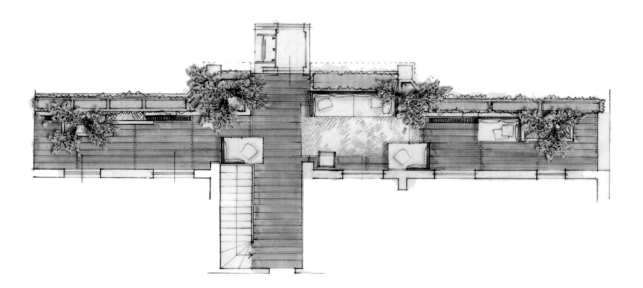

Climate
USDA Zone 9a (-6.7 to -3.9ºC / 20 to 25ºF)

Plants
Confederate jasmine (*Trachelospermum jasminoides*)
Heavenly bamboo (*Nandina domestica* 'Fire Power')
Japanese cheesewood (*Pittosporum tobira*)
Olive (*Olea europaea*)
Prostrate rosemary (*Rosmarinus officinalis* 'Prostratus Group')

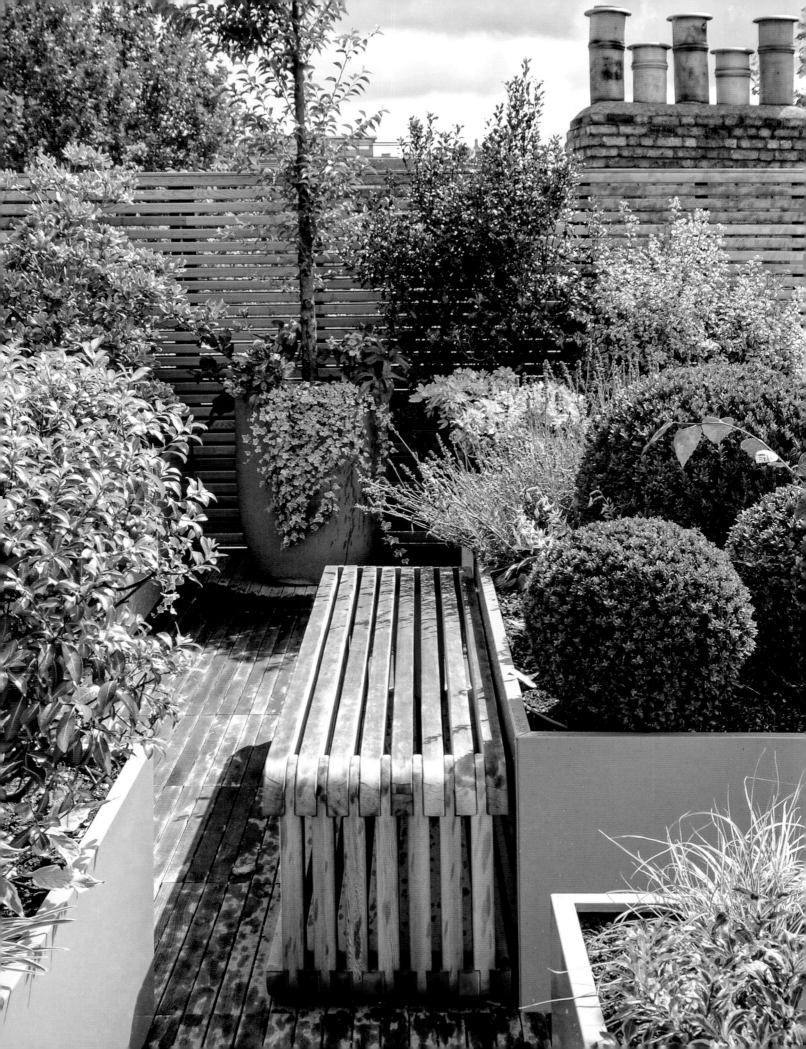

THAMES ROOF TERRACE

London, United Kingdom

Category
Roof garden

Year
2014

Area
255 m² (2,750 sq. ft.)

Landscape Architecture
Modular.London

Photography
Modular.London and owner

The Thames Roof Garden in London is a multifunctional space that mixes versatility of use with beautifully framed vistas and lush planting. The terrace is divided up into a loose grid system of raised planters that create options of how to navigate the space. This variety of pathways and seasonality of the planting ensures that there is always something new to discover on the terrace. Two larger areas are carved out of this grid pattern. One forms a dining area, while the other a comfortable seating area.

The weight and access constraints of building on an existing roof have been overcome by the clever use of planters. These matte gray, square planters and soft tones of the untreated, weathered decking and granite pavers, create a hard landscape palette that is unassuming, letting the planting speak for itself.

The planting is an eclectic mix of species and styles. Features include cloud-form Japanese holly and myrtle in the Japanese *Niwaki* style. Further structure comes from close-clipped box balls, columnar English yew, and a 100-year-old olive tree. A touch of contemporary Scandinavian-inspired gardens comes from several multi-stemmed birch trees. The wide range of perennials adds seasonal color and a sense of a traditional English country garden.

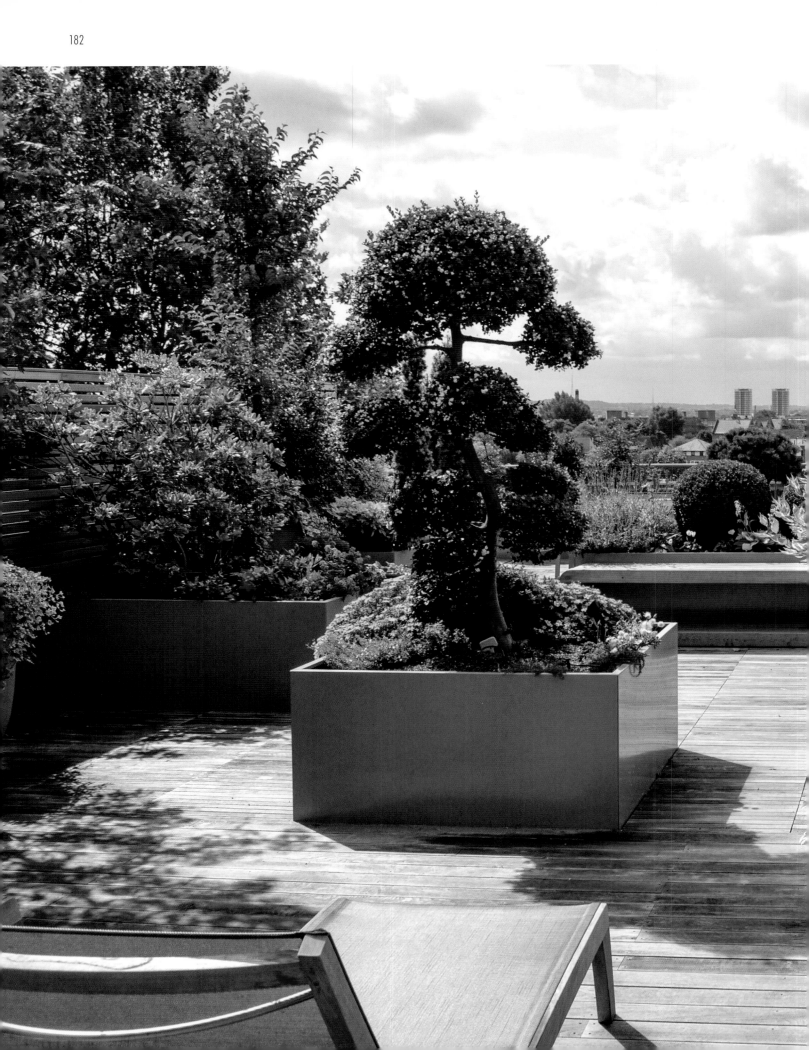

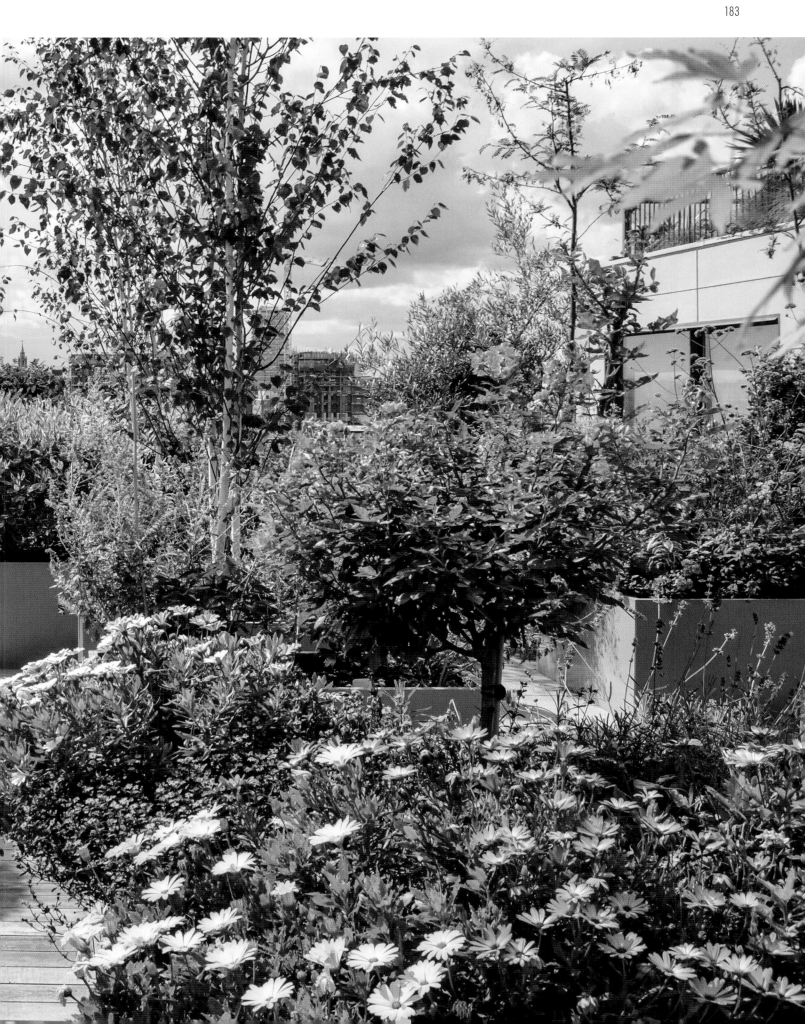

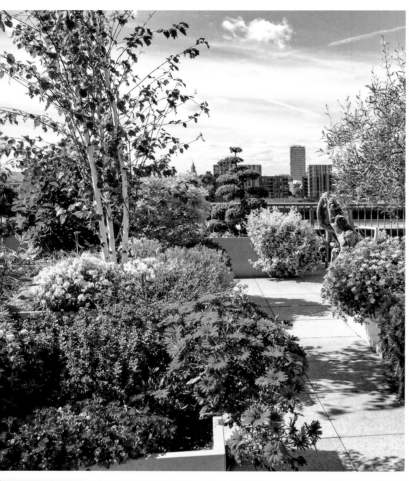

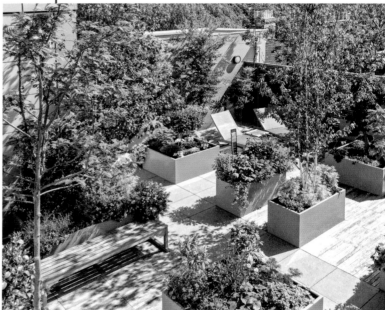

The planting is a riot of color that juxtaposes the monochromatic hard landscape. The arrangement of planters creates spatial definition without enclosure, striking a balance between privacy and accessibility.

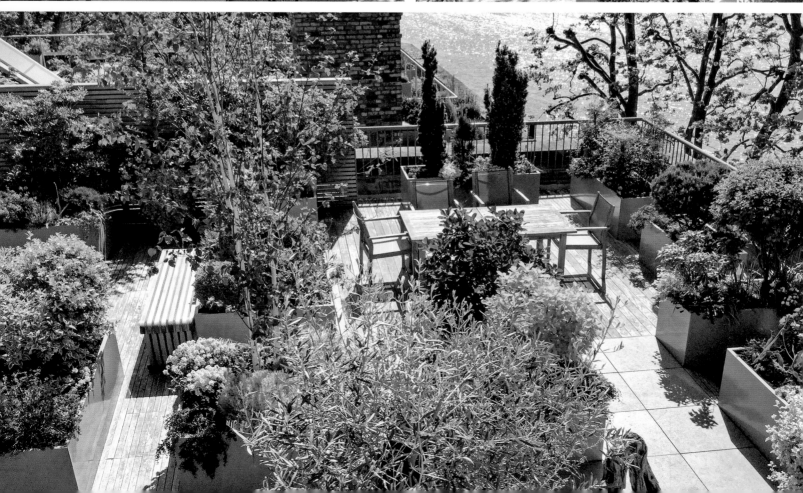

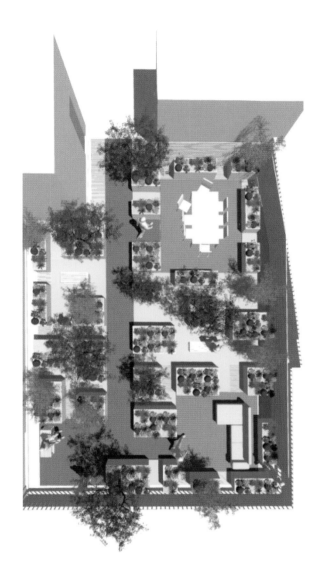

Climate
USDA Zone 9b (-3.9 to -1.1ºC / 25 to 30ºF)

Plants
African daisy (*Osteospermum*)
Birch (*Betula*)
Box (*Buxus sempervirens*)
English yew (*Taxus baccata*)
Japanese holly (*Ilex crenata* 'Topiary')
Lavender (*Lavandula*)
Maple (*Acer*)
Olive (*Olea europaea*)
Orange-barked myrtle (*Myrtus apiculata* 'Niwaki')
Perovskia (*Perovskia*)

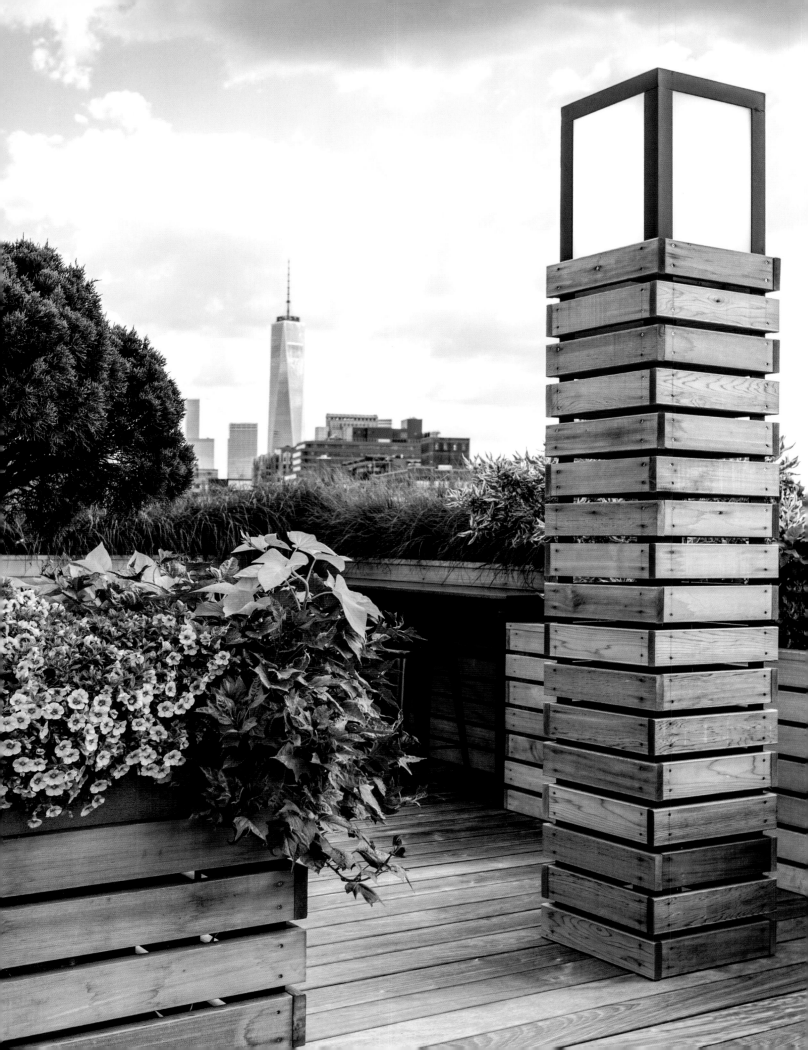

WEST VILLAGE CO-OP

New York City, USA

Category
Roof garden and extensive green roof

Year
2014

Area
440 m² (4,715 sq. ft.)

Landscape Architecture
Christian Duvernois Landscape/Gallery

Photography
Christian Erroi

The roof garden at West Village Co-Op is a beautiful mix of eclectic styles and forms that create a range of functional spaces from small intimate corners to more open multifunctional areas. The outward focus of the terrace makes best use of the stunning 360-degree panoramic views of Manhattan.

Throughout the terrace, existing vent pipes were concealed in cedar-wrapped towers to create vertical lighting and planter elements that connect with the views of the skyline, while ipe wood decking is used to link the various spaces together. The only area that is not decked is the dining area under the central custom-made aluminum and cedar pergola. Here concrete paving has been used for both spatial definition and extra durability. The spacious pergola provides a cool place to dine during hot summer days with clematis, trumpet vine, and wisteria providing shady respite to its users below. Just beyond the pergola, in a sunny space with southern exposure, is a small kitchen garden where residents can plant fresh edibles.

The linear pattern of the decking is contrasted by beautiful sweeping curves of sedum planting that provide an extensive green roof solution requiring minimal soil to establish. The sedum is punctuated in spring by the vibrant flowers of daylilies, adding to the seasonal interest. Larger plants and shrubs, such as red maple, Alberta spruce, Eastern redbud, Korean dogwood, hydrangea, and others are accommodated in raised planters of wood that complement the decking.

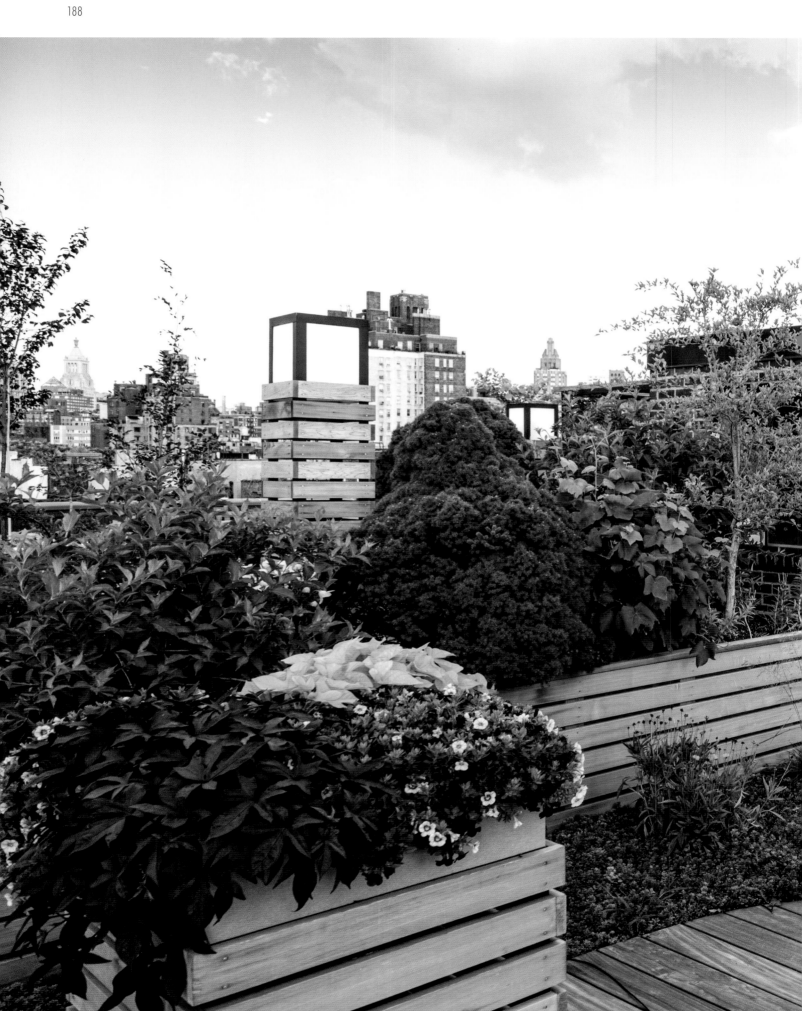

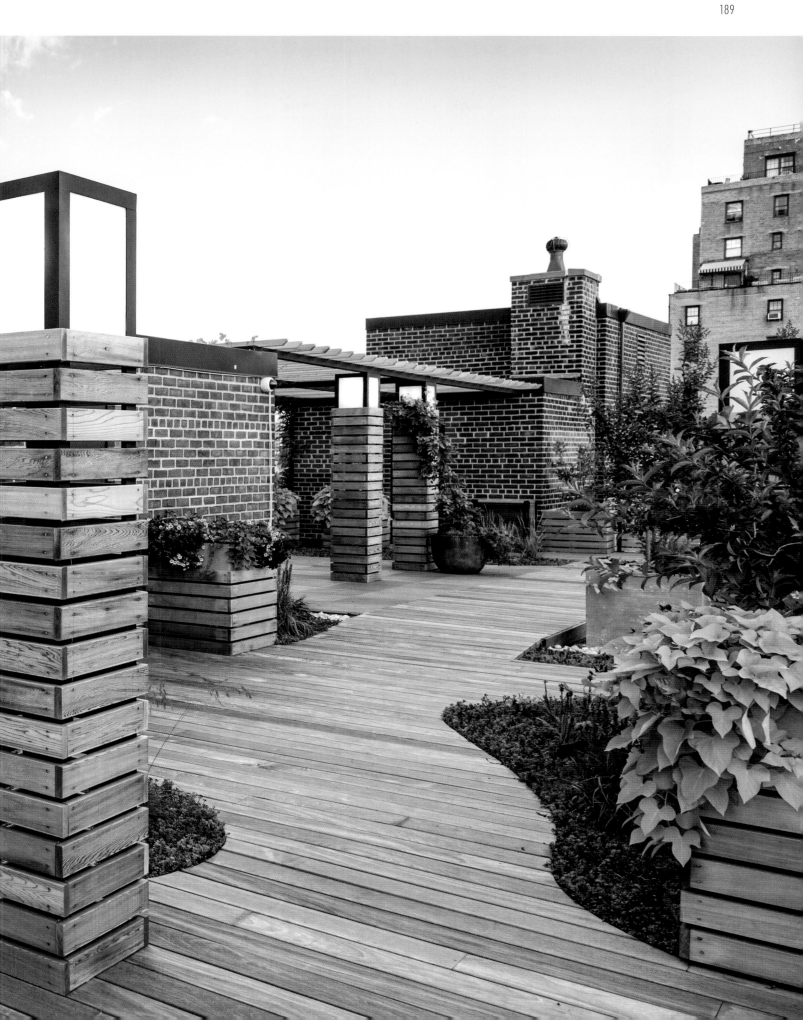

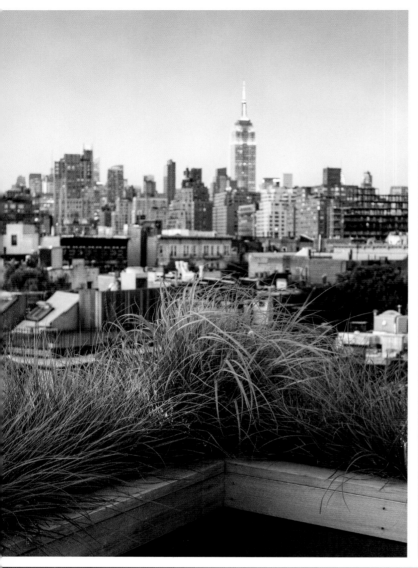

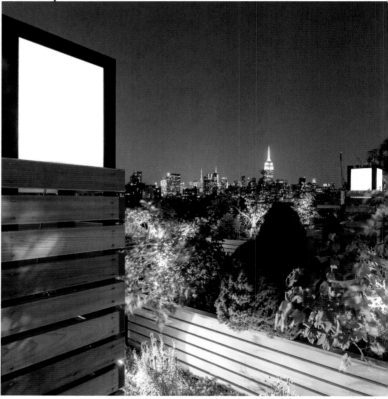

Below and bottom: The low-level lighting scheme of spotlights and luminaries hidden within the foliage of the planting creates a safe, welcoming environment without drowning the terrace in floodlighting.

Climate
USDA Zone 7b (-15 to -12.2°C / 5 to 10°F)

Plants
Alberta spruce (*Picea glauca* var. *albertiana*)
Blazing star (*Liatris spicata*)
Clematis (*Clematis sp*)
Daylily (*Hemerocallis sp*)
Eastern redbud tree (*Cercis canadensis* 'Hearts of Gold')
Holly (*Ilex sp*)
Hydrangea (*Hydrangea sp*)
Korean dogwood (*Cornus kousa*)
Red maple (*Acer rubrum*)
Sedum (*Sedum sp*)
Trumpet vine (*Campsis radicans*)
Wisteria (*Wisteria sp*)

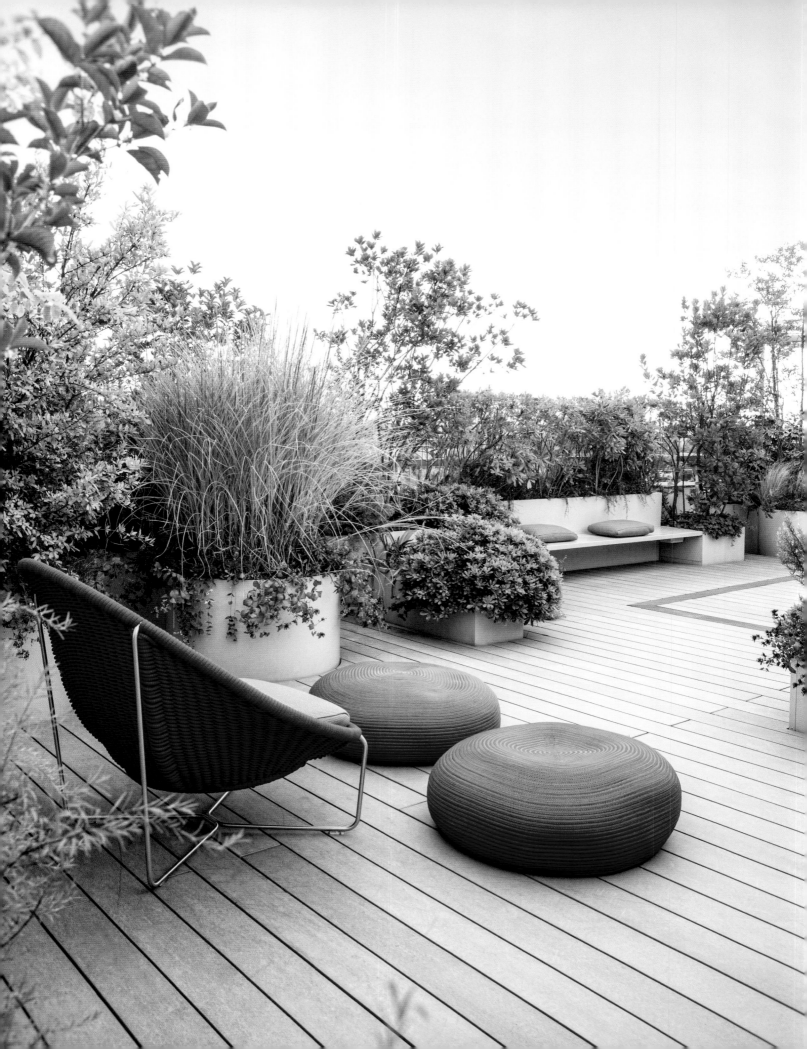

ROMOLO
PRIVATE TERRACE

Milan, Italy

Category
Roof garden

Year
2013

Area
200 m² (2,200 sq. ft.)

Landscape Architecture
Cristina Mazzucchelli

Architecture
Sangiorgi s.p.a.

Photography
Matteo Carassale

The Romolo roof terrace at is a playful, open-plan garden for entertaining and offers peaceful seclusion from the city and shade from the hot Milan summer sun.

The terrace is divided into three main areas, each with their own functional identity and atmosphere. The large dining area adjacent to the property is dominated by a pergola, which has retractable awnings to provide varying amounts of shade. An area with a large sofa offers a semi-enclosed place for a quiet drink of an evening. A third, more intimate space is formed by taller luscious plantings creating a cozy nook in which to relax. The three spaces are visually open to each other creating a light openness to the terrace that fosters an atmosphere of cool serenity.

Planting keeps the boundaries of the space and is used primarily for screening views from neighboring properties. Structure in the planting comes from snowy mespilus, the strawberry tree, and crepe myrtle, all chosen for their limited size. Much of the herbaceous planting, such as fountain grass, sedge, silvergrass, and bamboo has a soft nebulous form to it, reminiscent of clouds, thus conceptually linking the roof garden with its lofty location.

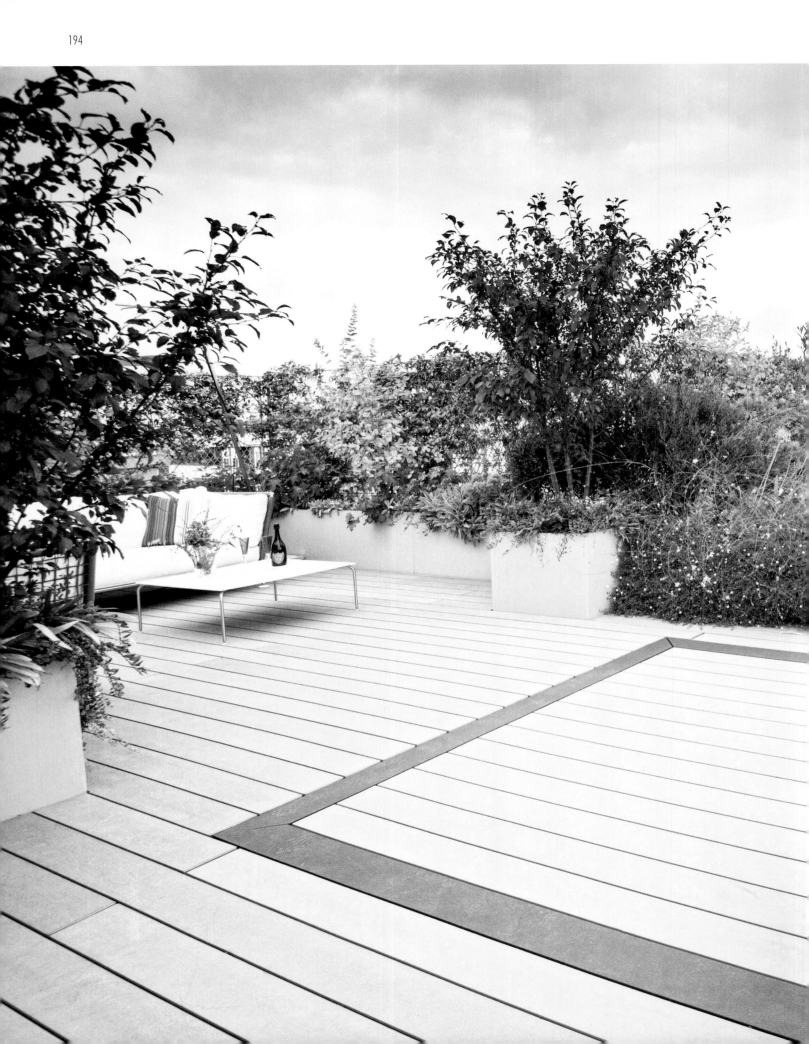

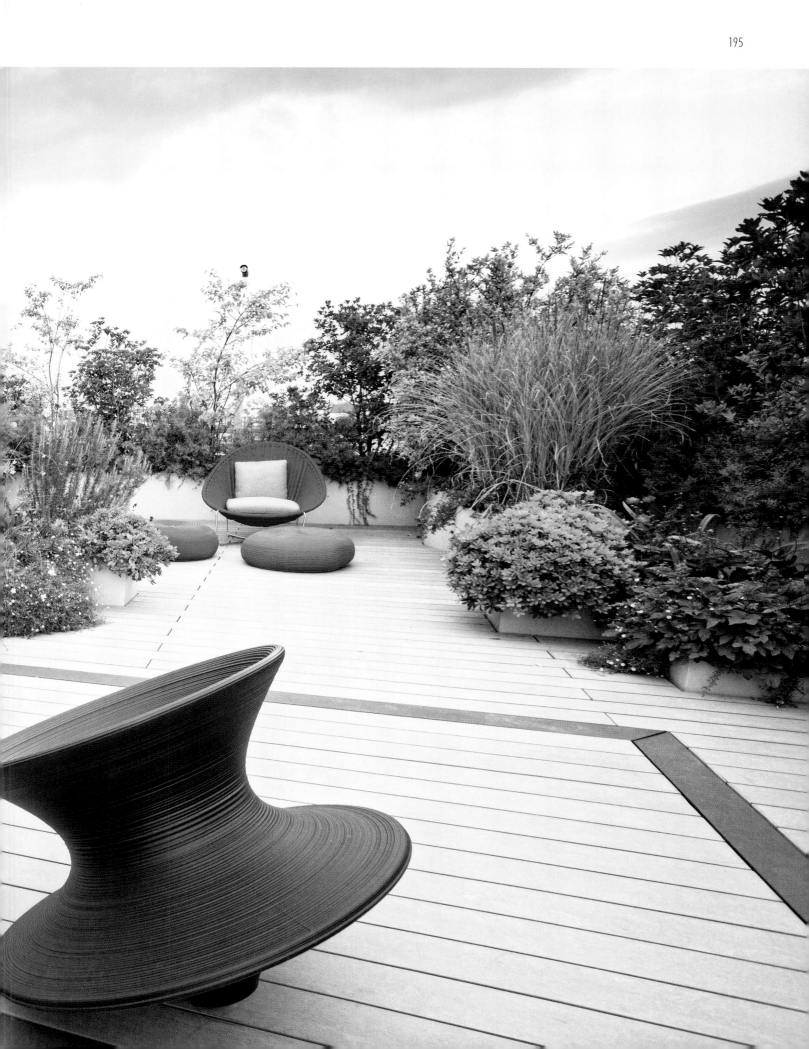

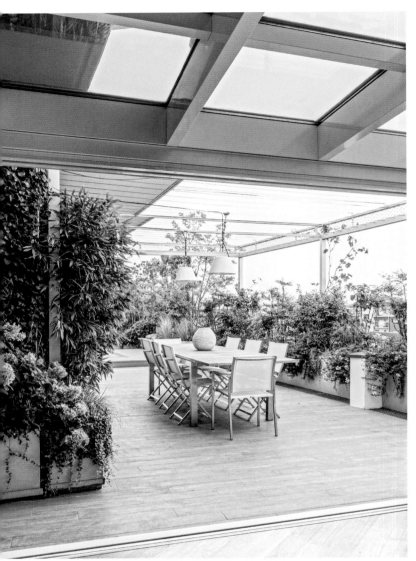

Previous page and below: Purple has been used as an accent color, not only in the soft furnishings, but also in plants such as the Japanese maple, geraniums, and sedums.

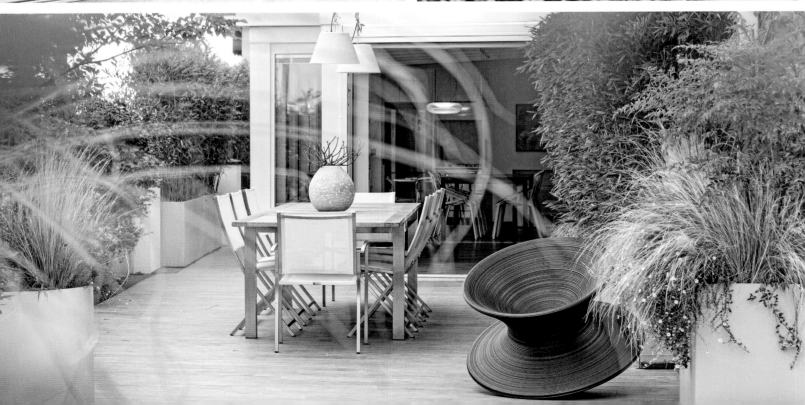

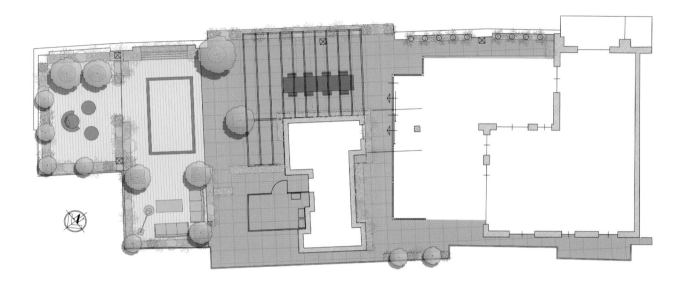

Climate
USDA Zone 9a (-6.7 to -3.9ºC / 20 to 25ºF)

Plants
Bisset's bamboo (*Phyllostachys bissetii*)
Chinese fountain grass (*Pennisetum alopecuroides* 'Little Bunny')
Crepe myrtle (*Lagerstroemia* 'Muskogee')
Geranium (*Geranium × cantabrigiense* 'Biokovo')
Purple Japanese maple (*Acer palmatum* 'Atropurpureum')
Sedum (*Sedum* 'Herbstfreude')
Silvergrass (*Miscanthus sinensis* 'Morning Light')
Snowy mespilus (*Amelanchier lamarckii*)
Strawberry tree (*Arbutus unedo*)
White variegated Japanese sedge (*Carex oshimensis* 'Everest')

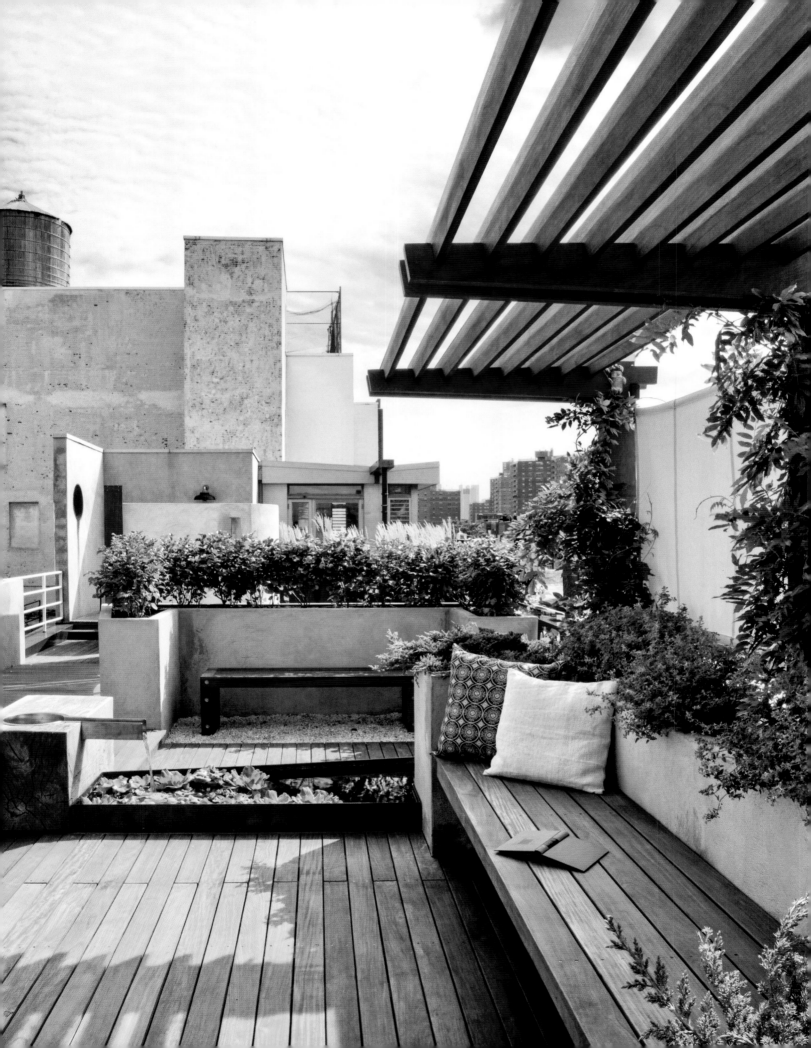

EAST VILLAGE ROOFTOP GARDEN

New York City, USA

Category
Roof garden

Year
2008

Area
58 m² (630 sq. ft.)

Planting
Roger Miller Gardens

Architecture
pulltab

Photography
Bilyana Dimitrova

The warm charm of the East Village Rooftop Garden displays a timeless elegance and an attention to detail in how the design will change over time. The materials chosen create a contemporary garden that respects its historic environment with an aesthetic that doesn't compete with the architecture around it.

Functionally, the garden contains everything one could hope for in a state-of-the-art roof terrace, with dining area and a quiet contemplation space, complete with a calming water feature adjacent to a pergola with Japanese wisteria rambling over it. The terrace also contains an outdoor shower, concealed behind high stucco walls for privacy. One small rectangular window in the wall allows a glimpse of the Empire State Building, but is cleverly angled so as to ensure the bather is not seen.

Perhaps the most striking element is the solid oak water feature, which was specially commissioned. A stainless steel trough extends from the wood, spilling water into an untreated Corten steel basin. Like the ipe wood deck that surrounds it, the oak block is left untreated and will, given time, mellow with the patina of age like the Corten steel.

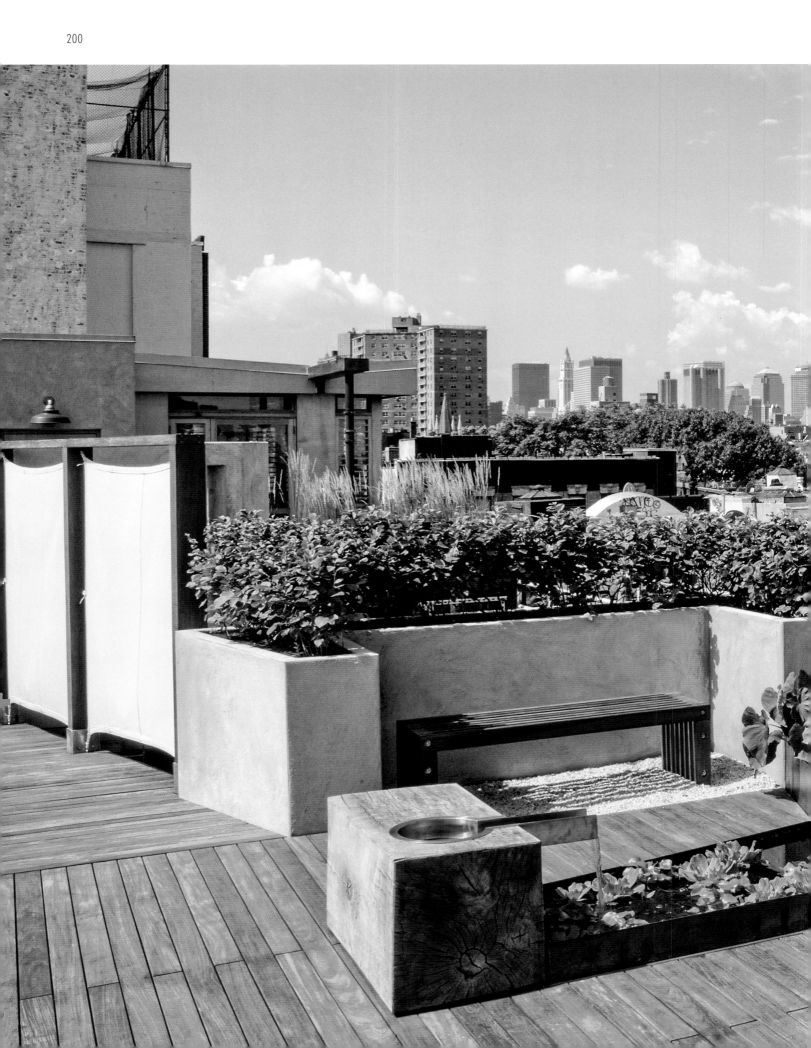

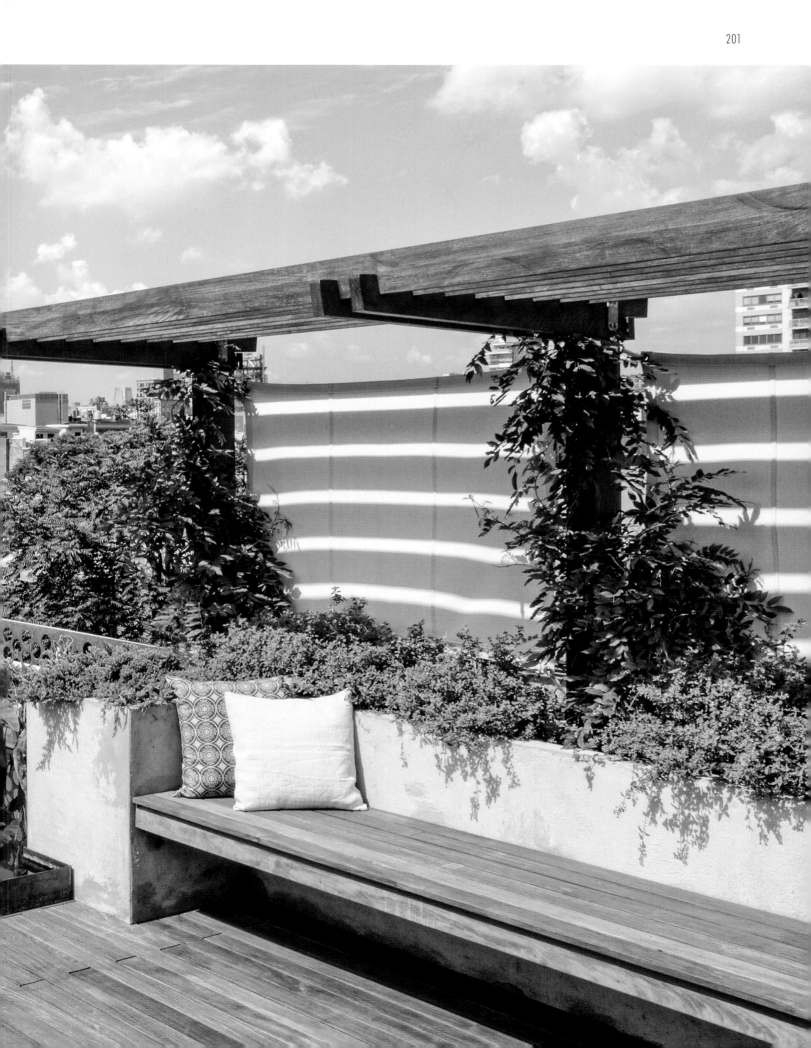

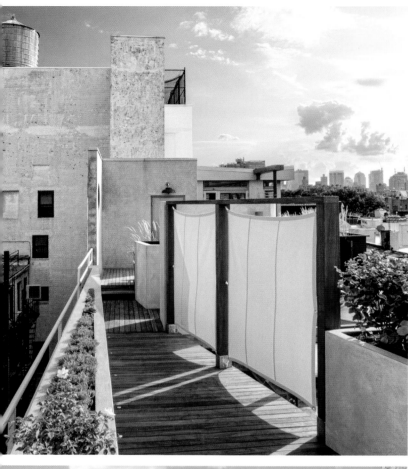

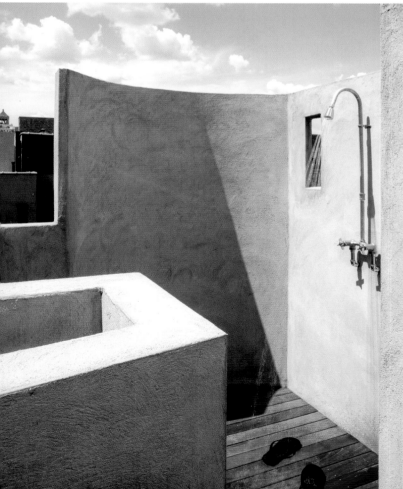

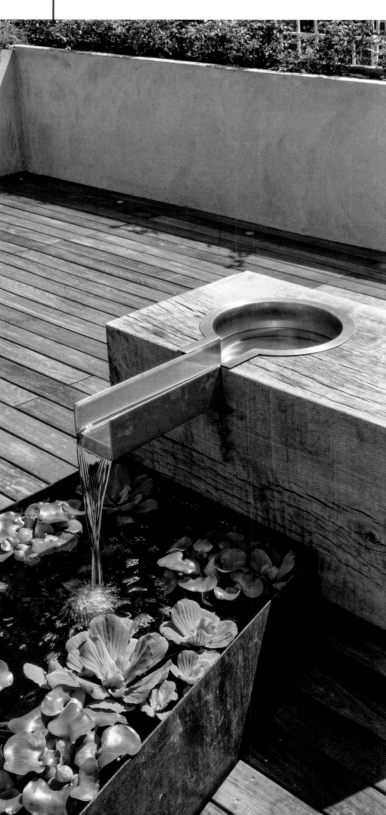

Below: The visual mass of the solid oak bench draws the eye into the space, while the sound of the falling water tumbling over the water lettuce fills the air with its hypnotic sound.

Climate
USDA Zone 7b (-15 to -12.2°C / 5 to 10°F)

Plants
Cape pondweed (*Aponogeton distachyos*)
Catmint (*Nepeta × faassenii*)
Chinese juniper (*Juniperus chinensis* 'Torulosa')
Climbing hydrangea (*Hydrangea anomala* subsp. *petiolaris*)
Colocasia (*Colocasia sp*)
Crape myrtle (*Lagerstroemia indica* 'White Chocolate')
Dwarf witchalder (*Fothergilla gardenii*)
Feather reed-grass (*Calamagrostis × acutiflora* 'Karl Foerster')
Houseleek (*Sempervivum sp*)
Japanese wisteria (*Wisteria floribunda* 'Texas Purple')
Lavender (*Lavandula*)
Recumbent juniper (*Juniperus procumbens*)
Water hyacinth (*Eichhornia*)
Water lettuce (*Pistia stratiotes*)

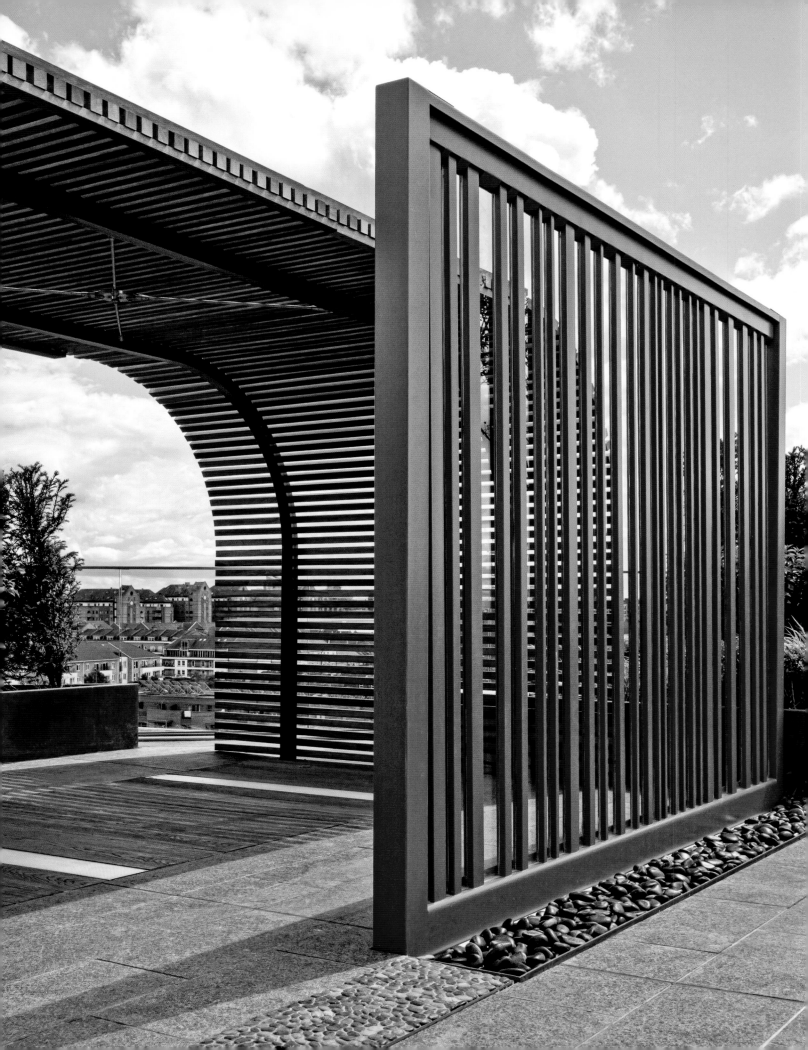

CHELSEA CREEK DOCKSIDE HOUSE

London, United Kingdom

Category
Roof garden

Year
2014

Area
363 m² (3,900 sq. ft.)

Landscape Architecture
Aralia Landscape Architects

Architecture
BroadwayMalyan

Awards
BALI Principal Landscape
Design Excellence Award –
Overall Scheme over £50k

Photography
John Glover Photography

The roof gardens at Chelsea Creek Dockside House for St George PLC are a thoughtfully designed and beautifully crafted series of contemporary spaces that offer the best in luxury penthouse living.

The gardens have been built using a contemporary palette of hard landscape materials such as weathered Corten steel and shot blasted glass, complemented by natural materials like granite and sustainably sourced hardwoods.

The gardens are divided into a series of intimate spaces offering residents privacy and seclusion. The gardens contain a range of cutting-edge features, such as fire pits, water walls, outdoor kitchens, and green walls— a contemporary outdoor living lifestyle.

The planting palette emphasizes the colors of the hard landscape materials with species like sneezeweed and coneflower reflecting the warm burnt oranges of the weathered Corten steel, while the feather reed-grass picks up the colors of the natural hardwood. Green walls offer an increased area for planting as well as a calming backdrop with a variety of plants creating a textural tapestry, such as hart's tongue fern and Japanese spurge.

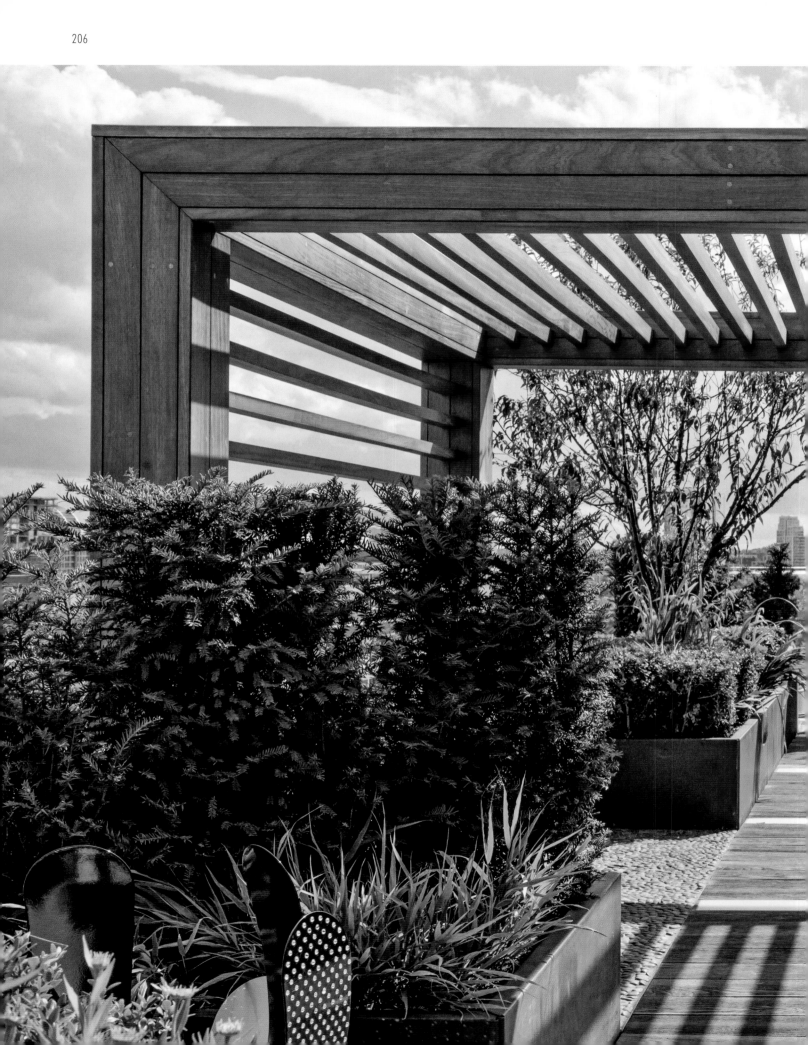

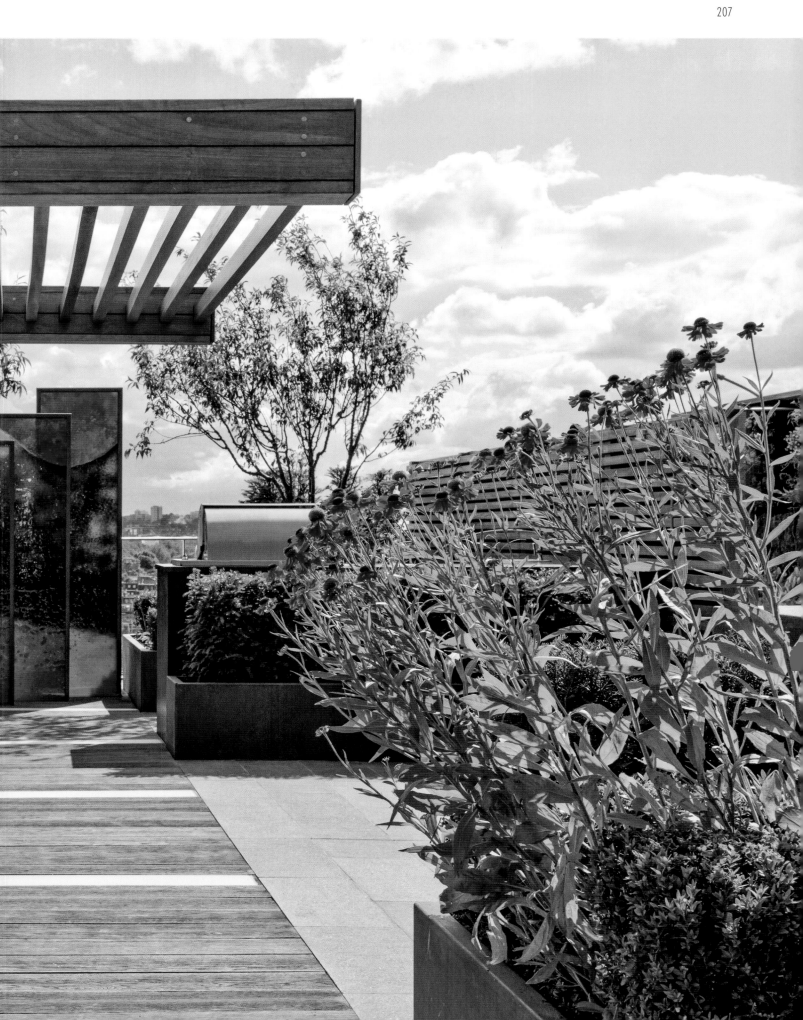

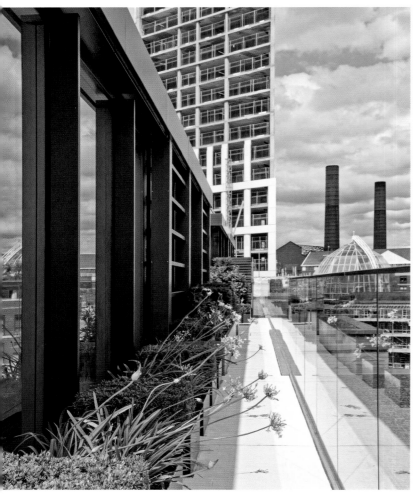

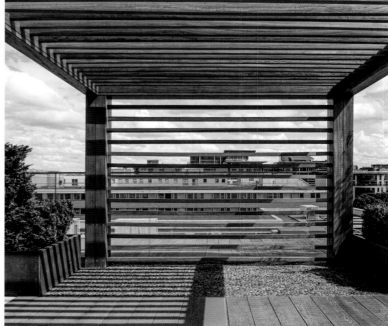

Previous page: Stunning artwork has been incorporated into the design forming focal points. The decking is inset with glass panels which are lit from underneath, washing the space in a soft glow in the evening.

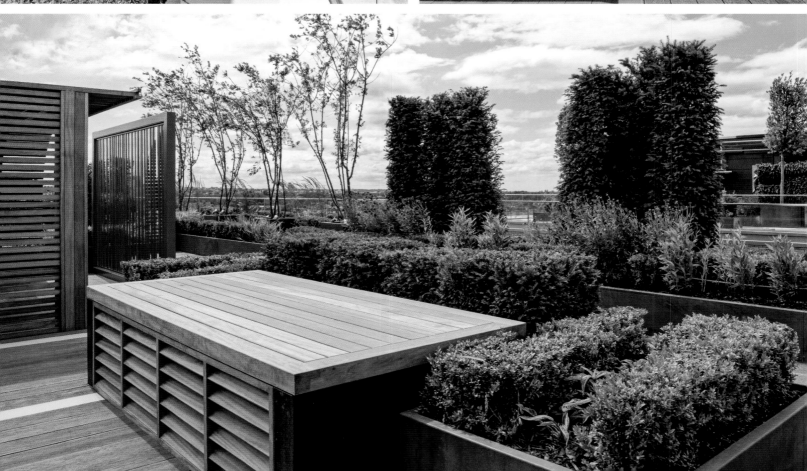

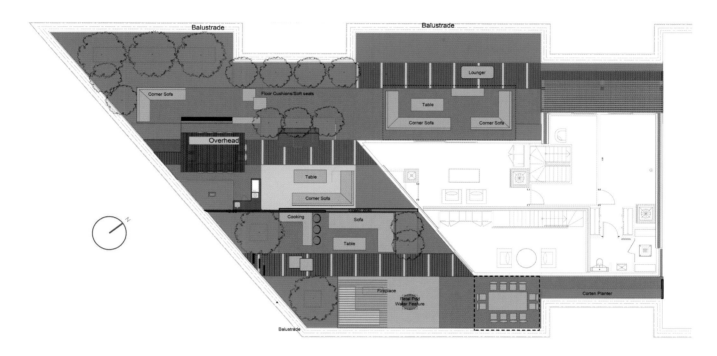

Climate
USDA Zone 9b (-3.9 to -1.1ºC / 25 to 30ºF)

Plants
Chamomile (*Chamaemelum nobile* 'Treneague')
Coneflower
 (*Echinacea* 'Sundown', *Echinacea* 'Tiki Torch')
English yew (*Taxus baccata*)
Feather reed-grass
 (*Calamagrostis* × *acutiflora* 'Karl Foerster')

Hart's tongue fern (*Asplenium scolopendrium*)
Japanese spurge (*Pachysandra terminalis*)
Manchurian cherry (*Prunus maackii* 'Amber Beauty')
Sage (*Salvia officinalis*)
Sneezeweed (*Helenium* 'Moerheim Beauty')
Tulip (*Tulipa* 'Ballerina', *Tulipa* 'Ego Parrot')

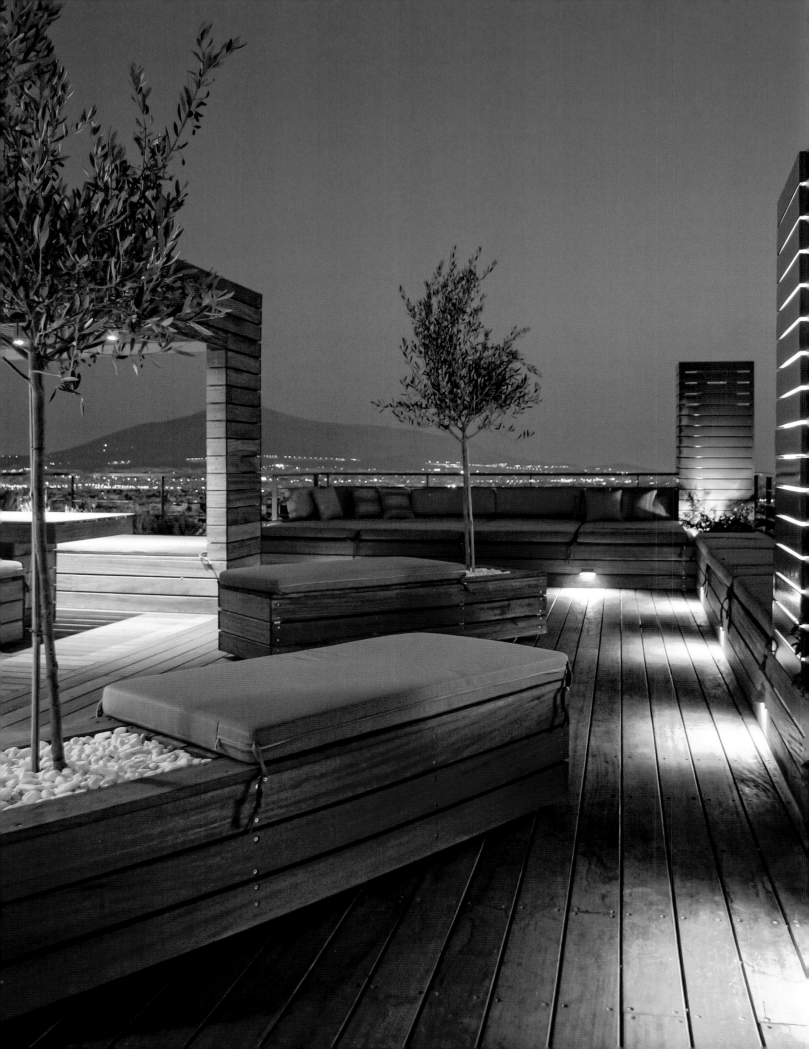

ROOFESCAPE MELISSIA

Athens, Greece

Category
Roof garden

Year
2008

Area
75 m² (810 sq. ft.)

Landscape Architecture / Architecture
mab architecture

Photography
mab architecture

Roofescape Melissia is a modest yet chic roof terrace designed for an outdoor entertaining lifestyle. With commanding 360-degree views of the city of Athens, the minimalist aesthetic of the design and materials allows the views of Athens to speak for themselves.

The designers made the very brave decision of using a 12-centimeter by 2-centimeter (5-inch by 1-inch) iroko hardwood plank as their inspiration. From this one base unit everything in the garden has been scaled. Therefore the design minimizes waste and delivery of different materials, not only saving the client money, but also enabling a net environmental benefit to the project.

The existing wall surrounding the space is clad in hardwood to provide flexible, non-prescribed spaces for sitting, eating, or enjoying the panoramic views. The only other furniture comes in the form of two movable benches on wheels, which can be arranged in different ways to add versatility to the space.

The minimal planting is largely native and all sourced locally to provide the best establishment while also minimizing maintenance requirements.

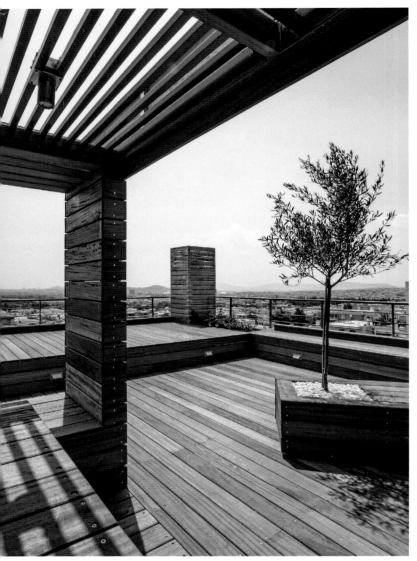

The movable planter/benches ensure adaptability of spatial arrangement while the open-plan layout allows for large social gatherings for the young owners of this roof terrace.

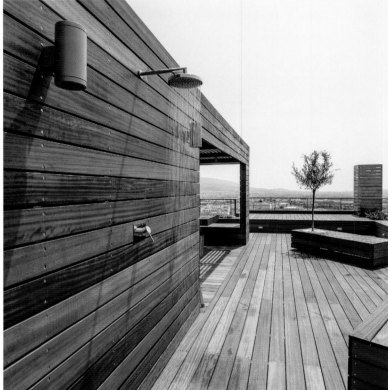

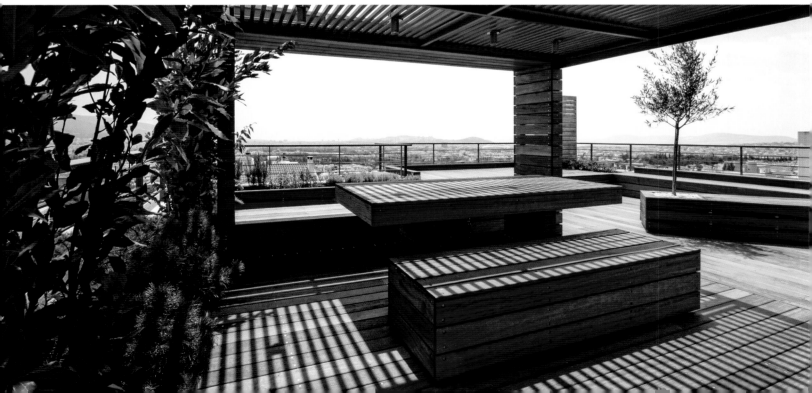

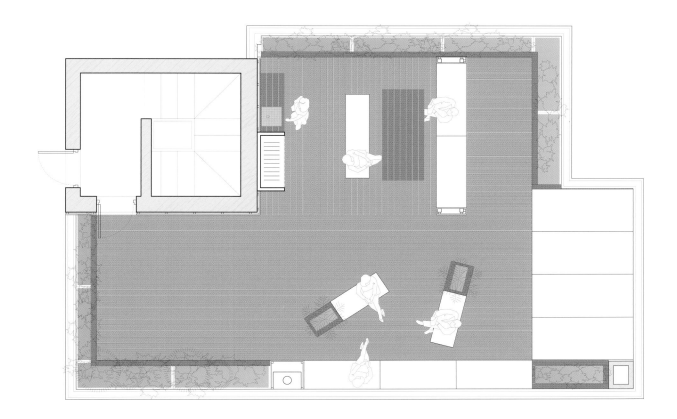

Climate
USDA Zone 10a (-1.1 to 1.7ºC / 30 to 35ºF)

Plants
Bay laurel (*Laurus nobilis*)
English lavender (*Lavandula angustifolia*)
Olive (*Olea europaea*)
Oregano (*Origanum vulgare*)
Rosemary (*Rosmarinus officinalis*)
Thyme (*Thymus vulgaris*)

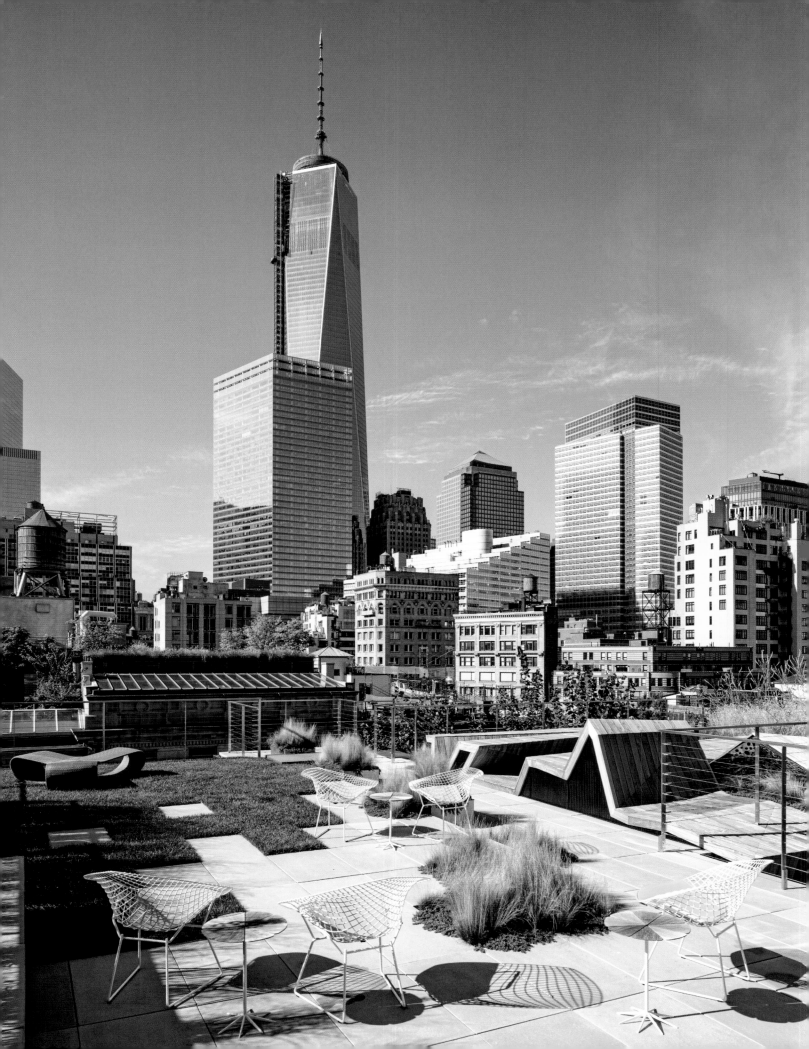

TRIBECA PENTHOUSE GARDEN

New York City, USA

Category
Intensive and extensive green roof

Year
2012

Area
600 m² (6,500 sq. ft.)

Landscape Architecture
HMWhite

Architecture
Steve Blatz Architects

Awards
The Chicago Athenaeum,
 American Architecture Award
Interior Design magazine, Best of Year

Photography
Nikolas Koenig Photography, HMWhite

Tribeca Penthouse Garden is a dynamic garden experience where crisp architectural geometries are infused with soft topographic forms and vegetation creating a harmonious and elegant residential landscape that floats within the downtown Manhattan skyline.

The modular stone paving pattern breaks up into lawn and planting areas knitting the building architectural infrastructure with planting systems and blurring the boundaries between interior and exterior spaces. Silky thread grasses erupt from the paving and swell into abundant swaths of plush meadow, highlighting an interplay of form and texture.

A glacier-like timber bench erupts from the wood deck and presents flexible seating for sitting and lounging. A stainless steel hot tub is inset into the deck taking contemporary luxury living to another level as users enjoy an intimate panorama of downtown New York. Areas of naturalistic prairie-style planting of switchgrass, Indiangrass, and dwarf prairie dropseed provide a wildlife habitat, inviting birds, bees, and butterflies into this lively sequence of exterior spaces.

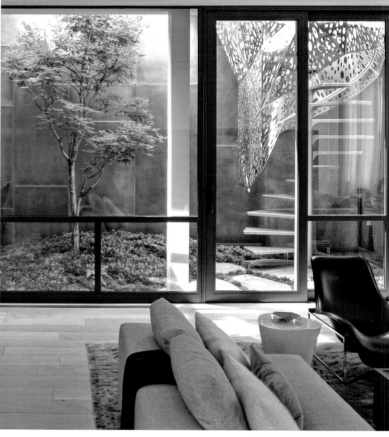

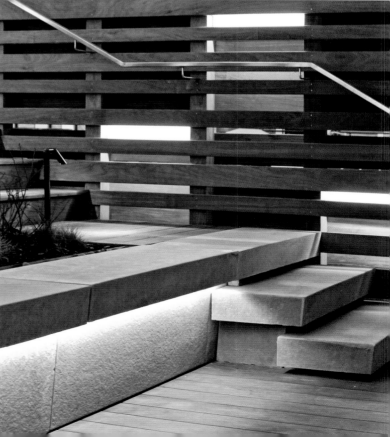

Below and next page: The design is based on the architecture of the building and draws the eye out to the city beyond.

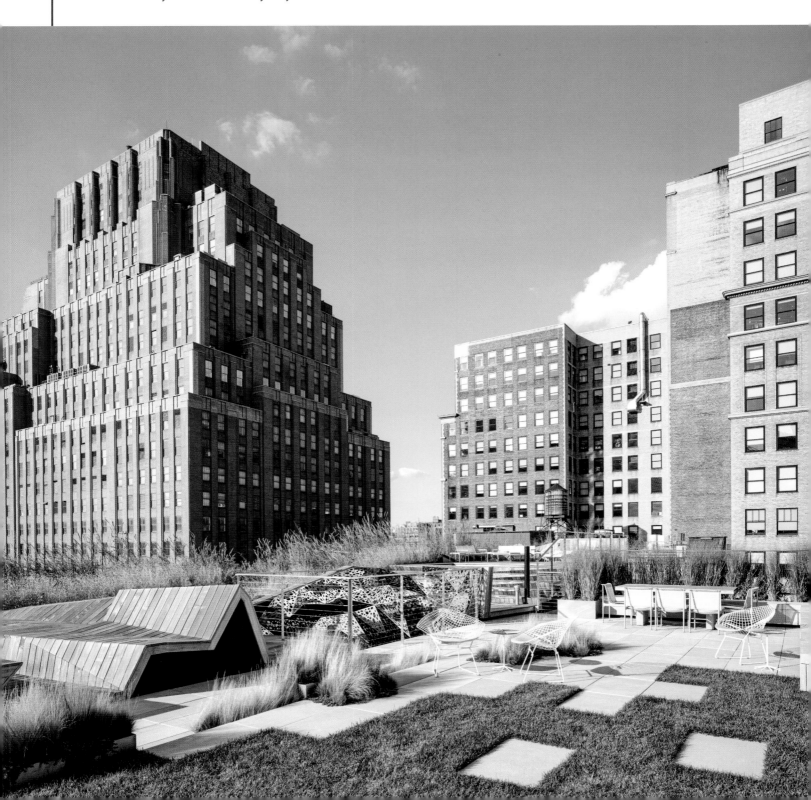

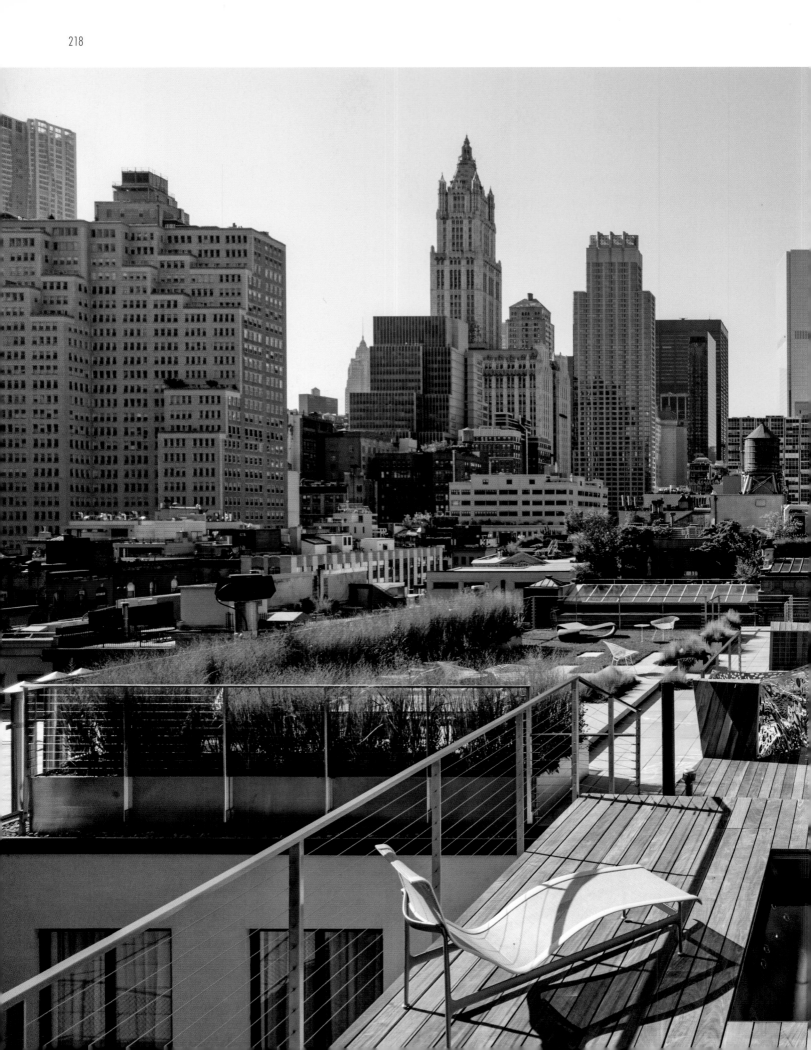

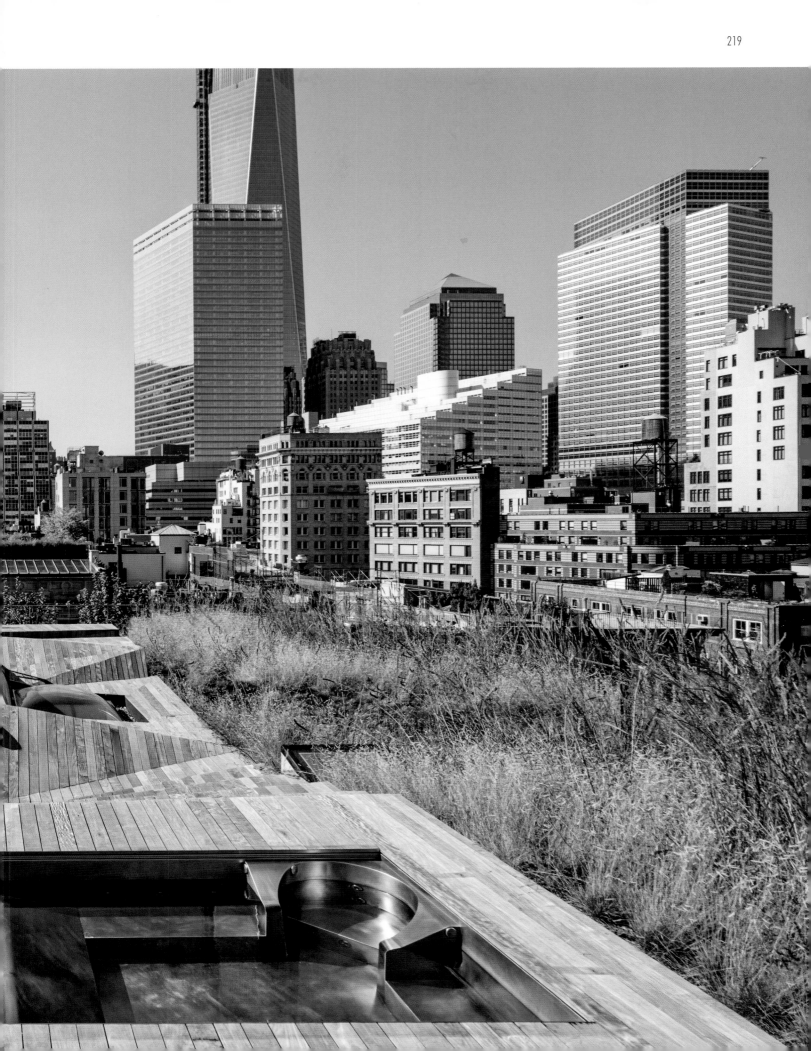

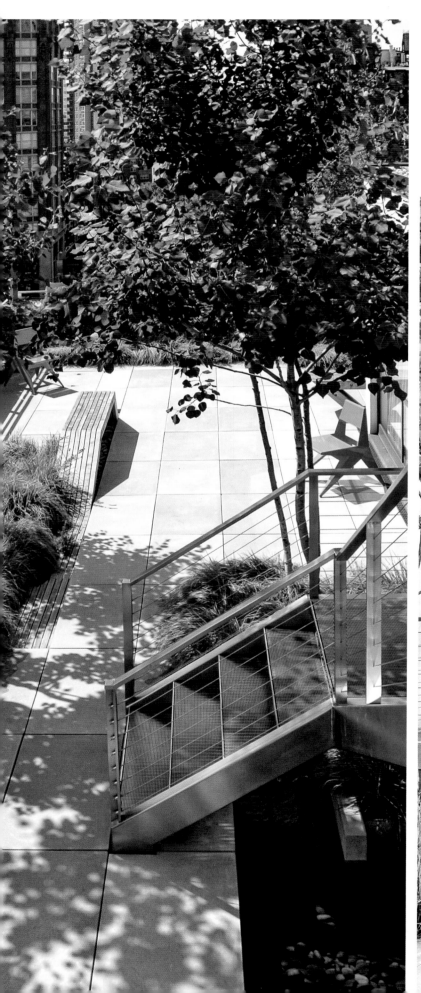

Semi-mature quaking aspens and crimson glory vines offer vertical vegetation systems that promote a seamless expansion of the penthouse interior.

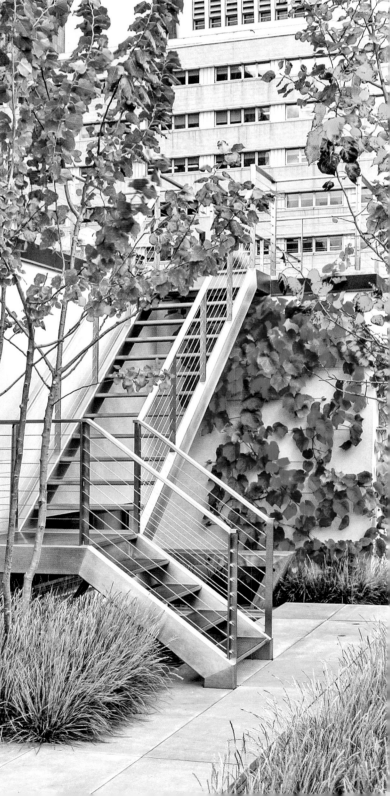

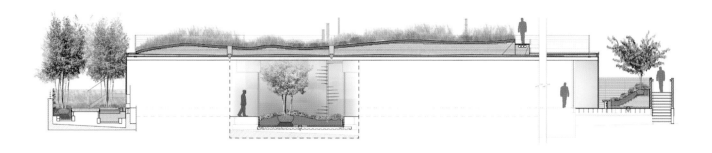

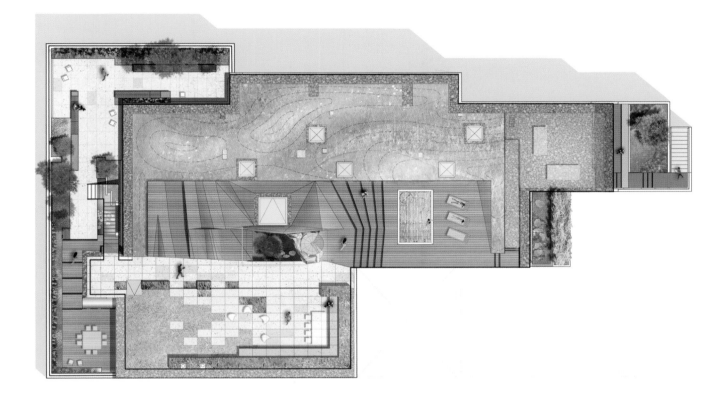

Climate
USDA Zone 7b (-15 to -12.2°C / 5 to 10°F)

Plants

Blue grama (*Bouteloua gracilis* 'Blonde Ambition')
Crimson glory vine (*Vitis coignetiae*)
Dwarf prairie dropseed (*Sporobolus heterolepis* 'Tara')
English ivy (*Hedera helix*)
Fineleaf fescue (*Festuca tenuifolia* 'Angel Hair')
Green fescue (*Festuca ovina*)
Japanese maple (*Acer palmatum* 'Glowing Embers')
Nash Indiangrass (*Sorghastrum nutans* 'Cheyenne')

Prairie dropseed (*Sporobolus heterolepis*)
Prairie junegrass (*Koeleria macrantha*)
Quaking aspen (*Populus tremuloides* 'Prairie Gold')
Silky thread grass (*Nassella tenuissima*)
Switchgrass (*Panicum virgatum* 'Northwind')
Virginia creeper (*Parthenocissus quinquefolia*)
Witchhazel (*Hamamelis vernalis* 'Sandra')
Yellow groove bamboo
 (*Phyllostachys aureosulcata* 'Spectabilis')

INDEX

Landscape Architects / Architects

Feldman Architecture, Inc.
1005 Sansome Street, Suite 240
San Francisco, CA 94111
USA
www.feldmanarchitecture.com
↳ *Mill Valley Cabins, page 41*
↳ *Pacific Heights Rooftop Garden, page 85*

Filip Deslee
Kronenburgstraat 27, bus 211
2000 Antwerp
Belgium
www.filipdeslee.com
↳ *Spain on the Roof, page 143*

Foley Fiore Architecture
316 Cambridge Street
Cambridge, MA 02141
USA
www.foleyfiore.com
↳ *Central Park West Rooftop Terrace,
page 127*

Future Green Studio
18 Bay Street
New York, NY 11231
USA
www.futuregreenstudio.com
↳ *41 Bond, page 55*
↳ *Periscope House, page 89*

Gunn Landscape Architecture, PLLC
345 Seventh Avenue, Suite 502
New York, NY 10001
USA
www.gunnlandscapes.com
↳ *Central Park West Rooftop Terrace,
page 127*
↳ *Crosby Street Rooftop Terrace, page 149*

Guz Architects Pte Ltd
3 Jalan Kelabu Asap
Singapore 278199
www.guzarchitects.com
↳ *Willow House, page 9*
↳ *Sky Garden, page 35*

HMWhite
107 Grand Street, 6th Floor
New York, NY 10013
USA
www.hmwhitesa.com
↳ *Tribeca Penthouse Garden, page 215*

Jori Hook Landscape Architecture
284 Sycamore Avenue
Mill Valley, CA 94941
USA
www.jorihook.com
↳ *Mill Valley Cabins, page 41*

Lady Bird Johnson Wildflower Center
4801 La Crosse Avenue
Austin, TX 78739
USA
www.wildflower.org
↳ *Edgeland House, page 17*

LGA Architectural Partners
533 College Street, Suite 301
Toronto, Ontario M6G 1A8
Canada
www.lga-ap.com
↳ *Euclid Avenue, page 61*

Loretta Gargan Landscape + Design
308 Precita Avenue
San Francisco, CA 94110
USA
www.lorettagargan.com
↳ *Pacific Heights Rooftop Garden, page 85*

mab architecture
34 Filellinon Street
Athens 10558
Greece
www.mabarchitects.com
↳ *Roofescape Melissia, page 211*

Mary Barensfeld Architecture
73A Cumberland Street
San Francisco, CA 94110
USA
www.barensfeld.com
↳ *Hilgard Garden, page 23*

Modular.London
Unit 2 Angel Wharf
166 Shepherdess Walk
London N1 7JL
United Kingdom
www.modulargarden.com
↳ *Thames Roof Terrace, page 181*

MyLandscapes Garden Design
6a Sydney Road
London N10 2LP
United Kingdom
www.mylandscapes.co.uk
↳ *Ziggurat Rooftop Terrace, page 169*

nARCHITECTS
68 Jay Street, #317
New York, NY 11201
USA
www.narchitects.com
↳ *Periscope House, page 89*

Nelson Byrd Woltz Landscape Architects
310 East Market Street
Charlottesville, VA 22902
USA
www.nbwla.com
↳ *Carnegie Hill House, page 109*

Patrizia Pozzi Landscape Architect
Via Paolo Frisi 3
20129 Milan
Italy
www.patriziapozzi.it
↳ *Milan Rooftop Terrace, page 175*

pulltab
10 East 23rd Street, No. 710
New York, NY 10010
USA
www.pulltabdesign.com
↳ *East Village Rooftop Garden, page 199*

Restoration Gardens Inc.
61 Shaw Street
Toronto, Ontario M6J 2W3
Canada
www.restorationgardens.ca
↳ *Euclid Avenue, page 61*

Roger Miller Gardens
771 West End Avenue
New York, NY 10025
USA
www.rogermillergardens.com
↳ *East Village Rooftop Garden, page 199*

Steve Blatz Architects
1 Union Square West
New York, NY 10003
USA
www.blatzarc.com
↳ *Tribeca Penthouse Garden, page 215*

Terragram Pty Ltd
404/75 King Street
Sydney NSW 2000
Australia
www.terragram.com.au
↳ *Watermarque, page 31*

Vo Trong Nghia Architects
8F, 70 Pham Ngoc Thach Street, Ward 6
District 3, Ho Chi Minh City
Vietnam
www.votrongnghia.com
↳ *House for Trees, page 47*

IMPRINT

© 2016 teNeues Media GmbH & Co. KG, Kempen
All rights reserved

Edited by Arndt Jasper & Haike Falkenberg
Texts by Ashley Penn

Copy Editing by Maria Regina Madarang
Translation by Amanda Ennis,
Shearwater Language Service

Design & Layout by Sophie Franke
Imaging & Proofing by
David Burghardt & Moritz Meyer-Buck
Production by Alwine Krebber

ISBN 978-3-8327-3245-5
Library of Congress Number: 2015958055

Printed in the Czech Republic

Bibliographic information published by the Deutsche Nationalbibliothek.
The Deutsche Nationalbibliothek lists this publication in the Deutsche Nationalbibliografie; detailed bibliographic data are available in the Internet at http://dnb.d-nb.de.

Published by teNeues Publishing Group

teNeues Media GmbH & Co. KG
Am Selder 37, 47906 Kempen, Germany
Phone: +49-(0)2152-916-0
Fax: +49-(0)2152-916-111
e-mail: books@teneues.com

Press department: Andrea Rehn
Phone: +49-(0)2152-916-202
e-mail: arehn@teneues.com

teNeues Publishing Company
7 West 18th Street, New York, NY 10011, USA
Phone: +1-212-627-9090
Fax: +1-212-627-9511

teNeues Publishing UK Ltd.
12 Ferndene Road, London SE24 0AQ, UK
Phone: +44-(0)20-3542-8997

teNeues France S.A.R.L.
39, rue des Billets, 18250 Henrichemont, France
Phone: +33-(0)2-4826-9348
Fax: +33-(0)1-7072-3482

www.teneues.com

MIX
Paper from responsible sources
FSC® C005833